Robert E. Fisher
completed his PhD on the Buddhist art of China
and India at the University of Southern California in 1980.
He taught Asian art history for twenty-one years at the
University of Redlands, California, and has lectured widely
and travelled throughout India, South-East Asia and China.
He is the author of *Buddhist Art and Architecture* in the
World of Art, as well as numerous articles and exhibition
catalogues on the arts of Kashmir and the Himalayas,
Korean and Chinese Buddhist art and Chinese
jade and ceramics.

WORLD OF ART

This famous series
provides the widest available
range of illustrated books on art in all its aspects.
If you would like to receive a complete list
of titles in print please write to:
THAMES AND HUDSON
30 Bloomsbury Street, London WC1B 3QP
In the United States please write to:
THAMES AND HUDSON INC.
500 Fifth Avenue, New York, New York 10110

Printed in Slovenia

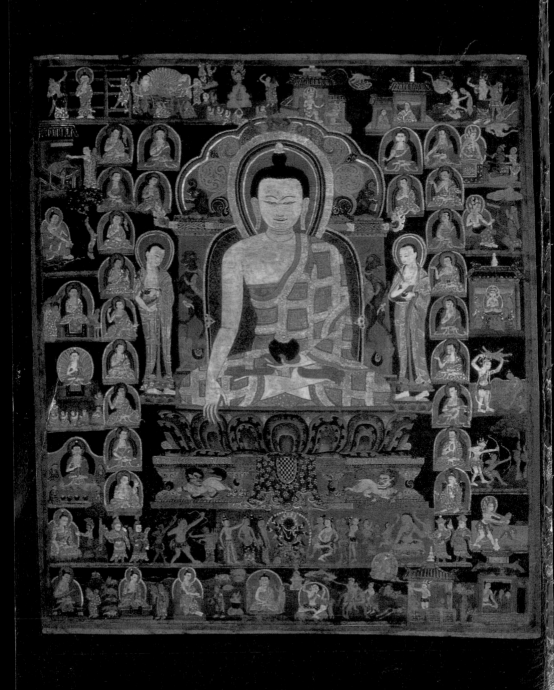

ROBERT E. FISHER

ART OF TIBET

180 illustrations, 93 in color

THAMES AND HUDSON

To Jan

N
7346
.T5
F57
1997

FRONTISPIECE Scenes from the life of Shakyamuni, the historical Buddha, 14th century, Tibet. Tangka, gouache on cotton, h. 86 cm (34 in)

ACKNOWLEDGMENTS

The great collectors Jack and Muriel Zimmerman and John and Berthe Ford have once again made photographs of their objects available, as have others, including Fosco Maraini, Bill Bueler, John Eskenazi, Anna Maria and Fabio Rossi and Alfred Speelman, and in New York Michael McCormick, Robert Ellsworth, Ramesh Kapoor, Krishna Nathan and Namka Dorjee. Museum scholars, such as Steven Kossak, Stephen Markel, and, especially, Valrae Reynolds and Barry Till, gave time and expertise at short notice. Among the contemporary scholars, Jane Casey Singer, Michael Henss, Marylin Rhie and the current generation of Italian specialists in the tradition of the great Giuseppe Tucci, continue to rejuvenate the study of Tibetan art. A special note of gratitude to Jisho Cary Warner, for her masterful editing. *R.E.F. Carmel, California*

Designed by Liz Rudderham

First published in the United States of America in 1997 by Thames and Hudson Inc., 500 Fifth Avenue, New York, New York 10110

Library of Congress Catalog Card Number 97-60253
ISBN 0-500-20308-3

Printed and bound in Slovenia

Contents

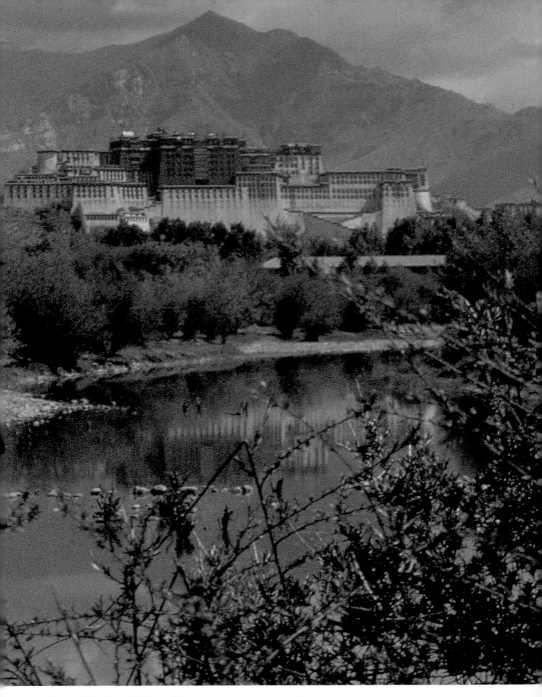

1 View of the Potala, Lhasa, Tibet

Preface

The tremendous bounty of Tibetan painting, sculpture and ritual objects has permeated the religious and cultural life of that isolated plateau for a millennium, and for most of that time Tibetan art and religion have influenced the cultural institutions of neighbouring areas of Buddhist Asia as well, from Central Asia to China, and south to Nepal. The tragic invasion and occupation of Tibet by China since the mid-twentieth century has brought the country into the consciousness of the rest of the world. Although the ongoing turmoil there has devastated most of the ancient monasteries and monuments, the many objects carried out by refugees have contributed to the preservation of Tibet's artistic and religious heritage, and with that a growing interest in its remarkable tradition by the rest of the world. This broader awareness may yet prove one of the most effective forces for the preservation of Tibet and its culture.

It was not until the latter half of the twentieth century that specialized interest in the study of Tibetan art began to develop in the West within the larger field of Asian art. Beyond missionary treatises and a few travel documents, little was published through the nineteenth century, although Tibetan language and Buddhist literature had begun to be addressed early in the century. Tibetan art had been exhibited by the end of the nineteenth century, but it was not until the pioneering studies of Giuseppe Tucci, beginning in the 1930s, that Western scholarship began to treat the subject of Tibetan art in its cultural context. With the wholesale destruction of more than 90 per cent of the temples since the invasion by the Chinese, the subject of Tibet has taken on ever greater urgency. Today, comprehensive collections of Tibetan art are displayed in a number of museums, as well as by discerning American private collectors, such as the Zimmermans and the Fords. This body of material has enabled contemporary scholars – who can no longer devote years to study within Tibet as did Tucci and others – to build on those first pioneering studies, and what has emerged is an understanding of Tibetan art within its cultural sphere and in its relationship to Asian cultures as a whole. The major touring exhibition *Wisdom and Compassion: The Sacred Art of Tibet* (1991–92 and 1996–97), organized by Marylin Rhie and Robert Thurman, has travelled to America, Europe and Japan, bringing many of the finest Tibetan objects before their largest audience to date.

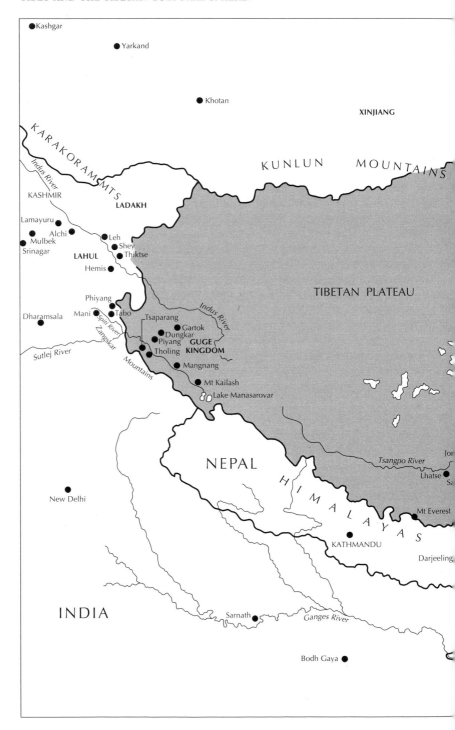

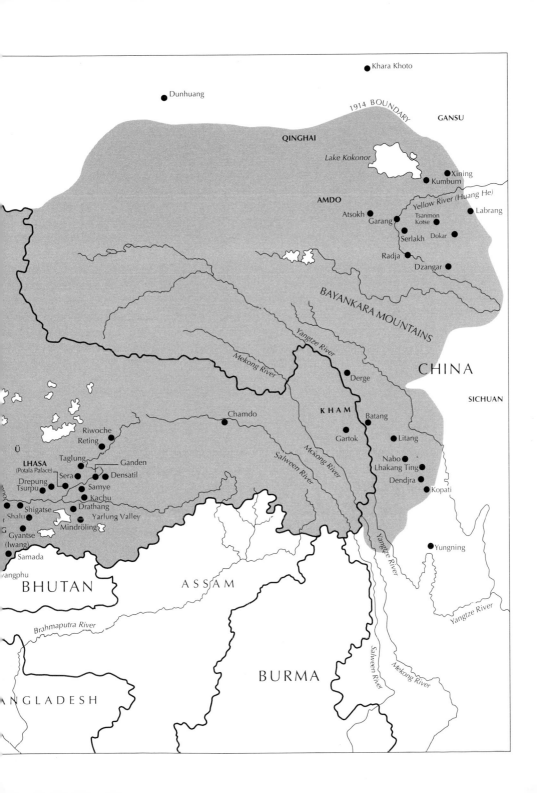

Khara Khoto

Dunhuang

1914 BOUNDARY GANSU

QINGHAI

Lake Kokonor Xining
 Kumbum

AMDO Yellow River (Huang He)
 Atsokh Tsanmon Labrang
 Garang Kotse
 Serlakh Dokar

 Radja
 Dzangar

 BAYANKARA MOUNTAINS

 Yangtze River

 Mekong River

 CHINA

 Derge
 SICHUAN
 KHAM
 Chamdo Batang
 Gartok Litang

Riwoche Nabo
Reting Lhakang Ting
 Dendjra
Taglung Kopati
Ü LHASA Ganden
 (Potala Palace)
Drepung Sera Densatil
Tsurpu Samye
 Kachu Yungning
Shigatse Drathang
Shalu Mindröling Yarlung Valley
Gyantse
(Iwang)
 Samada
angphu

BHUTAN ASSAM

 Salween River Yangtze River

 Brahmaputra River

 Yangtze River

NGLADESH BURMA
 Salween River Mekong River

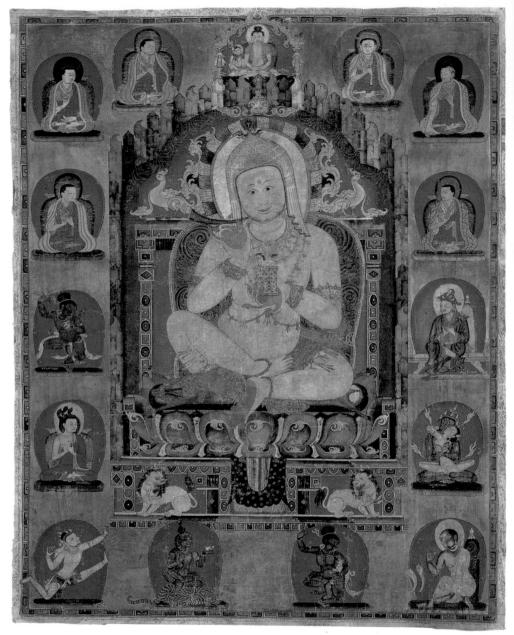

2 Portrait of Jnyanatapa, 14th century, eastern Tibet. Tangka, gouache on cotton, h. 68.5 cm (27 in)

Introduction

Tibet's physical situation is unique. The average altitude across the Tibetan plateau is more than twelve thousand feet, bordered as it is on three sides by most of the tallest mountains in the world – the Himalayas to the south, the Karakorams to the west and the Kunlun Range to the north. Access along the eastern border is interrupted by the path of several rivers which flow to the southeast (the Mekong and the Salween). Other rivers flow west into India and Pakistan, adding further barriers. Deserts complement the mountain chains to the north, completing the ring of natural boundaries that isolate this enormous land mass. Nature deities, especially associated with those awesome mountains, passes and rivers that encompass the land, have given Tibetan culture a shamanistic flavour throughout its history. The population of this vast area has never been great, until recent times probably not exceeding four million.

The earliest Tibetan peoples likely originated among non-Chinese Central Asian tribes and maintained a partly nomadic culture based on raising sheep, goats and yaks. Most of the population gathered in the relatively hospitable southern valleys; the northern areas of the country are essentially desolate plains. The Tibetan language belongs to the Tibeto-Burman group, while their written script derives from the Indian-Kashmiri traditions.

The Buddhist religion arrived from several directions between the seventh and twelfth centuries AD, though mainly from the Pala kingdom of eastern India and Kashmir. The Pala lands were the homeland of the historical Buddha, Shakyamuni. This region of northeastern India has always been the primary destination for Buddhist pilgrims, for it includes such sacred sites as Bodh Gaya, the location of the Buddha's enlightenment, and Sarnath, where he delivered his first sermon. By the end of the first millennium, the Pala kingdom was also the dominant influence on the Buddhist art of Southeast Asia, Nepal, and much of Tibet, particularly the central regions. Buddhism arrived in Tibet from other directions as well: from trade with Nepal and from active commerce with China and Chinese-dominated Central Asian centres such as Khotan on the Silk

Route, the international link between East and West that connected the vast deserts of northwestern China with Persia and cultures further west. A combination of commercial venturing and pilgrim piety carried Tibetan religion and art back out along these same trading routes into the neighbouring Himalayan regions, such as Nepal, Ladakh, Sikkim and Bhutan, as well as into Mongolia and China itself. Thus, the art of Tibet is at once a blend of influences from those various civilizations and also itself a tradition so distinctive and vibrant that it came to influence the arts of other cultures, and not only those immediately adjacent to Tibet, but as far as Mongolia and the imperial court of China. Tibetan art is almost entirely Buddhist art, reflecting the tremendous influence of religion throughout the culture. From government, education and land distribution to ordinary lives, all were deeply interwoven with the Buddhist establishment.

Central Tibet's dynastic history started in the seventh century AD, through coalitions among the chiefs within the Yarlung valley, not far from what would ultimately be the capital, Lhasa. These first kings began to embrace and support Buddhism shortly after, in the mid-seventh century. Evidence suggests that the concept of divine kingship was known in the early, pre-Buddhist period, so the claims by the first Buddhist rulers to royal and divine reincarnation based on their religion were probably a continuation of a native custom that predated the arrival of the new faith. The early history of Buddhism in Tibet repeats a pan-Asian historical pattern in which initial royal support is followed by calamities that befall the regime, which its rivals immediately blame on royal support of the foreign religion. One or more periods of religious persecution are finally succeeded by broad support and the growth and integration of the Buddhist faith into the society.

The western regions of Tibet are far enough beyond the Yarlung region that the initial growth of Buddhism there occurred outside the direct influence of central Tibet. A similar, almost parallel scenario unfolded, mainly in the independent kingdom of Guge, but also extending further west into Ladakh and Spiti. The western regions did ultimately join the Tibetan cultural mainstream, but their early development, especially between the tenth and the twelfth centuries, was dominated by Kashmiri Buddhism and art forms, with some influence from Indian Buddhists from the Pala lands, who also visited the area.

Another distinction that separates western and central Tibet is the legendary kingdom of Zhangzhung, described in literary sources as the home of the pre-Buddhist Tibetan faith, the nature-based Bon religion. Beyond being situated in the western regions, perhaps around Mt Kailash,

Zhangzhung has never been precisely located; it exists as much in myth and faith as in fact. The Bon religion has its own literary and ritual traditions, some of which were absorbed into Tibetan Buddhism, and it had developed a structured system based upon traditional, shamanistic practices. It has been noted that the two religions might be viewed as parallel developments with some degree of mutual influence. Traditions of mystics, or *mahasiddhas*, are found in both systems and some of the beliefs of Bon were absorbed into Buddhist ritual, while Buddhism provided the source for Bon images.

By the end of the fourteenth century, however, western Tibet's relationship with its bordering cultures, Kashmir to the south, and Central Asia to the north and west, had irrevocably changed. The Muslim invasions brought an end to Buddhism in northern India, and the Mongols, following Genghis Khan's rapid conquests (ultimately including China), altered the relationship of Central Asia not only with the western regions, but with all of Tibet.

Although Tibet lacked both the geographic expanse and the religious diversity of India and China, several important and distinct regions evolved over the centuries, each with its own characteristic style of art. Central Tibet can be divided into two areas. The river valleys – the settled areas around Lhasa – constitute one of Tibet's historically most important centres. Known as Ü, this region includes the oldest monasteries, founded by the Yarlung kings of the seventh century, and the area was the scene of the earliest attempts to enlarge political hegemony beyond limited agricultural districts. Among the important monastic sites in Ü are Samye, likely Tibet's oldest monastery, Kachu, Sera, and the best-known temples in Lhasa itself, the Jokhang and Potala. Directly west is the other cultural sphere of central Tibet, known as Tsang. The historically dominant monastic settlements there include Shigatse, Gyantse, and Tashilumpo. Both Ü and Tsang were much influenced by their proximity to northeastern India.

Some distance further west were the monastic centres of the Guge kingdom, at Tabo, Tholing and Tsaparang. These derived their artistic inspiration less from northeastern India than from the neighbouring regions of Kashmir and via the trade routes into Central Asia. A third major area completes the Tibetan cultural sphere, namely the northeastern regions of Amdo and Kham, which border upon and often are included within the Chinese cultural zones. Artistic styles at monastic centres such as Derge, Labrang and Kumbum reveal the influence of their proximity to China, although these sites' early development is not yet well known.

Early Tibetan religious leadership included both secular rulers and Buddhist adepts, a pattern that would continue throughout the country's history. The introduction of Buddhism, with critical backing by the ruling class, took place in Tibet at the time of the first great historical king, Songtsen Gampo (reigned *c. 629–c. 650*). His concurrent marriages to two foreign Buddhist princesses, one Chinese and one Nepalese, aided the continuing development of Buddhism in Tibet, for each introduced elements of the type of Buddhism practised in her homeland. Songtsen Gampo's active patronage – he was soon regarded as an incarnation of Avalokiteshvara, Tibet's patron deity – included the erection of at least two major temples in Lhasa, the Ramoche and the Jokhang.

Literary sources suggest Chinese styles strongly influenced the style of the Ramoche temple, while Nepalese – and ultimately Indian – taste likely directed the earliest phases of the Jokhang, which remains Tibet's most sacred site. In the main hall of the Jokhang is the famous image of

3 Shakyamuni Buddha, the Indian founder of Buddhism, which is said to have accompanied the Chinese princess Wencheng when she arrived in Tibet to take her place as King Songtsen Gampo's consort, and it is today the most sacred icon in the country. Even though it has been repainted many times over the centuries, it still suggests a seventh-century Chinese style. Some sense of the veneration with which it is regarded is indicated by the assemblage of ritual objects in the foreground, such as the large gold and silver butter lamps, and the array of gold, silver and precious stones which adorn the image and its elaborate mandorla, a large almond-shaped halo much used in Buddhist painting and sculpture.

The Jokhang's floor plans and its architectural details, such as the pillars and the capitals with fanciful animal motifs, are in the tradition of Indian

6 styles as preserved at Ajanta, the fifth-century Indian monastic centre which was one of Buddhist Asia's most important and influential monuments. This tradition of Tibetan patronage of Indian Buddhism and borrowing of Indian styles was continued by a succession of kings, who issued invitations for Indian Buddhists to come to Tibet and dispatched young Tibetans to study the religion in its homeland. Best known among the first wave of Indian monks to arrive in Tibet was the eighth-century

4 mystic Padma Sambhava, the most influential among those early masters who contributed to the initial development of the religion on Tibetan soil. His teachings, which probably incorporated native, shamanistic beliefs, were the foundation for the earliest of the major Tibetan religious orders, the Nyingma.

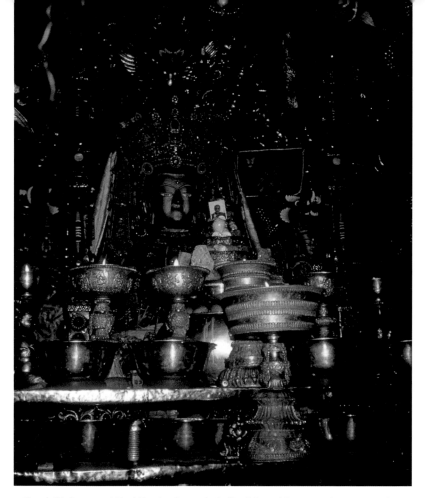

3 Jowo Shakyamuni Buddha, in the main hall of the Jokhang in Lhasa. Note the photograph of the Dalai Lama beside the Buddha, in this 1995 photograph. The near-total covering of a revered icon is a pan-Asian Buddhist practice traced back to Indian customs. *c.* 641, brought to Tibet by the Chinese princess Wencheng

By the late eighth century, encouraged by Padma Sambhava's teachings, Tibet's first monasteries had been established, one of the earliest at Samye, followed shortly by the nearby and better preserved monastery at Kachu, both in the Yarlung valley, the heartland of Tibetan culture from where most of the primary styles of Tibetan art would evolve. Normal rebuilding, the traditional Buddhist practice of repainting temple walls, and modern-day destruction have combined to eradicate practically all

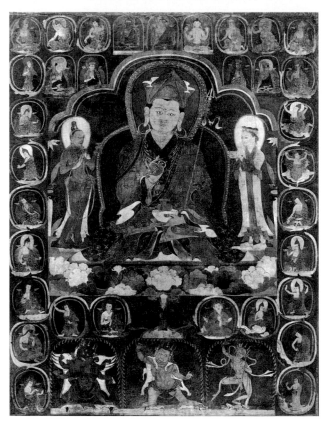

4 Padma Sambhava,
14th century, central Tibet.
Tangka, gouache on cotton,
h. 104 cm (41 in)

original paintings and sculptures from this era. However, Central Asian sites, notably Khotan and Dunhuang, briefly captured by Tibetan armies, have preserved some examples of paintings in what has come to be viewed as the early Tibetan style. Aurel Stein, the English explorer and cartographer, visited many of the important Central Asian sites early in the twentieth century, the most important of these being Dunhuang, which was controlled by Tibetans between c. 787 and 848. Most of the paintings and inscriptions he brought out from Dunhuang are now in the British Museum. Several ninth-century silk banners found by Stein stand noticeably apart from the majority of Chinese-derived, ninth-century paintings found at the oasis; their method of weaving, tall format and Tibetan inscriptions may represent an early Tibetan style which also appeared at Khara Khoto, another Central Asian centre and the Uigur capital, located in the Gobi desert. Khara Khoto was captured by the Tangut peoples in the early eleventh century. Their warlike presence

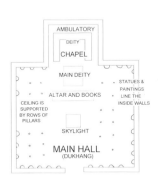

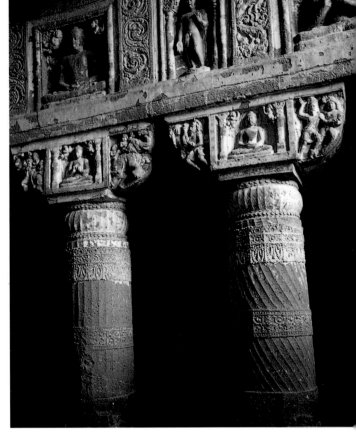

5 Tibetan monastery plan, based upon western Tibetan designs

6 Detail of capitals in Cave 19, Ajanta, India. 5th century. Stone

created problems for the Chinese until their defeat and destruction by Genghis Khan before 1227. But prior to that Mongol conquest, a cache of Buddhist objects, mostly paintings, had been buried within a stupa. This cache was not discovered until the early twentieth century, by Russian archaeologists exploring the site. Most of this body of work is in a style closely related to central Tibetan art of the eleventh and twelfth centuries, and so indicates the early export of Tibetan style outside of the country proper. This Tibetan-Central Asian style continued at Khara Khoto into the twelfth century, and due to a continued Tibetan presence in the region, paintings found there combine central Tibetan models with a mixture of Nepalese and Pala-dynasty art.

In 779 Buddhism was proclaimed the state religion of Tibet, primarily in the form of Mahayana Buddhism, the major division of the religion that dominated late Indian Buddhism and also came to predominate in China, Korea and Japan. By the end of the century, following years of

debate, the Indian version of the Mahayana tradition was selected over Chinese interpretations, giving an Indian direction and focus to subsequent religious evolution in Tibet and ultimately leading to the distinctively Tibetan form of esoteric Buddhism known as the Vajrayana path. By 825, after years of warfare with China, Tibetan rulers had established a peace which ushered in two decades of relative calm and allowed the continued growth of Buddhism. After this initial success Buddhism suffered a period of persecution, and by the middle of the ninth century, this first golden age of Tibetan Buddhism, known as the period of the Religious Kings, was interrupted. By the close of the ninth century, Buddhism was in decline.

Following that era of persecution Tibetan Buddhism entered a seminal period, beginning in the last quarter of the tenth century, which has come to be known as the 'second diffusion' of Tibetan Buddhism. This renaissance lasted from the eleventh through the thirteenth centuries. As Tibetan religious and artistic culture began to assume its mature forms, one of the key events that helped determine the direction it took was associated with another of the influential early secular rulers, King Yeshe Od, this time of the western Guge kingdom. In the late tenth century, Yeshe Od dispatched Tibetan monks to Kashmir and beyond, to master the teachings of Buddhism. One, Rinchen Sangpo, returned with monks and texts, and his brilliant translations helped to inspire much of the growth of Buddhist activity that marked the second diffusion. A short time later, in 1042, another catalyst arrived, the Indian monk Atisha from the Pala kingdom of eastern India, who established Tholing monastery, soon a centre of the renewed Buddhism that would in turn spread throughout Tibet. In addition to his retinue of monks and artists, Atisha brought with him concepts of monastic discipline, at a time when such practices had lapsed in Tibet.

Atisha's influence cannot be overestimated, both for his impact on monastic behaviour and for the fresh styles that began to appear in the art of Tibet, and he is included in nearly all the spiritual lineages of Tibetan religious orders. In addition to the influence of these masters of Buddhism, other forms of Tantric Buddhism, including practices from China, were also being incorporated into the rapidly developing Tibetan religious setting. By the mid-eleventh century, most of the major religious orders had been created – following the Nyingma came the Sakya, Kagyu and Gelug orders (the latter supplanting the Kadam Order in the early fifteenth century) and numerous suborders – each with features so distinctive that many have retained their identity and particular beliefs into the present time.

Although the historical Buddha, Shakyamuni, lived in the fifth century BC, most of our knowledge of the history of the faith and nearly all the art created in its service are of the last two thousand years. The development of Buddhist art is complicated not only by the huge size and the cultural and artistic variety of the Asian continent, but also by the doctrinal differences that developed in each area. In Sri Lanka, for example, a more conservative form remained dominant, that of the Theravada (the path of the elders, also known by the pejorative term Hinayana, the 'lesser path'). The Mahayana (the 'great path'), the path of commitment to the goal of salvation from suffering for all beings, developed later and was widely accepted throughout northern and eastern Asia.

The Tibetan monks sent to India to study brought back enormous numbers of Sanskrit texts. These were mainly from the Mahayana forms of Buddhism, with their emphasis on an ordered monastic life and practices, but the wholesale gathering of Buddhist materials also included texts with a variety of liturgical methods, many radically different from mainstream practices, and it was this later, esoteric phase of Buddhism that found a receptive environment in Tibet, in part because of similarities to the existing native religious practices of Bon. The esoteric texts and rituals were gathered into what came to be known as Vajrayana (the 'diamond path' or 'thunderbolt path') or apocalyptic Buddhism. Vajrayana Buddhism is a ritually and visually complex form that builds on Mahayana philosophies and their accompanying belief that ultimate Buddha-nature, or truth-nature, resides awaiting discovery within all beings.

Esoteric Buddhism sought to bridge the gap between the phenomenal world of the senses and a higher, absolute world of formless truth. The Vajrayana forms of esoteric Buddhism are based on a belief in the possibility of swift progress towards enlightenment; instead of having to wait aeons, through endless rebirths, for the completion of the process of freeing all beings from the shackles of ignorance, as in most of the Mahayana schools, this could be realized by an individual in a single lifetime. The Mahayana emphasis upon an intellectual, contemplative process is modified into an individualistic system based on faith, and centred on devotion to deities and ritual observances. Belief in the awesome possibility of harnessing the powers needed to achieve enlightenment in this existence inspired complex and mysterious practices. Such secret doctrines, visualizations and magical powers were not things that could easily be spelled out in texts, and Vajrayana literature remains as complex and mysterious as any in the world's religions.

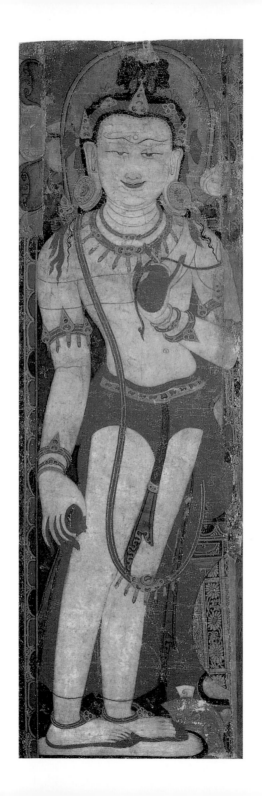

The texts the monks brought back included Indian Tantric texts which were adapted to native beliefs. One of the important differences that emerged was the essential role of the teacher, or guru. The master interpreted the texts, which were intentionally written in esoteric, mysterious language, and led the devotee through ritual practices which were guided by the belief that the final truth was not just within the texts but could be revealed through years of diligent practice under the tutelage of the teacher, who understood the complexities of the Tantric customs. The authority of the leader, from lamas – a term originally limited to religious masters considered embodiments of the Buddhist teaching, but now used as an honorific for any Tibetan monk – to eccentric gurus operating outside the orthodox monastic establishment, was considerably greater in Tibet than elsewhere, and this aura of individually vested authority is carried throughout the entire culture. These special individuals, the gurus, were added to the traditional Buddhist clergy as translators and guides to assist the believer along this accelerated path to realization. Belief in the possibility of achieving ultimate objectives in this world and this lifetime brought a strong sense of urgency to faith and practice. The need to harness the myriad powers and to organize the parts of this vast system into a manageable whole required a large and complex visual system of support and gave rise to the ritual instruments 8

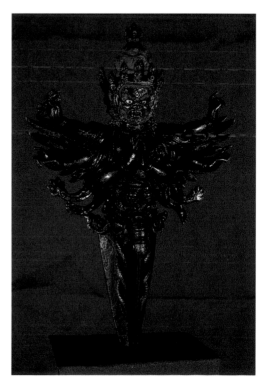

7 (left) Bodhisattva Padmapani. This tangka, discovered at Khara Khoto, reveals little of its sectarian or geographic origins, but retains decorative details of Pala and Nepalese art, similar to contemporary wall paintings in central Tibet; the mix of styles accords well with records of Tibetan artists working in Central Asia. Late 11th–early 12th century. Tangka, gouache on cotton, h. 75 cm (29.5 in)

8 (right) Phurpa or magical dagger, 16–17th century, Tibet. Polychromed metal, h. 30.5 cm (12 in)

and images that have given the Vajrayana its distinctive flavour, as well as to the huge array of deities representing the tremendous range of powers and practices.

The historical person of Shakyamuni Buddha was deified and multiplied as the Mahayana developed, in an attempt to express the great value and breadth of the teachings. In esoteric Buddhism, especially the Vajrayana that evolved in Tibet, there was a veritable explosion of deities, which can be divided roughly into two groups, both of which contain hierarchies of deities. First are the sets of deities arranged under the umbrella of the five Tathagatas, an epithet for Buddha (see pages 36–37). These 'Buddha families' incorporate nearly all the members of the pantheon, and through devices such as mandalas, their relationships and the hierarchy can be visually portrayed. The second group of deities Buddhism had appropriated from Hinduism and other Indian and Central Asian religions; they included the god Shiva and fierce protector deities, and a number of these assumed greater stature as they were absorbed by Tibetan practice, many finding an important place within both the individual Buddhist orders and the families of the five Buddhas. This organizational structure was defined and passed from guru to devotee; complex, esoteric practices could be illustrated by this schema of deities, providing an essential support for the faith and aid in the process of liberation. A hierarchic structure pervades Tibetan language as well, giving a distinct character to the culture and religion.

Related to the eminent position of the authority figure is the belief in reincarnation and its particular emphasis within the Tibetan system. As with many other doctrinal matters that came from India, this concept, known as *tulku*, achieved greater prominence in Tibet. A *tulku* is an enlightened teacher or religious personage who is reborn in another body. This belief became a major subject in Tibetan art, as paintings displaying the spiritual lineage of a particular order provided a visual authority for legitimacy, especially critical during times when the orders competed for power. In Tibet, eminent lamas are apotheosized, seen not only as reincarnations of previous revered lamas but as emanations of divinities as well. It is understood that this process of reincarnation will continue until all sentient beings are saved, and is a living, dramatic application of the bodhisattva concept at the heart of Buddhism. The bodhisattva, or 'enlightenment being', dedicates his or her enormous spiritual ability to the liberation of all beings, and as the somewhat symbolic hero of Mahayana and Vajrayana Buddhism is a favourite topic in Buddhist art. Since Buddhism does not recognize the existence of a soul, the term *emanation* may be more appropriate than *rebirth* or *reincarnation*

9

in relation to the concept of a *tulku*. This belief is best known in the West in the person of the Dalai Lama, leader of the Gelug Order, an emanation of the bodhisattva Avalokiteshvara, who is regarded as the patron deity of the order.

THE FOUR MAJOR BUDDHIST ORDERS

The complex array of Buddhist monasteries and sectarian lineages, with their rich artistic heritage embodying all aspects of Tibetan culture, ultimately came to be dominated by four major orders, although numerous suborders and smaller sects also continued. The oldest of the major orders, the Nyingma (the monks of the order being the Nyingma*pa*), which traces its origins back to the eighth century, was formally designated in 1062 in central Tibet. The Kadam Order, based on the teachings of Atisha and his disciple Bromston (1008–64), was organized at about the same time; although it enjoyed a period as one of the major orders, it was ultimately assimilated by the Gelug Order some four centuries later. The Kadampa placed severe restrictions upon their members, including abstention from marriage, intoxicants, travel and money, a formula destined to appeal to a limited group in most societies.

By the end of the eleventh century the other two major orders, the Sakya and Kagyu, were formed. By the end of the fourteenth century, with the Gelugpa absorption of the Kadampa, the four major orders that have survived into the present were in place: the Nyingma, Sakya, Kagyu and Gelug. The Sakyapa were dominant during the Mongol Yuan dynasty in China (1260–1324) and their political agreements with the Mongols were to play a significant role in Chinese-Tibetan relations. Ultimately, the Gelugpa became the most powerful, and through their leader, the Dalai Lama, also the best-known order outside Tibet. The surviving orders retained a careful record of their lineage into modern times, and now they occupy contemporary headquarters in exile, spread across northern India, Bhutan and Sikkim in the foothills of the Himalayas, while awaiting an opportunity to return to Tibet.

Some characteristics of the individual orders are distinctive, such as details of spiritual lineages and elements of dress – best known being the yellow hats of the Gelugpa – or reliance upon particular scriptural sources and liturgical practices. At the same time, the overlapping of these elements, as well as a shared reliance upon particular deities, including many of the spiritual masters, complicates the organizing and grouping of Tibetan art by orders. The often precise lineage records maintained by the individual orders do enable many Tibetan works of art to be traced

back and placed within their proper historical context; however, using sectarian distinctions to outline the history of Tibetan art is especially difficult. Many important individuals, such as Padma Sambhava and Atisha, as well as most major Buddhist deities, are included within each order's pantheon. During the thirteenth century, a time of heightened competition for political hegemony among the orders, lineages were sometimes manipulated to give an order the appearance of added historical legitimacy. Thus, in some paintings, individuals are included who properly belong to another lineage, but are borrowed for their importance, to lend greater authority to that particular order.

In addition to a shared subject matter, the styles of painting and sculpture often differ little between the orders. Individual artists sought work at different monastic establishments, and while each could adapt to varying instructions and iconography for commissions, an individual's artistic style was more difficult to change. Likewise, Tibetan rolled paintings (tangkas) and bronze images were readily transported, which helped to spread styles to areas well beyond their place of origin. A more effective means of introducing the broad panorama of Tibetan art is to place the emphasis and make most of the distinctions primarily along geographical lines, and to incorporate sectarian characteristics, lineages, textual records and historical events when appropriate. The accompanying chart (pages 26–27) provides a summary of the founders, monastic establishments, major deities and leading figures of the orders, providing a background to the themes and figures that dominate Tibetan art.

9 The Tibetan emphasis on authority and hierarchical order can seen in this 13th-century banner painting of deities favoured by the Kagyu Order. At the top is Prajnyaparamita, representing wisdom; next to her is the spiritual progenitor of Kagyu teachings, Vajradhara. The second register begins with Shakyamuni Buddha, followed by the five Tathagatas: Ratnasambhava, Akshobhya, the Sarvavid form of Vairochana, and Amitabha and Amoghasiddhi in the last row. The major gestures or *mudras* found among Buddhist images are displayed by these figures. Central Tibet. Tangka, gouache on cotton, h. 174 cm (68.5 in)

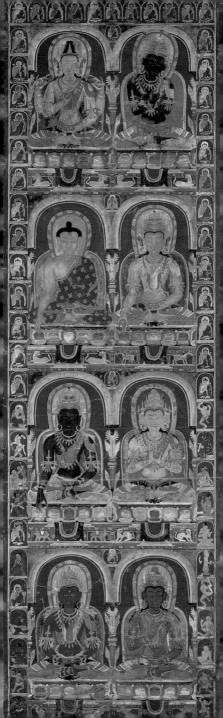

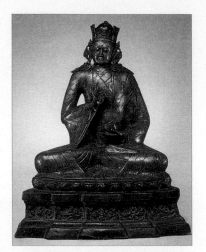

10 Padma Sambhava, late 15th century, Tibet. Brass with copper and silver inlay, h. 61 cm (24 in)

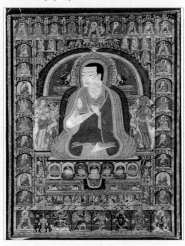

11 Portrait thought to be of Taglung Thangpa Chenpo, founder of Taglung monastery, 13th century, Tibet. Tangka, gouache on cotton, h. 50 cm (20 in)

THE MAJOR TIBETAN ORDERS

The main differences among these orders are less in doctrine than in their textual preferences and in their lines of founders, teachers and particular tutelary deities. This list emphasizes individuals and deities prominent in Tibetan art.

I The Nyingmapa

Founded: Late 8th century

Important Monastic Centres: Samye, Mindröling and, in recent centuries, several in the Kham region

Leading Figures & Spiritual Lineage: Padma Sambhava (also known as Guru Rinpoche), Shantarakshita

Primary Deities: Hayagriva, Vajrakila-Vajrakumara, Vajrapani, Mahakala, images of the Bardo region

II The Kagyupa (and the Karmapa)

Founded: 11th century by Marpa and his disciple Milarepa

Important Monastic Centres: Tsurpu (main monastery of the Karma suborder, founded 1189), Taglung (formed by disciples of Gampopa in the late 12th century), Drikung, Densatil, and in Sikkim, Ralang (dedicated in 1730) and Rumtek (dedicated in 1740)

Leading Figures & Spiritual Lineage: Tilopa, Naropa, Marpa, Milarepa, Gampopa (the principal organizer), Karma Pakshi (d. 1283, the second of the Karmapa lineage), the fifth Karmapa (d. 1415, teacher to the Chinese Yongle emperor, awarded the black hat, emblem thereafter of the Karmapa). Generally, the Kagyu order is the most mystically oriented of the four

Primary Deities: Mahakala, Paramasukha-Chakrasamvara, Hevajra, Vajravarahi, Vajradhara

III The Sakyapa

Founded: 1073 by Gyalpo

Important Monastic Centres: Sakya (whence the order's name), Gyantse, Ngor (founded in 1429 by Kunga Sangpo)

Leading Figures & Spiritual Lineage: Virupa, Atisha, Drokmi, Sonam Tsemo, Gayadhara, Sakya Pandita, Phagpa, Tsong Khapa (founder of the Gelugpa)

Primary Deities: Mahakala, Hevajra, Nairatmya, Raktayamari, Paramasukha-Chakrasamvara

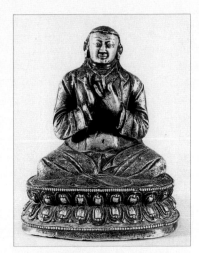

12 Sonam Tsemo, 16th century, central Tibet. Copper, h. 18.4 cm (7.25 in)

IV The Gelugpa

(the 'yellow hats', evolved out of the Kadampa)

Founded: Early 15th century by Tsong Khapa (1357–1419)

Important Monastic Centres: Reting (founded by Dromton, originator of the Kadam Order, the precursor of the Gelugpa), Ganden (founded by Tsong Khapa), Drepung, Tashilumpo (founded by the first Dalai Lama in 1447 and seat of the Panchen Lamas), Sera, Labrang

Leading Figures & Spiritual Lineage: Atisha (and his disciple Dromton), Tsong Khapa (also the primary teacher of the Sakyapa), the Dalai Lamas (especially the third and fifth)

Primary Deities: Avalokiteshvara, Manjushri, Mahakala, Vajravarahi, various protectors: Yamantaka, Vaishravana, Palden Lhamo, Begtse, Sertrap

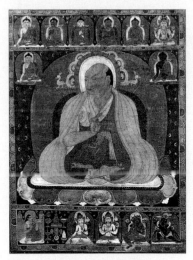

13 Lama, possibly Atisha, early 12th century, central Tibet. Tangka, gouache on cotton, h. 35.3 cm (13.9 in)

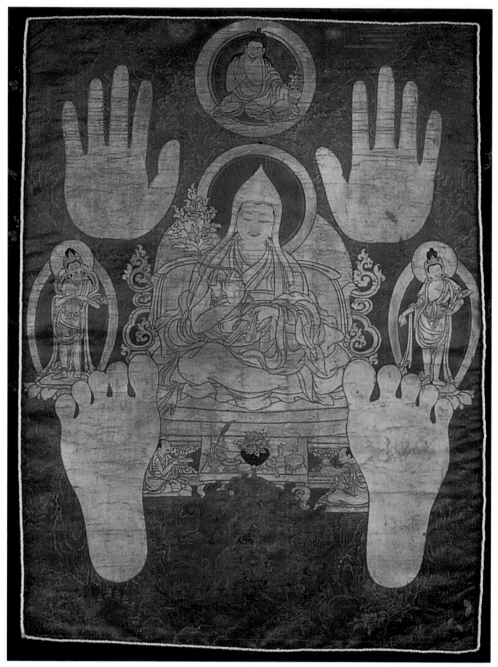

14 Silk tangka of the revered Fifth Dalai Lama, with palm and footprints rendered in gold, his mystic teacher above, and three golden lines of nectar flowing to him. Two palm prints on the reverse are likely the Dalai Lama's own, further enhancing the image's auspicious qualities. Mid-17th century, Tibet. Gouache and gold on silk, h. 59.7 cm (23.5 in)

The Tibetan Pantheon

Compared to the rest of Asia, Tibet's artistic tradition appeared relatively late in time. Although Buddhism began to be embraced by the Yarlung valley kings in the seventh century, it was not until the end of the tenth century that a Tibetan style of art began to develop. Few of the major subjects and characteristics of Tibetan Buddhist art are known from the formative era, the period before the tenth century. However, by the time of the second diffusion and the integration of Buddhism in Tibet, Tibetan art began to gain an identity suited to the culture. Tibetans favoured deities appropriate to their religious needs and in harmony with their shamanistic heritage, with an emphasis on ritual images and implements, and on the portrayal of individuals, both historical and mythical. In contrast, as Buddhism was assimilated into Chinese culture, the art it inspired expressed a greater emphasis upon heavenly realms and their complex levels of representation. Individuals enjoyed an important status from an early time in Tibetan history, for religious hierarchs were highly esteemed even before the arrival of Buddhism, and despite the enormous number of complex and esoteric Vajrayana images and ritual objects, portraits of individual figures have continued to give a distinctive flavour to Tibetan art. Many assumed the status of an icon, and included inscriptions indicating that the spirit remained within the portrait. On some, actual hand prints of the subject provided a timeless association 14 between the deceased and the worshipper. Such linkage between a high lama and his portrait remained an especially potent form of imagery, an association that extended to ritual objects as well, a further connection with the shamanistic heritage of Tibet. The small sculpture of Milarepa illustrated on page 93 is created from bones and ashes that are, at least to a 73 believer, the actual remains of the saint.

The number of Tibetan deities is considerable, yet whether the subjects are human or divine, benign or terrifying, an aesthetic of harmony and symmetry prevails in images. Explorations of the duality of this symmetry often take remarkable forms. The viewer can be startled by the combination of grace and elegance with anger and ferocity in the same 161 image, a reminder of the constant coexistence of these extremes both in

nature and in our own individual natures. In Tibetan art the figure is paramount, and contrast and volume are achieved through the juxtaposition of contrasting colours and pure, defining lines, seldom with an eye towards the suggestion of illusionistic depth. This idealized vision was applied to portraiture and landscape as well, and although details suggest inspiration from immediate observation and serve to enliven the subject, the art tends to be stylized, remaining within the boundaries of the broader aesthetic.

SHAKYAMUNI BUDDHA

The image of the Buddha presents unique issues for artists, who must portray a figure at once human and divine, beyond boundaries of gender and time, who personifies the ultimate levels of wisdom and compassion. Both his achievement of transcendence and his humanness – for he is often portrayed as a teacher – must be served in creating his image. Generally, the Buddha is represented as an idealized monk, with a set of distinguishing marks that designate his celestial status, such as a cranial bump and a conspicuous dot in the middle of his forehead. In the Mahayana form of the religion (see page 19), the Buddha's transcendence is marked by his having not one body, but three: one that embraces the reality of this world, another that rejoices in what can be conceived as heavenly realms of bliss, and finally an encompassing body-state beyond human conception and coterminous with the entire universe, a body synonymous with the ultimate reality itself. The Buddha is neither creator nor judge, but one whose example offers a path towards self-realization, a path predicated upon the believer's capacity to overcome ego and cravings. Central to the Buddha's message is the gaining of wisdom, which consists of a limitless compassion for others as well as the ability to move towards the ultimate goal of freedom from suffering, craving and delusion. The Buddha taught that everyone has the same potential for transcendent insight, or the same nature of Buddha-ness, and a great deal of Tibetan art consists of images of individuals who fully express this Buddha nature, from ancient sages to the Dalai Lamas.

Images of the Buddha can be grouped into three general categories: stories of his former lives, known as *Jataka Tales*; episodes from the life of the historical Buddha, Shakyamuni; and portrayals of a variety of celestial or cosmic Buddhas, who are considered to reside in numerous heavenly realms, beyond the bounds of this world.

Painted images of Shakyamuni Buddha provide prime opportunities for elaboration, especially for extended settings. In these, the Buddha is

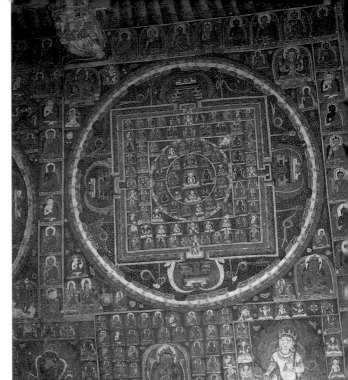

15 Mandalas from the Dukhang at Alchi, Ladakh. These wall paintings of the late 12th century present one version of Vairochana, at the centre of a large mandala, recognized by his white colour, and a form well known in the early western Tibetan tradition

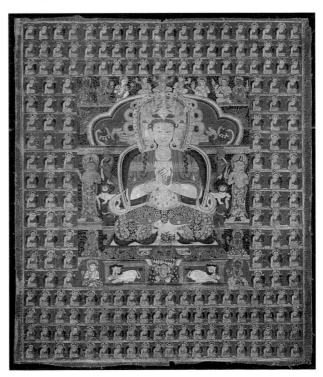

16 Sarvavid (The Omniscient Illuminator), a multi-headed form of Vairochana, sits on his lion throne and displays his typical gesture, a variant of the teaching *mudra*. His prominence is enhanced by the small images of Shakyamuni at the moment of his enlightenment, signified by the right hand reaching down to touch the earth. Late 13th century. Tangka, gouache on cotton, h. 53.3 cm (21 in)

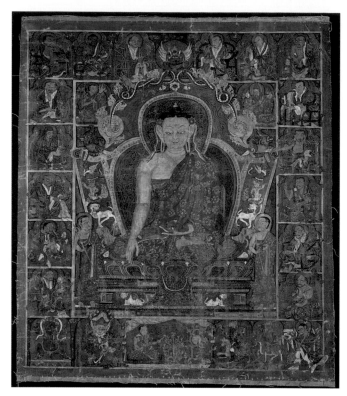

17 Shakyamuni Buddha and the 17 arhats. This tangka is similar to wall paintings at Shalu. Shakyamuni's bright orange robes are enriched with delicate, golden patterns extending into the circular halo and lotus throne and the elaborate shrine rising above the central group. To either side stand devout disciples holding ritual staffs, the trio surrounded by a typical set of mythical beasts. 14th century, central Tibet. Gouache on cotton, h. 52 cm (20.5 in)

the largest figure, at the centre, seated on a throne and wearing his distinctive 'patchwork' monk's robes, flanked either by paired bodhisattvas or by disciples, and surrounded by mythical creatures and elaborately decorative, especially floral, motifs. The Buddha is further identified by the inclusion of several of the thirty-two marks (*lakshanas*) that are considered characteristic of Buddhas alone. Such symbols of his enlightened state as his cranial protuberance (*ushnisha*), a small hair curl between his eyebrows (*urna*) and the spoked wheel that is a symbol of the dharma upon his palms or the soles of his feet attest to his supernal state. The Buddha displays a number of gestures (*mudras*), most representing enlightenment (the right hand reaching down to touch the earth: *bhumisparsha*), teaching (both hands at the chest, the fingers and thumbs forming two interlocking circles: *dharmachakra*), and contemplation (both hands flat in the lap, the thumbs touching: *dhyana*). He is enclosed by a variety of devices to indicate transcendent stature, such as haloes and mandorlas (pictorial devices suggesting radiance) and he is usually seated upon a double lotus throne. The lotus is an emblem of purity, a symbol shared by

22

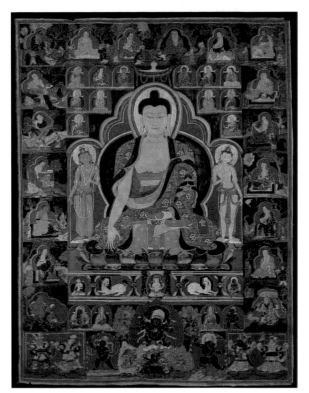

18 Buddha with arhats. The central Buddha and paired bodhisattvas are represented in a typical 14th- and 15th-century Tibetan style, while each of the arhats is enclosed in a bright red aureole and placed in a setting consisting of gnarled trees and fantastic rocks against a night sky, a style derived from Chinese artistic traditions. Along the bottom register are various ferocious deities, flanked by the four *lokapalas*. 14th century, Tibet. Tangka, gouache on cotton, h. 114.3 cm (45 in)

other Indian religions, but especially auspicious for the Buddha, who, like the flower, rises above this world to open pure and unsullied by the residue of the lower realms.

The richness of Tibetan art styles can be seen by comparing two similar images of the Buddha. Both are fourteenth-century tangkas (hanging paintings on fabric) of Shakyamuni from central Tibet, in one flanked by two disciples (above left), and in the other by two bodhisattvas (above right). Surrounding each central group is a set of arhats, an honorific term for beings who have attained nirvana, or release from rebirth in the phenomenal world, and who are themselves one of the primary subjects of Tibetan art. They are joined by various lamas, mythical creatures and benign and ferocious deities, and in one case by the four guardian deities, the *lokapalas*, as well, occupying the two bottom corners. In each, the central three figures are rendered in a flat, two-dimensional manner which contrasts with the arhats, who are placed within landscape settings, creating an illusion of depth in stark contrast to the flatness of the enclosed space of the Buddha and two flanking figures. The settings of

17, 18

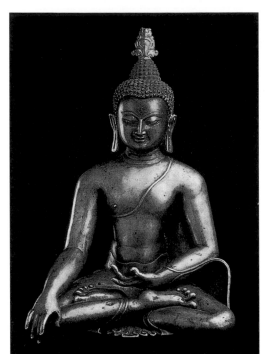

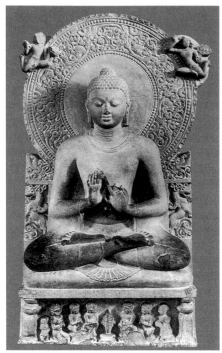

19 Shakyamuni Buddha, 11th–12th century,
Tibet. Brass, h. 40.6 cm (16 in)

20 Shakyamuni Buddha, *c.* 475, Sarnath,
India. Sandstone, h. 160 cm (63 in)

the arhats follow the Chinese manner, with highly stylized versions of
traditional Chinese gnarled trees and fantastic rocks. In one tangka the
arhats are placed against Chinese lattice-type chairs (*ill.* 18).

Sculptural images of the Buddha likewise embody distinct stylistic
characteristics, despite the absence of elaborate settings and the host of
images included in paintings. Just as Tibetan Buddhism grew out of its
Indian sources, images of the Buddha can be seen as a continuation of the
earlier tradition. Although this eleventh–twelfth-century bronze and this
19, 20 fifth-century Gupta-period stone Buddha were created more than five
centuries apart, the later Tibetan image retains the refined abstraction
and spiritual elegance of the Indian figure, while adding an approachable
human dimension, especially in its gentle smile. At a time when many of
the older, long-established Buddhist traditions had slipped into formal-
istic, repetitive image-making, this Tibetan statue achieves the traditional
balance between ritual demands and the need to communicate on a
mortal level, elements that mark the highest goals of the Buddhist faith.

In the earliest Indian images of the Buddha, the favoured portrayals were of the historical Buddha, Shakyamuni, particularly the four central episodes of his life: his nativity, enlightenment, first sermon and departure from this life (*parinirvana*). Gradually, in the northern areas of Asia, where the Mahayana and Vajrayana forms of the religion came to dominate, the Buddha came to be often portrayed as a celestial figure. The esoteric Buddhism which was introduced into Tibet did include narrative events of Shakyamuni's life such as the four great events, and episodes from his 175 former lives taken from the *Jataka Tales*, but these usually appeared in paintings as vignettes displayed around the large, centrally positioned image of the Buddha. As Tibetan Buddhist art developed, it favoured portrayals of the Buddha in transcendent splendour, regardless of the theme or context. Compositions extended into multiple niches and aureoles filled with numerous lesser deities and individual portraits, usually graded by rank, with the individuals and deities who comprise the order's spiritual lineage given a prominent place. Various mythical creatures complete the elaborate entourage: *makara*s (composite beasts, with elephant-crocodile heads), whose tails issue into golden, circular, floral designs that take on a decorative life of their own; *gandharva*s (half-human, half-bird celestials); *garuda*s (bird-man creatures); and *shardula*s (with lion body, horns and wings).

CELESTIAL BUDDHAS

The celestial Buddhas, also called Tathagatas – literally meaning one who has gone into, or realized the ultimate reality – occupy an auspicious, transcendent position in the Vajrayana pantheon, inhabiting heavenly realms often referred to as Pure Lands. They head the Tibetan hierarchy and came to be linked with particular orders and major historical and mythical individuals in Tibetan history. In the countless tangkas and wall paintings in which they are displayed individually, the identity of each is conveyed through specific characteristics, such as the attributes, colours and gestures usually included when they are portrayed as a group. The term Tathagata is most often used for the set of five transcendent Buddhas: Vairochana, Ratnasambhava, Akshobhya, Amitabha and Amoghasiddhi. These are frequently arranged symmetrically with one at the centre, usually Vairochana, and the other four assigned to the cardinal directions. Each of the five celestial Tathagatas is also portrayed alone, displaying appropriate attributes. They are typically shown seated on lion 15, 16, 24 thrones, adorned with crowns and jewels, and most often displaying gestures of enlightenment or teaching.

THE FIVE TRANSCENDENT BUDDHAS: THE TATHAGATAS
(Also known as the Dhyani (Contemplation) Buddhas)

VAIROCHANA

mudra	colour	element	meaning of name	location	symbol	vehicle	aspect
teaching (*dharmachakra*)	white	ether	Shining One	centre	wheel (*chakra*)	lion	consciousness

role: transforms ignorance and delusion into the wisdom of the perfect reality of the universal law
associated deity: Samantabhadra Bodhisattva

RATNASAMBHAVA

mudra	colour	element	meaning of name	location	symbol	vehicle	aspect
charity (*varada*)	yellow	earth	Precious Birth	south	jewel	horse	sensation

role: transforms pride and avarice into the wisdom of equality
associated deity: Ratnapani Bodhisattva

AMOGHASIDDHI

mudra	colour	element	meaning of name	location	symbol	vehicle	aspect
reassurance (*abhaya*)	green	air	Unfailingly Accomplished	north	double/ crossed *vajra*	*garuda*	volition

role: transforms envy and greed into the broad wisdom of accomplishment
associated deity: Vishvapani Bodhisattva

Each Tathagata is typically portrayed seated, in this case making a gesture (*mudra*) of reassurance and wearing the ornaments and crown of a bodhisattva. Each is associated with a particular distinguishing colour and one of the five aspects, or characteristics, of human existence. Most of the deities in the Vajrayana pantheon are included in these five families.

21 Manuscript cover, 13th century, Tibet. Painted wood, l. *c.* 40 cm (*c.* 16 in)

AMITABHA (Amitayus)

mudra	colour	element	meaning of name	location	symbol	vehicle	aspect
contemplation (*dhyana*)	red	fire	Infinite Light	west	begging bowl	peacock	perception

role: transforms passions and cravings into discerning wisdom
associated deity: Avalokiteshvara Bodhisattva (as Padmapani, he holds a lotus). Amitayus, the Buddha of Eternal Life, is often interchangeable with Amitabha, especially in East Asia but also in Tibet, and shares the heaven called Sukhavati, the Western Pure Land; Amitayus gradually acquired a separate identity in Tibetan worship as the Buddha for the attainment of long life, signified by the elixir of eternal life he holds in his hands.

AKSHOBHYA

mudra	colour	element	meaning of name	location	symbol	vehicle	aspect
earth witness (*bhumisparsha*)	blue	water	Unshakeable	east	diamond sceptre/*vajra*	elephant	body

role: transforms anger and hate into the wisdom of purity
associated deity: Vajrapani Bodhisattva, who may be blue (also found in another form, Mahasthamaprapta)

The Medicine Buddha, Bhaishajyaguru, was another popular Buddha image, a form representing the Buddha's ability to embody healing for all beings. Bhaishajyaguru is portrayed much like other Buddhas, seated on a lotus throne and accompanied by symbols representing his transcendent nature. The most distinctive signs of the Medicine Buddha are the medicine bowl held in his left hand and the myrobalan plant with three buds, a medicinal herb, held in his right hand. The Buddhist belief in the value of healing through medicine coincided with the wish for long life, which extended the opportunity to achieve the process of understanding that would lead to enlightenment. As with many of the emblems displayed by Buddhist deities, the bowl is not reserved only for Bhaishajyaguru; a begging bowl is also a common feature in images of Shakyamuni, the living Buddha. Although Shakyamuni is usually portrayed as a simply dressed monk, in some images he wears a crown and jewellery, attributes typically associated with images of bodhisattvas. The origins of this seemingly anomalous combination of the attributes of a bodhisattva with the traditional image of the Buddha can be traced to Indian sources, especially to royal patronage and to the rise in popularity of the bodhisattva cult.

There are other groups of celestial Buddhas as well, two of which are portrayed fairly frequently. One is a set of seven Buddhas, usually representing five Buddhas of the past, together with Shakyamuni, the Buddha of the present era, and the future Buddha, Maitreya. The other group is the Thirty-five Buddhas of Confession, of whom Shakyamuni is the thirty-fifth; anywhere from four to all thirty-five Buddhas of Confession may be included in a single painting.

Most of the celestial Buddhas and Tathagatas reside in one or another of the heavenly realms known as the Pure Lands. Of these, the one most often encountered in both literature and art is the Western Paradise, the Land of Bliss (Sukhavati), presided over by the celestial Amitabha Buddha. The various descriptions of this paradise, like those in the *Lotus Sutra*, evoke an abundance of jewels, flowers and heavenly beings. It is a limitless and bountiful paradise which awaits those who follow the Buddhist path. Tibetan mandalas gradually became one of the visual means of portraying these perfect, celestial worlds. Bodhisattvas, such as Avalokiteshvara, Tara and Manjushri, came from these realms to illuminate the path for all sentient beings. The Pure Land of Manjushri was believed to have a real-world analogue in China, at Wutaishan, which was a major pilgrimage site for Buddhists throughout Asia. It was in such lands that venerable adepts like Padma Sambhava ultimately settled. Of particular importance to Tibetans is the Pure Land of Shambhala, a

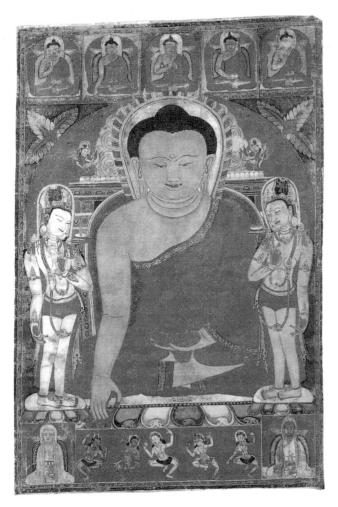

22 Among the Buddha Shakyamuni's typical attributes on this early tangka are the gesture of the right hand, touching the earth to announce his enlightenment, and his cranial protrusion. The paired bodhisattvas reflect Indian-Pala sources. Across the top register are the five Tathagatas, here distinguished by their gestures. Before 1227, Khara Khoto, Central Asia. Gouache on cotton, h. 80 cm (31.5 in)

mythical kingdom hidden among the highest mountains north of Tibet and attainable only by those pure of heart, entirely untouched by anger and ignorance. Shambhala is the subject of elaborate, often mandala-like, paintings composed of ideal monasteries set in the perfect harmony of nature and deities (see page 204). 173

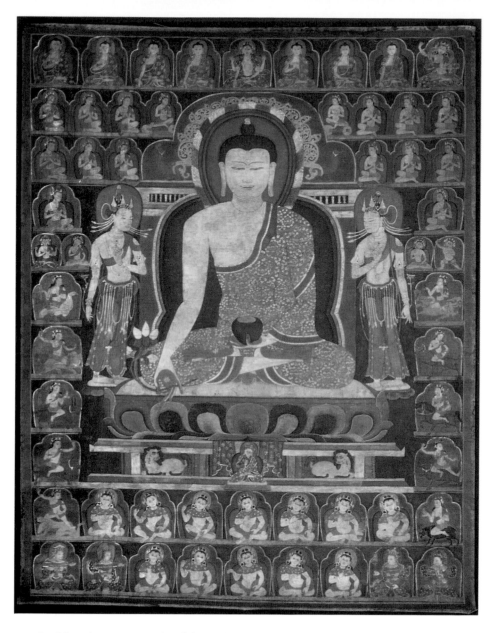

23 In this 14th-century tangka of the medicine Buddha Bhaishajyaguru flanked by two bodhisattvas, he holds his begging bowl, and, in his right hand, the medicinal plant, the myrobalan, both symbols of his healing powers. Tibet. Gouache on cotton, h. 100 cm (39.4 in)

24 The celestial Ratnasambhava Buddha. This exceptional tangka is also important for the method of manufacture, likely a regional characteristic, revealed in the checkered pattern visible in the damaged outer areas. 13th century, Tibet. Gouache on cotton, h. 49 cm (19.3 in)

The concept of the bodhisattva, the Buddhist ideal of the saviour figure, evolved into a dominant feature of Mahayana Buddhism and was carried from India across northern Asia in the early centuries of the first millennium. A bodhisattva is any being who has achieved a level of purity and enlightenment that will result in an end to being caught in the cycle of rebirth, a liberation which is the universal Buddhist goal known as nirvana. However, so great is the compassion of bodhisattvas that they vow to save all sentient beings from ignorance and suffering, intentionally postponing their personal salvation and devoting as many lifetimes as needed, sacrificing as much as necessary, to achieve this higher, altruistic goal. In Tibetan Buddhism this bodhisattva activity of saving all beings was extended into cosmic realms, and bodhisattvas as a consequence were portrayed in resplendent, celestial surroundings that include a host of supporting deities. The bodhisattva image was further enhanced by additional attributes such as a thousand arms or eyes, all in the service of the believer in the struggle to move beyond ordinary existence. A bodhisattva can equally be an ordinary being engaged on the path towards wisdom rather than a highly evolved deity, but Tibetan art most often portrays cosmic bodhisattvas, who are awarded a stature equal to and even exceeding that of the Buddha, so highly developed are their powers.

The bodhisattva ideal can also be seen in the many previous lifetimes ascribed to Shakyamuni Buddha as he pursued his quest to understand and provide a model for others along the path towards liberation, as described in the *Jataka Tales*. Such compassion for others led bodhisattvas to be accorded greater stature than the ideal practitioners of the older forms of Buddhism, the arhats of Theravada Buddhism. Arhats embodied the monastic, ascetic ideal, highly respected in all schools of the Buddhist religion. But their path remained beyond the reach of most individuals, who are unable to renounce the material world to follow such an eremitic life. Arhats did become one of the favourite images in Tibetan art, but in the process they lost some of their asceticism and acquired more worldly eccentricities, making them more approachable figures. The arhat as liberated saint is included in many paintings, as part of spiritual lineages as well as in individual portraits.

By the time Buddhism entered Tibet, both kinds of paths were well established: that of the bodhisattva, driven by the compassionate mission of salvation for all beings, and the arhat journey, a more direct route available to all, but followed successfully only by those with the ability to retain concentration on the goal. The former dominated Buddhism in

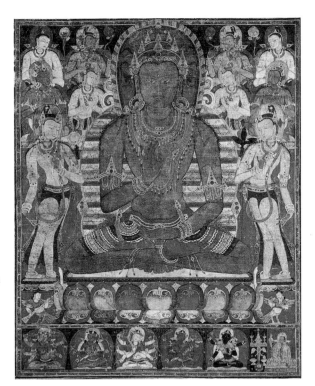

25 The Buddha Amoghasiddhi attended by bodhisattvas. The bodhisattvas are in the Indian Pala style, also carried across Central Asia to Dunhuang and Khara Khoto (see *ill.* 7), and the entire composition is closely related to early Tibetan wall painting, such as at Drathang and Shalu. First half of 13th century, Tibet. Tangka, gouache on cotton, h. 68.8 cm (27 in)

northern Asia, while the latter route to enlightenment was favoured by many South Asian cultures, such as Sri Lanka, Burma and Thailand. Although Tibetan Buddhism was formed out of the messianic ideal of the bodhisattva, it embraced the ascetic ideal of the arhat as well. The countless images of exemplary humans – arhats, eccentrics and venerable religious figures such as Atisha, Padma Sambhava and Tsong Khapa – attest to the deep respect for the monastic path that was available to any-one as the fog of ignorance lifted.

In India, the earliest portrayals of bodhisattvas appeared at about the same time as those of the Buddha, since the Buddha was not represented in images for the first several hundred years after his death. Initially the bodhisattvas were side figures flanking the larger, seated Buddha. This traditional formula continued to be followed in Tibetan art, in which the most popular bodhisattvas were Avalokiteshvara, Manjushri, Tara, Vajrapani and Maitreya, each of whom stood for particular spiritual val-ues. In such groupings Buddha continued to be portrayed simply, in tra-ditional monastic robes, while the bodhisattvas were shown with crowns and jewellery, suggesting wealth and princely status.

37

25

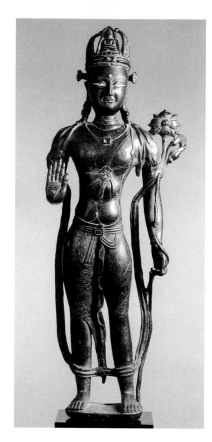

26 This early 12th-century bronze from western Tibet, possibly Ladakh, illustrates the primary attributes of Avalokiteshvara: the image of Amitabha in his crown, the lotus in his hand, and an antelope skin over his shoulder. His right hand is extended in the universal gesture of reassurance, the *abhaya mudra*. Bronze with copper and silver inlays, h. 55.8 cm (22 in)

Avalokiteshvara

Tibet's most popular bodhisattva and also its patron saint, Avalokiteshvara came to be worshipped as an individual deity with his own cult. In keeping with the Tibetan Buddhist doctrine of reincarnation, prominent Tibetan lamas and saints were believed to be emanations of specific bodhisattvas, and none was more important than Avalokiteshvara. In various forms throughout northern Asia, this bodhisattva remained the most venerated emblem of the ultimate Buddhist goal of selfless dedication towards the salvation of all living beings, which led to his being seen as the remover of obstacles for the worshipper. Buddhist literature lists at least 108 forms for him, though in practice a select few are actually worshipped and portrayed. No doubt due to the widespread popularity of Avalokiteshvara, related deities and shared symbols provide a close family of images, including a parental Tathagata (Amitabha), female colleagues

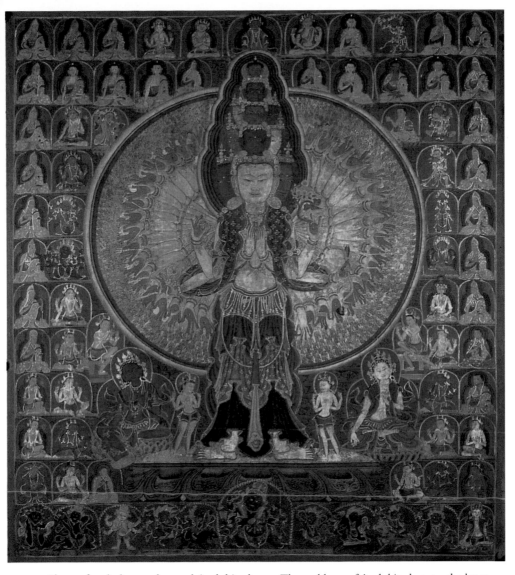

27 Eleven-faced, thousand-armed Avalokiteshvara. The emblems of Avalokiteshvara – the lotus, antelope skin and small image of Amitabha (here placed atop the other heads) – are joined here by symbols also associated with other bodhisattvas, including the wheel (sign of spiritual and benevolent behaviour), a rosary (for reciting the mantra OM MANI PADME HUM), a bow and arrow (symbolizing meditation and wisdom), and the vase of elixir of immortality (enlightenment will result in boundless life). c. 1400, Tibet. Tangka, gouache on cotton, 82 cm (32.3 in)

(Tara) and fierce deities (Hayagriva), all of whom are likewise accorded separate worship as individual deities. In addition to the typical crown and jewels of a bodhisattva, two emblems in particular are associated with Avalokiteshvara: a tiny seated image of Amitabha Buddha in his crown, with his hands resting in his lap in the gesture of meditation (*dhyana mudra*); and a lotus held in his left hand. The latter is linked so closely with Avalokiteshvara that he is also known as Padmapani, 'lotus-in-hand'. The small, seated Amitabha usually nestled in his crown is considered a miniature emanation of that Tathagata. Another common emblem of Avalokiteshvara is an antelope skin, thrown over his left shoulder, a common symbol of ascetic, yogic qualities.

Another widely popular form of Avalokiteshvara in Tibetan worship, found as well across northern and eastern Asia, was an eleven-headed, eight-armed form (a six-armed version was known in western Tibet: see *ill.* 124). Multiple heads and arms (there are even thousand-armed versions: see *ill.* 27) express the far-reaching compassion and the bodhisattva's awareness, his ability to see and reach into whatever realm is required to help free beings from their ignorance and suffering; the hands often hold symbols of spiritual power and compassion.

Tara
Several female bodhisattvas assumed independent identities. The best known of these is Tara, who was worshipped for her assistance in aiding the believer to overcome obstacles on the path to enlightenment. Tara is found in a variety of forms (twenty-one are represented), with the most popular being the White and Green Taras. This bodhisattva is also closely linked with Avalokiteshvara; according to one source she was born from his compassionate tears. Tara's great popularity, which developed early in western Tibet, coincides with the growth of Tantric worship, which had particular influence on later Buddhism. Inscriptions and various textual references to Tara indicate the broadest range of responsibilities, including overcoming ghosts and demons, curing diseases, and conquering all manner of obstacles. She is the manifestation of wisdom, and as the embodiment of *prajnya*, or insight, she is praised by the highest Buddhas and bodhisattvas and worshipped by lamas and laymen.

Manjushri
Another bodhisattva who assumed an independent stature from early times, Manjushri symbolizes wisdom, as Avalokiteshvara does compassion. Since wisdom is a greatly honoured quality in Buddhism, Manjushri's position in the pantheon is among the highest. His heavenly Pure Land is

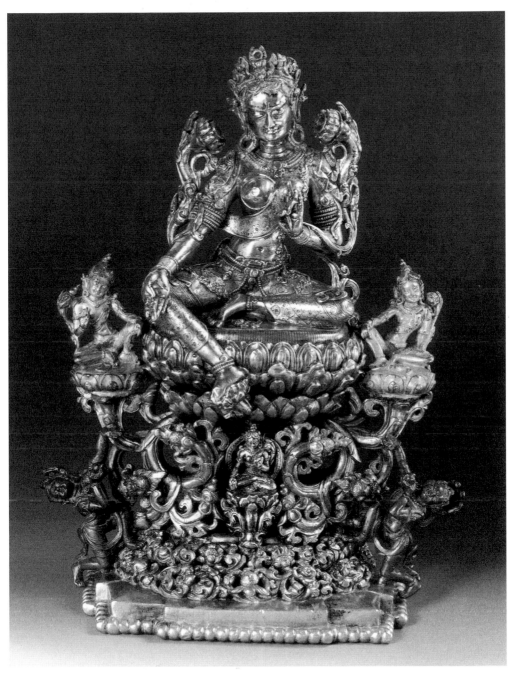

28 Green Tara, 17th century, Tibet or Nepal. Brass, copper, silver, gilt bronze and gold, h. 22.2 cm (8.75 in)

seldom portrayed, but his earthly Pure Land, located at Wutaishan in northeast China, has long been a major site of pilgrimage. Manjushri is portrayed in two- and four-armed forms and is identified by two primary attributes: a sword he wields to cut through ignorance, and a book (the *Sutra of Transcendent Wisdom*, the *Prajnyaparamita*). In addition, the lotus, symbol of purity, is often included, as are a bow and arrow, symbols of the effort to combat the evils of self-delusion and egotism.

Maitreya

Essential to the faith is the Buddha of the future, Maitreya, at present a bodhisattva who resides in his special heaven awaiting the auspicious moment, still in the distant future, to descend to earth and incarnate as the next, and last, Buddha of this world. Maitreya was incorporated into all the major Buddhist systems as a connecting link to the future, and he came to be identified as the deity linked to the future lives of the believer. From early times he was portrayed both at the side of Shakyamuni Buddha and as an individual image of worship. He is generally shown in

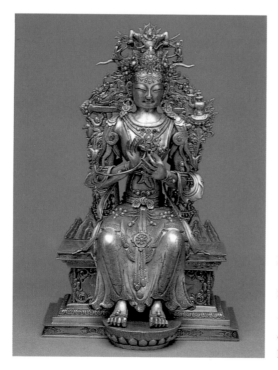

29 (*left*) Maitreya, Sino-Tibetan, mid-18th century (Qianlong period), China. Silver, h. 28.6 cm (11.25 in)

30 (*right*) Manjushri, 13th century, central Tibet. Tangka, gouache on cotton, h. 55.9 cm (22 in)

48

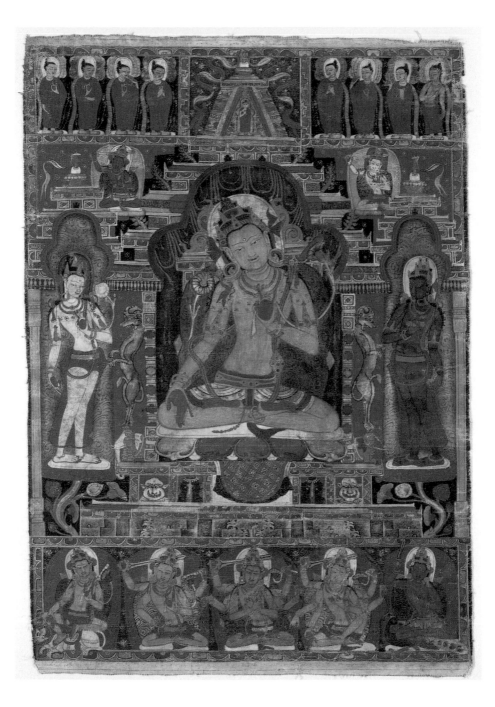

human form, with the usual bodhisattva adornments, and he typically displays his two primary emblems, a stupa in his crown and a vase of elixir of immortality in his left hand; he is usually depicted either standing or sitting with one or both legs hanging down, ready to descend to aid humanity. In Tibet there are relatively few individual images of Maitreya, compared with those of other bodhisattvas, such as Avalokiteshvara, Tara, Manjushri or Vajrapani. The paucity of images of Maitreya may be due in part to the sheer number of deities in the Tibetan pantheon, and also to the prominent role the arhat assumed in Tibetan worship. As enlightened individuals sent back to earth by the Buddha to assist the worshipper along the path to salvation, arhats are perhaps more readily identified with by the believer than the more distant image of Maitreya.

Vajrapani

This bodhisattva, who is portrayed in a variety of forms, is accorded special prominence in Tibetan Buddhism. Vajrapani is the holder of the thunderbolt – the *vajra* – and is thus an emblem of the concentrated power of the Buddha and of the whole Vajrayana system. He is depicted alone as a celestial bodhisattva, accompanying the Buddha, Avalokiteshvara or Manjushri, and also in energetic, fierce forms.

PROTECTOR DEITIES

In one sense, all Tibetan Buddhist deities are protective figures and defenders of the Buddhist teaching, the dharma, and a great many figures are depicted in the act of carrying out that task, some with the fiercest vigour imaginable. The many wrathful deities are called the protectors of the dharma, and are often warriors and kings both mythical and human, such as the guardians of the law, the *lokapalas*, among the most important of whom are the four also known as the guardians of the directions, or the Four Kings. The most significant of the set of four is Vaishravana, king or guardian of the north, who also came to be worshipped as a separate deity, widely venerated throughout Central and northern Asia.

If one includes detailed literary descriptions along with the actual imagery, there can hardly be a pantheon of terrifying deities the equal of those found in Tibetan Buddhism. Despite their horrific appearance, however, they are protectors of the faithful, as compassionate as other gods, and their demonic nature represents not the personification of evil but rather the violence that exists in the universe and the tremendous effort it takes to vanquish evil. Some Tibetan guardians are other deities in ferocious form: Manjushri, for example, has a terrifying form,

29

35, 89
121, 141

31

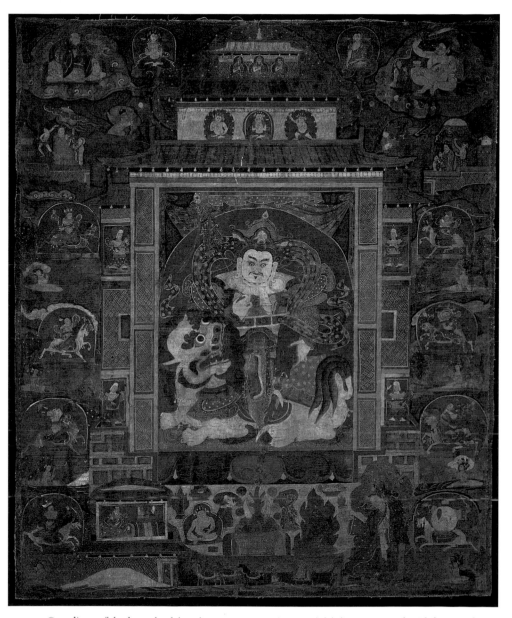

31 Guardians of the law, the *lokapala*s, are presented as wrathful deities merged with human form, as in this beautiful, early 15th-century tangka from central Tibet. Vaishravana, the guardian of the north, is inside a palace against a vivid red background, riding a Tibetan snow lion; the other three guardians are relegated to side figures. *c.* 1400. Gouache on cotton, h. 98.4 cm (38.7 in)

Vajrabhairava. Such emanations both carry the compassion of a bodhisattva and lead the faithful away from ignorance and fear.

Mahakala

The *yidam* is a kind of highly realized protector deity, worshipped as a personal tutelary deity as well as a guardian of the realm as a whole. The Indian *yidam* Mahakala is known in various forms, and given the nomadic heritage of Tibet, it is no surprise to find him especially revered in his role as lord of the tent and as such one of the most popular guardians in the Tibetan pantheon. In his terrific form, with numerous adornments and attributes that symbolize his ability to destroy all impediments to enlightenment, Mahakala exudes power, the equal of any of the protectors along the spiritual path. He is considered to be the fierce manifestation of the bodhisattva Avalokiteshvara, and he maintains a similar function of overcoming obstacles, especially negative ones. Mahakala was the personal tutelary deity for the Mongol ruler Kublai Khan and became especially popular with the Sakya Order, where the greatest variety of his forms is known, although he is well represented among the other orders as well. His terrifying imagery ultimately derives from the angry form of the Hindu god Shiva, known as Bhairava. In Tibetan iconography he typically holds a staff across his arms, and rather than standing fully upright he is shown bent-legged, as if ready to leap up. His place in the pantheon was established by the time of the second diffusion, and his popularity continued to grow until his worship reached beyond that of a protector to the level of an enlightened being.

Vajrabhairava

The terrifying emanation of Manjushri, Vajrabhairava is one of the most powerful of the protector deities and the *yidam* for the Gelugpa, although his image is also prominent among the other orders, especially during Buddhist rituals and shamanistic ceremonies. He is typically portrayed with numerous arms and heads, with a buffalo head at the centre whose horns rise up to enclose another ferocious head, and an assemblage of weapons and symbols befitting a deity wielding the greatest of protective powers. Tibetan artists fully explored the possibilities inherent in such complex sculptural assemblages, creating dense images of great rhythmic force that communicate a demonic ferocity at the same time as an almost hypnotic attraction. The importance played by this protective deity in Gelugpa ritual ensured that his image would remain in demand, and eighteenth-century images differ very little from examples created many centuries before.

32 Mahakala's demonic energy is enhanced in this brilliant 15th-century tangka by the array of fearsome creatures around him. He is joined by images of his other, equally terrific forms, as well as ferocious deities such as the female protector Lhamo, who can be seen to the right, upon her mule. Tibet. Gouache on cotton, h. c. 45 cm (c. 17.7 in)

33 Mahakala is found in every Tibetan monastery. In this wall painting from Alchi, he is placed over the door to the main shrine, directly above the head of the worshipper entering the temple. c. 1200, Sumtsek temple, Alchi monastery

36 Along with the female bodhisattva Tara, Palden or Penden Lhamo is the most revered of all Tibetan goddesses. She is the protector of the capital, Lhasa, and is especially significant to the Gelugpa order, for she is also the protector of the Dalai Lama. As with Vajrabhairava, she is widely worshipped in the ceremonies of the other orders as well. In paintings of Mahakala, Lhamo is frequently given a prominent position as one of the major subsidiary figures. Literary descriptions, such as this piece translated by René de Nebesky-Wojkowitz, exceed even the most graphic of pictorial representations:

> She is of a black colour and her body is lean as a skeleton. The goddess has one face, four hands and two feet.... A human corpse lies in her mouth and she bares her teeth ... and she laughs thunderously. She has three eyes, and her hair is yellow-red. She rides a mule ... with a pair of dice hanging from straps ... in the middle of a vast wild sea of blood and fat ... with a belt of severed heads and a flayed skin as cover... holding reins consisting of poisonous snakes.... An elephant-hide covers the upper portion of her body, and the skin of an ox serves as a loin-cloth.... She dwells in the centre of cemeteries, where her shrieks can be heard.

In addition, Lhamo has an extensive retinue of supporters, whose portrayal has resulted in some of the most complex, densely composed paintings in the whole of Tibetan art. Her origin lies partly in the Hindu goddess Kali, and there is evidence to suggest that she also derives some of her Tibetan attributes from native deities of the Bon tradition which were absorbed into Buddhism. Even these grotesque depictions of Lhamo are visions of a kind of compassionate activity, as her story makes clear. She is said to have been married to a bloodthirsty warring king who refused all her entreaties to stop his wanton killing. She finally issued an ultimatum: if he wouldn't stop the killing, she would personally slay their child so the king would experience for himself the pain that his warring caused to others. He did not stop, she carried out her threat, and

34 Vajrabhairava in *yab-yum* or sexual union. All the heads are angry except Manjushri's at the top. One of the two primary hands makes the gesture of exposition while the other holds a human skull cup, and they embrace his *prajnya*, his partner representing wisdom, who joins him in trampling various demons. His 34 hands hold many of the ritual instruments found on Tibetan altars. This remarkable figure's complexity bridges the differences between two- and three-dimensional art. 17th century, central Tibet. Polychromed bronze, h. 24 cm (9.5 in)

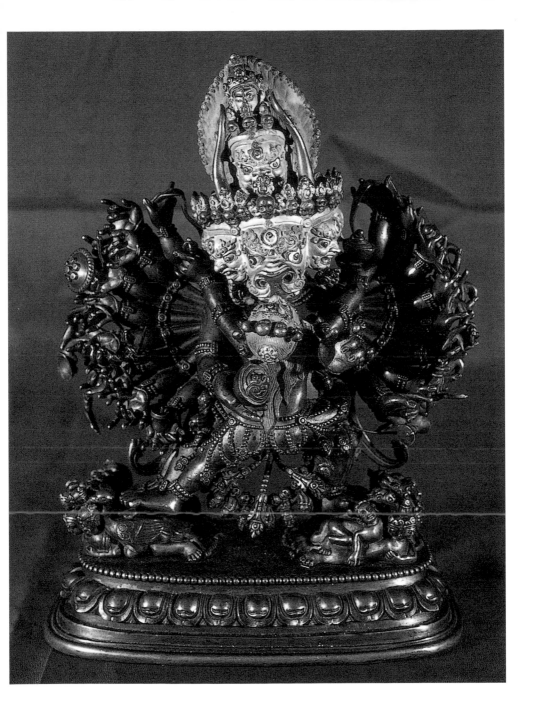

his loss finally did bring him to a halt. She is often depicted carrying her dead son's body with her on her mule, showing that she will stop at nothing to achieve peace.

Yab-yum

34, 35 Although not entirely within the broad category of wrathful deities, the *yab-yum* – literally 'father-mother' – are pairs of male and female deities depicted in sexual union. At least one of the pair, usually the male, is often in a ferocious form, although the female may be in angry form as well. These paired figures express a fundamental concept of Buddhism, the essential process of joining insight with compassion, also referred to as the union of wisdom and skilful means of action. The male figure, who embodies compassion, embraces the female, who represents transcendent wisdom. The development and marriage of wisdom and compassion are necessary for transcending the self-concerns that hinder progress towards understanding the ultimate nature of reality. The *yab-yum* image is linked to fundamental aspects of the unconscious, serving to identify and sublimate conscious and unconscious instincts into a potent visual metaphor. Similarly powerful and overtly sexual images do occasionally appear in the artistic traditions of other religions, but it has remained for

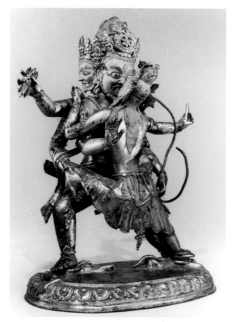

35 (*left*) Vajrapani portrayed in union with his consort. Vajrapani is very often worshipped in his fierce form, as a protector, and is one of the Tibetan deities known in both benign and ferocious forms. 15th century, central Tibet. Gilt bronze, h. 38.1 cm (15 in)

36 (*right*) The goddess Palden Lhamo, fearsome protector of Lhasa and the Dalai Lama. Early 19th century, central Tibet. Tangka, gouache on cotton, h. 72.4 cm (28.5 in)

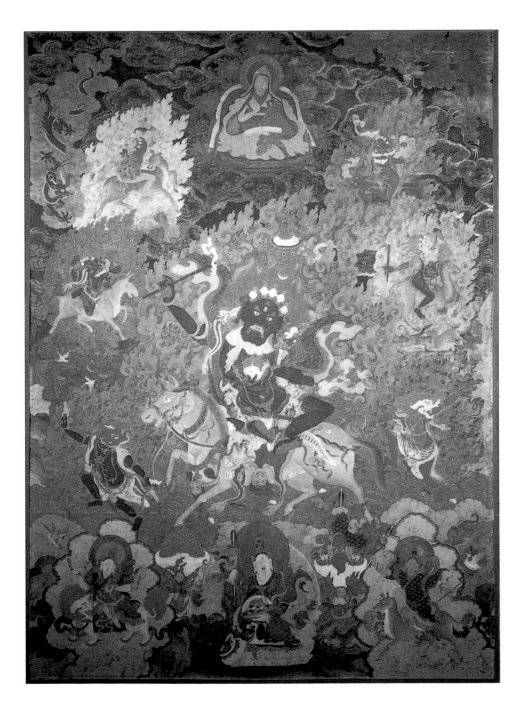

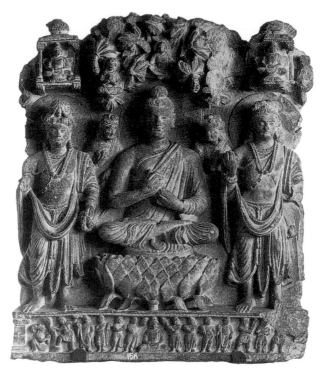

37 The Buddha, displaying the teaching gesture, flanked by two bodhisattvas. On the left is Maitreya, the Buddha of the future (identified by the small stupa in his crown) while the other lacks an attribute such as the small Buddha that is typically placed in the crown of Avalokiteshvara or the *vajra* in the hand of Vajrapani. 3rd–4th century, Gandhara. Schist, h. 59 cm (23.25 in)

Tibetan artists to translate so effectively such fundamental instincts into visual metaphors that express the most sublime of concepts.

Pairs of ritual objects and symbolic images, such as a number of variations with pairs of *vajra*s and bells, are also used to express this same message in Tibetan ceremony and art. By assigning to one ritual object the symbolism of compassion, or skilful means, and to another object the role of the female as insight, or wisdom, the power and significance of the act of sexual union – the fundamental concept at the most basic and universal level of human experience – can be translated into countless images and rituals. Although the concepts that underlie this symbolism originated in Indian Vajrayana literature, very few visual representations are known from India; as a visual metaphor it is almost unique to the Tibetan artistic tradition.

Arhats

The name *arhat* literally means 'worthy', and it is widely applied in Buddhism to those attaining nirvana. The concept originated in India, although representations are not found in Indian art, or in the art of two of the major cultures under Indian influence, Sri Lanka and Southeast Asia, where the name was used for the most advanced disciples of Shakyamuni Buddha and of a few succeeding generations, generally referring to a monk whose insight was so deep that he would never have to be reborn as a person, to suffer, become ill and die. Arhats came to be viewed as the disciples who spread the doctrine after the Buddha's death, and in Tibet they also assumed a major role as intermediaries who could assist the believer along the path to enlightenment, much in the manner of a bodhisattva. By the time of their appearance in northern Asia, a thousand years after their mortal existence in India, they had assumed a mythic stature which included extraordinary magical powers and exotic appearance, all of which was well suited to the later forms of Buddhism. They are widely represented in Tibet in a style similar to that found in East Asia, where the original cult of four grew to sixteen or eighteen arhats (*lohan* in Chinese), and finally evolved into as many as five hundred images, necessitating their own separate building in a Buddhist complex. In Tibet, they are usually portrayed as either seventeen or eighteen individuals, with such groups depicted as early as the thirteenth century.

Chinese portraits of arhats are notable for capturing their religious intensity and bizarre appearance, though the latter is due in part to the traditional Chinese practice when portraying Indian figures. Early Chinese arhat images, beginning in the Tang dynasty (618–907), when 38 interest in foreign and exotic subjects was especially strong, are so exaggerated as to be caricatures, although that could also be seen as an effort to set them even further outside the realm of mortals in a tribute to their supernal powers. Tibetan artists followed a similar tendency in their por- 39, 40, 42 trayals, and in images from the eastern areas they are given Chinese land-scape, clothing and furniture, and Chinese faces as well. In some other Chinese and Tibetan examples, the arhat is dark skinned, a device commonly used by Chinese artists to indicate Indian subjects. Thus, while the concept of the arhat originated in India, Tibetan images mainly derive from Chinese sources and follow the Chinese mode of portraying Indian subjects. A fifteenth-century portrait of the arhat Hvashang, from a set of 134 sixteen arhats, sets him in a Chinese-derived landscape of trees and rocks. Hvashang's intensity, as well as the flattened shapes, are signs of Tibetan

38 (*left*) Arhat, 13th century,
China, Song dynasty, in the
manner of Tang *lohan*
painting. Hanging scroll,
h. 75 cm (29.5 in)

39 (*right*) Arhat Rahula, early
15th century, central Tibet.
Tangka, gouache on cotton,
h. 67.9 cm (26.7 in)

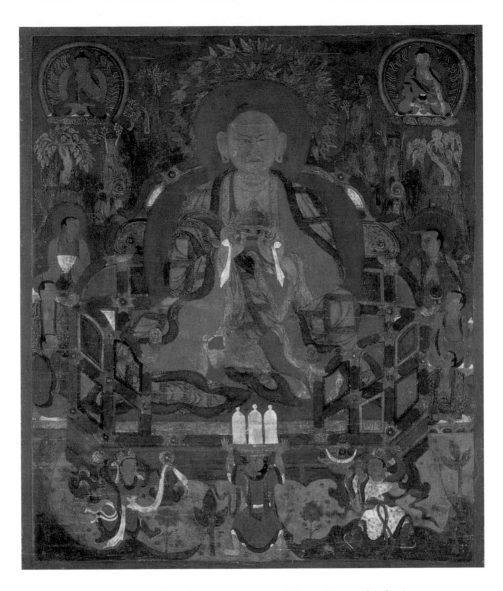

style, in an interesting mix of two artistic traditions. Given the lasting impact of Indo-Nepalese art on Tibet, had arhat images been part of that tradition it seems likely Tibetan arhats would have been less Chinese in style. The subject remained a powerful tradition in Tibetan art, and a primary example of the particular form of idealized portraiture at which Tibetan artists excelled.

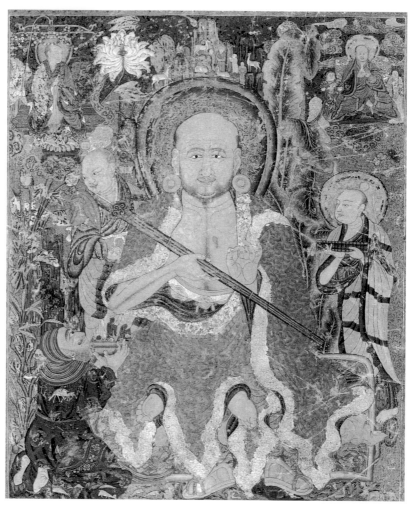

40 Arhat, *c.* 1400, Tibet. Tangka, gouache on cotton, h. 64.8 cm (25.5 in)

References to arhats are found in Tibetan literary records beginning at least as early as the tenth century. These include references to Indian, Chinese and Tibetan images, the first not surprisingly said to have been brought to Tibet in the eleventh century by Atisha. The oldest available examples, however, date from several centuries later, and are strongly influenced by the Chinese tradition, although enriched by Indo-Nepalese colours and decorative styles.

Mahasiddhas

Unlike the arhat, images of the *mahasiddha* – a Sanskrit term for a great being who has attained his goal – were largely unknown outside of Tibet. These highly venerated figures, like arhats originating in India but known there only through literature, were Tantric practitioners unfettered by orthodox rules but greatly admired for their unconventional, often bizarre practices. They differ from arhats in that they have already attained spiritual enlightenment, putting them closer to the fully enlightened Buddha. They are yogis, great mystics who practise absorption in special states of ecstatic experience, and, like arhats, they could perform miracles and possessed supernatural powers. In artistic representations they are shown in various kinds of dress befitting forest-dwelling, eccentric individuals, while the arhat is portrayed as a monk. *Mahasiddhas* were famed for their eccentric behaviour and appearance, both of which were well exploited by Tibetan artists.

45

43, 44

One of the most popular was Virupa, a *mahasiddha* especially important to the Sakyapa, who regarded him as their first earthly teacher. This master of Tantrism lived in ninth-century India and was believed to have gained power over the sun. He was also renowned for his love of liquor.

136

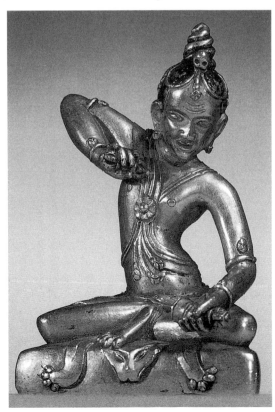

41 The *mahasiddha* Ghantapa holds the ritual bell and *vajra* in this graceful 16th-century brass image. He also displays the animal-skin blanket and skull in his crown which are typical attributes of these venerable individuals. Tibet. Gilded brass, h. *c.* 11 cm (*c.* 4.33 in)

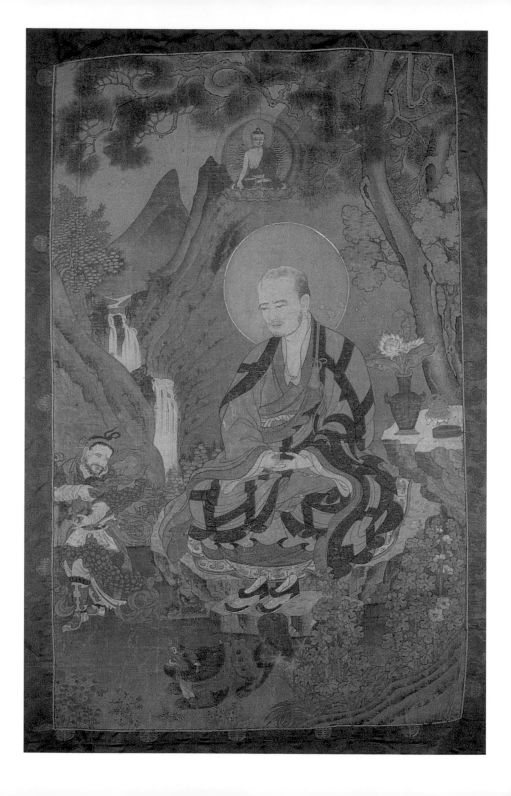

42 (*left*) Chudapanthaka. This arhat is in harmony with the serenity of his very Chinese-style landscape, but he still remains apart from it, as if floating beyond the mundane world, concentrating on the process of control over his inner powers, the goal of long meditative practice. 16th century, Tibet. Tangka, gouache on cotton, h. 147.3 cm (58 in)

43 (*below*) *Mahasiddha* (detail), 18th century, eastern Tibet. Tangka, opaque watercolour on cloth, h. 63.7 cm (25 in)

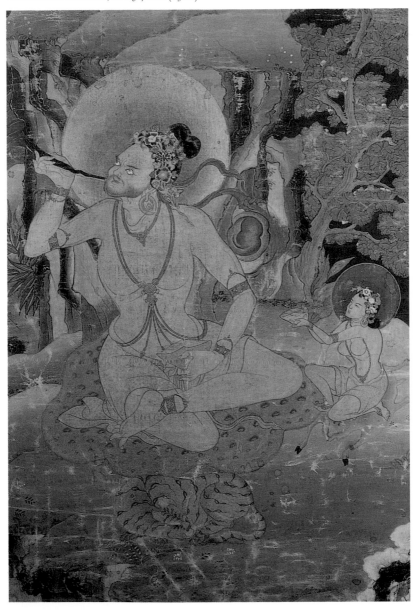

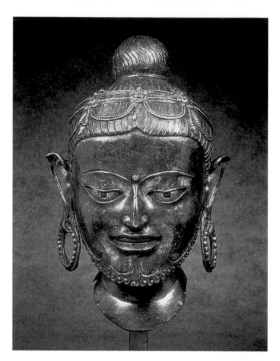

44 The exotic expression of a *mahasiddha* is captured in this rare, 13th-century bronze head. Tibet, h. 38 cm (15 in)

45 These *mahasiddha*s are interesting not only for their location on a bodhisattva's dhoti (a traditional Indian lower garment) but for their varied poses, ranging from meditative to ecstatically dancing, some with female companions on their laps, and with most of the figures shown nude. The curious checkerboard pattern may be stylized rocks, representing the caves they frequent. Statue of Manjushri (detail), *c.* 1200, Sumtsek temple, Alchi monastery, Ladakh. Painted stucco

Ultimately, a group of eighty-four Indian *mahasiddha*s came to be identified, each with distinctive attributes and roles. The group included historical individuals, some of whom founded, or were identified with, particular teachings, and so became part of the spiritual lineage of the established orders. The importance of the guru role throughout Tibetan Buddhism contributed to their popularity.

Philosophers and kings

At the foundation of Tibetan religious culture is its great corpus of literature, first as preserved from Indian texts and finally as developed by Tibetan scholars. This enormous body of instruction began to appear with the introduction of the Indian script, at the same time that the first religious kings of the Yarlung dynasty began the propagation of the Buddhist faith. By the end of the era of persecutions, certainly by the late tenth century, much of this literature had already been assimilated into the various orders. Tibetan teachers, philosophers and kings continued to interpret its meaning and, in the case of the kings, to protect its position. Across the spectrum of Tibetan culture many of these individuals joined the pantheon of deities and adepts, and their numbers increased over the centuries as their achievements continued to enrich the Buddhism they practised. The biographies of these venerated figures have been a subject for Tibetan artists from the beginning.

Philosophers and historical kings also constitute a second category of protectors of the dharma, such as the first religious king, Songtsen Gampo, and the great eleventh-century adept Atisha. 46

THE MANDALA

Literally a circle or arc, the mandala became a means in Tibetan Buddhism of representing the entire sacred universe. Elaborately detailed two-dimensional mandalas in paint or sand and three-dimensional mandalas in the form of metal sculptures or even entire monastery complexes – all are symbolic expressions of Buddhist cosmology and serve as teaching devices for initiated practitioners.

The mandala is not unique to Tibet, although no other culture has raised the subject to more elegant levels of complexity and beauty. As psychologists have discovered, the mandala concept is known in many forms, and qualifies as a fundamental human archetype. In India it is represented in both two- and three-dimensional forms in each of the three major religions, Hindu, Buddhist and Jain. In Buddhism, the human body is also a mandala, a microcosm of the universe, represented by the

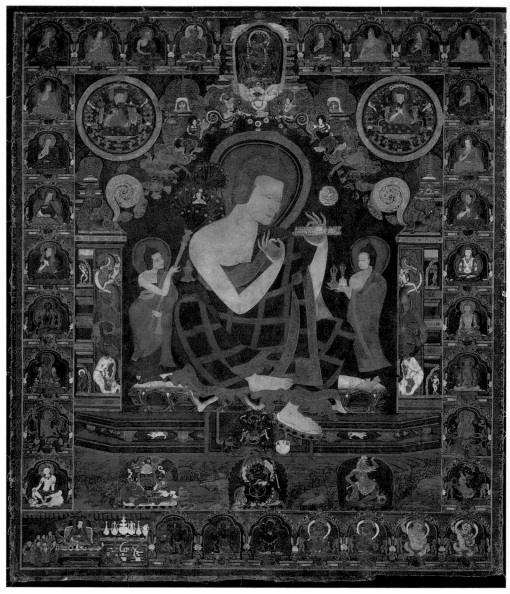

46 This superb portrait may be Atisha or Tsong Khapa, for both wear this distinctive hat. It follows the traditional pattern for portraits as idealized figures, but differs from many iconic images in its asymmetry, including the feet of the primary figure extending beyond the boundaries of his enclosure. 15th century, Tibet. Tangka, gouache on cotton, h. 101.6 cm (40 in)

47 Attempts to illustrate the cosmic scheme of Mt Meru can only approximate its complexities. In this example in a Tibetan lamasery in Beijing, a Chinese palace is enclosed in a circular wall, and the 7 mountain ranges and 7 oceans form a column, symbol of Mt Meru. Bronze, h. c. 250 cm (98 in)

vertical channel running along the centre of the body, a symbol of Mt Meru, the axis mundi of the universe. In visual form, the mandala is a symmetrical and spatial arrangement of forms representing a palace and incorporating aspects of architecture such as walls and gateways, and the dominance of its symmetry communicates a sense of order and permanence. The imagery includes combinations of deities, with a primary deity at the centre as in other compositional formats in Tibetan art.

According to Buddhist cosmology, the centre of the universe is a mountain, surrounded by seven oceans and seven concentric mountain ranges, with several levels of heavens above. Beyond the mountain ranges is the great ocean, containing the four island continents, one in each of the four regions of space, with the southernmost, the island of Jambudvipa, being the realm of humans. This entire universe is surrounded by a final huge wall of rock. The heights of Mt Meru contain the residence of the gods, including guardians and the celestial Buddha Vairochana. Ambitious attempts have been made to reproduce this cosmology, resulting in enormous architectural achievements at the Bayon in Cambodia, near Angkor Wat, and the even larger Borobodur in Java, each built in a mandala design at vast expense and labour.

The symbolism of the mandala also extends beyond the expression of universal order to include the essence of a deity, as a palace into which the deity descends, much as a germinating seed is within, and protected by, its outer shell. This dimension of the symbolism of the mandala is incorporated in the design and placement of buildings of Tibetan Buddhist temples. It has been noted that the mandala embraces the totality of awareness, from an entire cosmic vision to a dwelling and the human body as well. By such means an entity can be shown to partake of archetypal patterns which form the whole of life.

Three-dimensional mandalas can be extremely detailed expositions of the sacred universe, often with moving parts so they can be closed and opened to hide and reveal many levels of symbolism. Such three-dimensional mandalas derive from nearly identical Indian works of the Pala period (eighth to twelfth century), and along with other objects, such as small copper boxes, they portray the geometric symmetry of the mandala concept in three-dimensional form. In Indian worship, figures of deities in sexual union were usually kept enclosed within such a device, to be opened during the appropriate ritual.

Tibetan imagery extended the symbolism of the mandala into countless images, making it a major theme in Tibetan art. Painted mandalas exhibit the greatest range of subject matter and pictorial inventiveness, from images consisting entirely of geometric shapes, without humans or

47

49

48

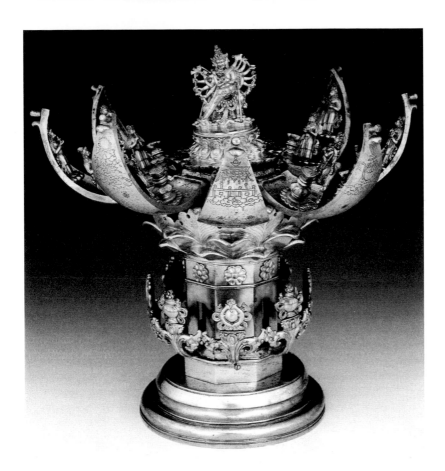

48 The mandala concept is beautifully illustrated in this 17th-century Sino-Tibetan gilded mandala in the shape of a pomegranate, enclosing the paired figures of Paramasukha-Chakrasamvara (see page 140). On top of a pillar, above 3 rows of leaves, sits a pomegranate whose 8 petals open to reveal 20 deities forming a Shamvara mandala, with Chakrasamvara and his consort Vajravarahi in sexual union at the centre. The rim of elaborate leaves at the base also functions as the apparatus which causes the pomegranate to open. Gilt bronze, h. open 22.5 cm (8.9 in)

deities, to multiple mandalas in the same composition. Whether the mandala, in its vibrant colours, is painted directly upon the walls of shrines or as a portable tangka, and despite seemingly endless variations, several basic guidelines are followed, beyond which the creativity of the artist is expressed. Religious texts define the type and number of deities, as well as iconographic features and the selection of colours, but many of the

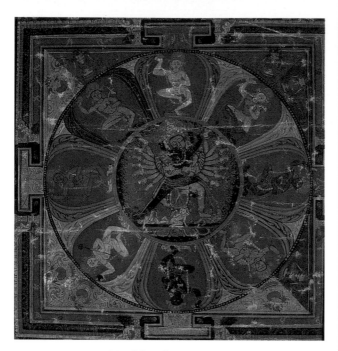

49 Mandalas of Hevajra and other deities
(detail), *c.* 1400, central Tibet. Tangka, gouache
on cotton, h. 73.6 cm (29 in)

50 This aerial view of Samye, despite the
considerable amount of rebuilding, captures the
mandala-like, walled arrangement portrayed in
the 18th-century tangka seen in *ill.* 56

remaining details, such as the areas outside the central mandala proper,
seem to be less restricted.

The central deity is typically enclosed by a series of concentric circles,
each containing groups of deities, often eight, such as eight guardians or
dancing goddesses. The primary circular enclosures are contained within
an elaborate palace, square in form and entered through gateways at the
cardinal directions, each adorned with bells, garlands and other decora-
tive elements. This central group (especially in mandalas of ferocious
deities) is surrounded by a circle of cremation grounds, representing the
phenomenal world which one leaves upon entering the central palace.
These cremation grounds are presided over by directional deities, or

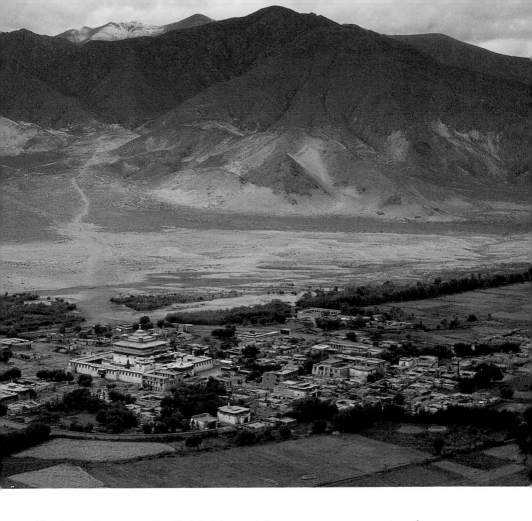

dikpalas, and are usually divided into eight segments representing the eight forms of consciousness and containing such elements as a stupa, a burning corpse, ascetics and *mahasiddhas*. A sequence of mandalas is often painted on temple walls, functioning as steps in initiation ceremonies. The initiate is led into and through each mandala by a teacher, beginning with the entrances and on through the various levels, with ignorance and delusion gradually removed by the combination of visualization and explanation, under the guidance of the master. Much of the effectiveness of the mandala, as a device for leading the initiate further into the realization of the nature of existence, is produced by the sheer repetition of forms, the symmetrical harmonies that impart a vision of the structure of

73

the universe, along with the subtle and fine distinctions between compositions which can appear nearly identical to the uninitiated. Changes in the particular deities portrayed, although their placement in the mandala itself remains unchanged, enable the teacher to reinforce the meaning while remaining within the same, structured framework. In some temples, as in the Sumtsek hall at Alchi, nearly identical mandalas face one another across a room, differing only in that the thirty-seven deities in one are all male, while those in the other are all female.

Individual temples are also designed as mandalas: horizontally, by surrounding a central altar platform with a circumambulation path that mirrors the circles about the square centre of painted mandalas; and vertically, by arranging deities, painted and sculpted, about the walls, beginning at the lower levels with imagery associated with salvation and rebirth in paradise and gradually ascending in the cosmic order as one's gaze moves upwards. The second level could be reserved for esoteric initiation and the highest devoted to transcendental images. In buildings with more than one storey, elaborate hierarchies of the pantheon could be displayed. The Sumtsek, for example, a three-storey hall, may well have been intended to embody such a mandala design.

The concept of the mandala was also carried out in grand architectural schemes in Tibet. One of the earliest monasteries, the eighth-century complex at Samye in central Tibet, still resembles a mandala even in its ruined state. In a striking aerial photograph of present-day Samye, which now includes reconstructed buildings as well as ruins, the Swiss scholar Michael Henss has revealed the basic mandala arrangement of the walled complex, with many of the same major components which are visible in the highly stylized, eighteenth-century tangka that depicts the monastery's plan. In the latter, the entire compound is encircled by a wall, indicated by a double zigzag, a formula often followed in such topographical views. Clearly revealed in both the tangka and the modern-day photograph are the key elements: the three-storey central building with its surrounding courtyard, flanked by four major temple buildings, and stupas (in Tibetan, *chortens*) and gateways at the cardinal directions. This symmetrical layout is a man-made recreation of the Buddhist cosmological vision, with Mt Meru at the centre, surrounded by the continents, and the whole contained within an alternating succession of mountains and oceans of cosmic grandeur.

Structures, Objects and Images

ARCHITECTURE

The most basic, singular example of Tibetan architecture is the tent, the appropriate dwelling for a nomadic-warrior culture. Made of felt over wood framing, such tents are first mentioned in Chinese records of the eighth century and are still found across Tibetan-related cultural areas today, such as Mongolia and the large steppe regions of Eurasia. They are included in the thirteenth-century record of Marco Polo, who noted the more elaborate examples owned by members of the highest levels of society. Just as interiors of constructed temples are richly decorated, the interiors of Tibetan tents are colourfully adorned, through the use of vivid rugs to cover the walls and floors, similar in effect to the painted walls and tangkas found in temples. It is not surprising that the tent, Tibet's fundamental form of architecture, is linked with Mahakala, the most revered of protector deities in the pantheon. Tibetan kings, although continuing to utilize the tent, also constructed fortresses, typically sited to take advantage of sheer cliffs, that served both as palaces and defensive strongholds. The castle at Leh, built in the sixteenth century, still retains this early palace-fortress combination, including interior walls covered with paintings.

51

The tombs of early Tibetan kings seem to follow the circular format of the tent as well. Several remain from the eighth century, built around a single stone pillar with inscriptions dedicated to the deceased king, much in the manner of Chinese stelae. The symbolism of the pillar, as emblem of the axis of the universe, is widely found throughout Asia, and it would seem to have played a role in Tibetan funerary customs as well.

The structural architecture of Tibet is remarkably consistent in its appearance, methods of construction and choice of components, whether the building be a farmhouse, a palace, or a temple. The Tibetan farmhouse may provide the model. It is typically multi-storeyed, with the ground floor used for animals, the second for storing food and animal feed, and the upper floors for people. The balconies and verandas of the upper levels are in striking contrast to the massive load-bearing walls of stone, mud brick or rammed earth below. In front of the building is a

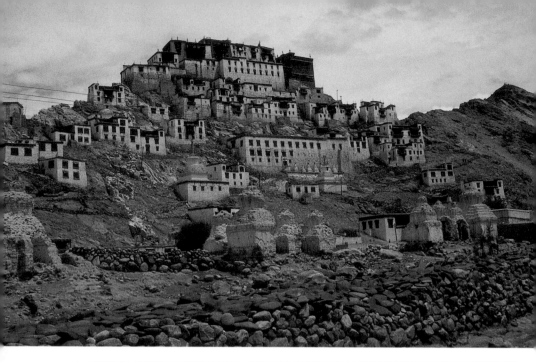

51 (*left above*) Thiktse monastery, Ladakh

52 (*left below*) Shalu Monastery, Tibet

53 (*right*) Yambulakhar royal palace, Yarlung Period, Yarlung, Tibet. Much damaged

courtyard, sometimes enlarged to surround the entire structure. Windows are few and small, and roofs are flat, for wind and storms are a greater threat than the build-up of snow, and the roofs can be used for living space and storage during milder times of year. The sheer weight of these roofs necessitates the use of wooden columns as additional support, a system also found in temples. Instead of having a constructed chimney, cooking smoke is released through a hole cut through the centre of the flat roof. In their use of load-bearing outer walls and their lack of arches and domes, these buildings are similar to the architecture found across most of western Asia.

The transitions between different floors are clearly evident in fortress architecture too, where several storeys emerge from rocky peaks high 53
above the surrounding land, yet in their development from bottom to top repeat the basic formula of other Tibetan buildings. The early fortresses also served as palaces, as did the seventeenth-century Potala at Lhasa. As a monastery, fortress and palace, the Potala reveals the unity of style among buildings of widely differing purposes. This coherent sys- 1, 163
tem of architecture remained essentially unchanged in Tibet over many centuries.

Monastic establishments across the land share the same solid, cubical 52
appearance, with inward tapering, whitewashed walls of sunbaked brick

77

or stone, tall, narrow windows and enclosed courtyards. This basic farm-house model was favoured over the cut-stone masonry used in Indian temples, or the elaborate wooden structural and bracketing systems of Chinese architecture, which were followed only for embellishments such as finials and tiles, mostly on the uppermost floor. The early Tibetan use of bracketing, revealed by what remains from the period of the second diffusion, has more in common with earlier Chinese styles of the Tang dynasty (618–907) than with the contemporary and more elaborate systems of China's Song and Yuan dynasties of the eleventh to thirteenth centuries. The wooden and carved pillars inside temples, although showing their derivation from Indian models in their materials and basic shape, were richly painted and carved into forms that could be described as a distinct Tibetan style.

At the core of Buddhist architecture are three main types of structures originating in India, two of them functional and one primarily symbolic. Of the two functional structures, one enables devotees to gather for worship and the other serves as a place of lodging and instruction for monks. The place of worship, the *chaitya* hall, is large enough to hold gatherings of monks and laymen, while the *vihara*, a dormitory-like residence, serves as a monastery. These two fundamental structures, initially created of wood, were so valued in their original, perishable forms that they were laboriously replicated in great detail in stone, the best preserved and most complete early examples being the rock caves carved into the sides of mountains at Ajanta. One of these copies, carved in the fifth century, was so faithful to the originals that pieces of wood were added between the carved stone ribs in some of the barrel-vaulted ceilings.

The third and the most distinctive of the various Buddhist structures, the Tibetan *chorten*, is best known by its Indian and East Asian names, stupa and pagoda respectively. In their earliest, pre-Buddhist Indian form, these dome-shaped structures were burial mounds. When adopted by Buddhists, one of their primary functions was to enclose an object of veneration, such as a sacred relic. This could range from a hair from the Buddha to an implement once used by a venerated monk, as well as any number of lesser articles connected with the faith. *Chorten*s range in size from the colossal, with rooms on several floors, as found at Gyantse, to small votive models which could be constructed from a wide variety of materials, including metal, wood or even butter. *Chorten*s carry special meaning over and above their function as buildings or objects of worship, for they are also a source of great merit for those who commission or work on them, whether they be royal patrons or modest donors of simple votive replicas.

54 Tibetan monks making a butter sculpture, Ta Er Si, Xining, China

The monastery

The role of the monastery in Tibetan history cannot be overemphasized. To a greater extent than in other Buddhist cultures, including India, the monastic establishments directed and controlled the entire culture for a thousand years. This religious, feudalistic system can be criticized in modern times, but the cohesiveness of Tibetan life was built around it. The traditional Tibetan monastic complex, especially in earlier periods, followed the orderliness of mandala designs, although the constraints of 56, 57 topography and the addition of buildings over time may have altered this arrangement. By the seventeenth and eighteenth centuries, the mandala plan had begun to give way to a hierarchical vision, with upper storeys assuming positions of greater ritual importance, although the courtyard 55 was retained throughout, being necessary for ceremonies such as elaborate ritual dances. These symmetrical configurations were a means of suggesting the greater harmony of the universe and the cosmological centrality of Mt Meru. A further modification took place with the consolidation of secular and religious power under the Gelugpa, as palace and monastic architecture merged into the single complex, the most dramatic example being the Potala.

79

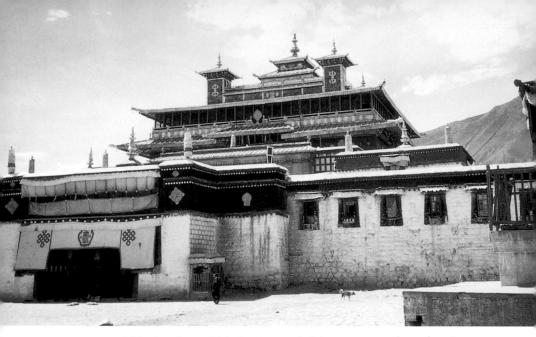

55 This view from within the courtyard of the reconstructed temple at Samye illustrates the multi-tiered plan, with the massive lower level giving way to ever more elaborate floors, just as the traditional farmhouse reserved most decoration and windows for the upper levels

The architectural style of the individual Tibetan temple favoured an interior consisting of a large square or rectangle which could be divided by rows of columns to create a surrounding 'nave' and side aisles and be entered from an enclosed courtyard, as with the traditional farmhouse. The altar was sometimes placed in the centre of the room, but just as often against the back wall or within an additional, smaller room entered from the wall opposite the entrance. Tibet's most sacred sanctuary, the Jokhang, follows the latter plan, based upon the Indian *vihara*. The Dukhang, the oldest temple at Alchi, is cruciform in plan, with a hypostyle hall. In addition to tangkas hanging from the ceiling, statues and paintings were arrayed along the walls, usually a progression of images with a theme such as the life of the Buddha or visions of the celestial worlds. The goal was to provide adequate space for numbers of worshippers; positioning the main deity platform at the rear of the room provided a larger area for the monks to confront the images than if the altar had been placed in the centre of the room, as might have been more congruent with the mandala schema.

57

The decorative scheme could also be repeated through the succeeding storeys, with different deities featured on each floor, a chapel devoted to fierce protector deities, or even private apartments for high-ranking lamas. Variations in building plan and image placement were made according to the function of a room – whether it was for initiation rites, for example, or for the gathering of numbers of monks. Some of the larger and more elaborate temples, such as the seventeenth-century Potala in Lhasa, are unable to conform to a symmetrical mandala plan, due to constraints of siting and adjunct military uses, but they do retain the traditional smoothed and whitewashed brick walls, set on top of stone foundations which are mortared with sunbaked mud.

The earliest examples of Tibetan Buddhist architecture, dating from the time of the first kings of the Yarlung valley in the seventh and eighth centuries, no longer exist, at least not in their original form. Important early temples, such as the Ramoche of Lhasa and Samye, also retain little of their original form, although an overall idea of the layout of the latter

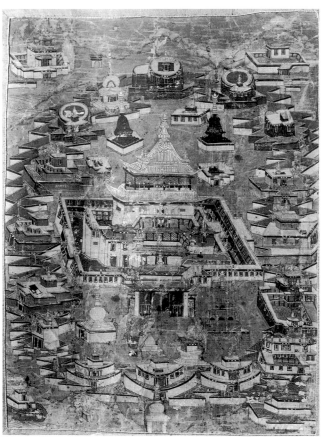

56 Although highly stylized, this tangka of Samye illustrates the typical mandala-derived monastery plan, with the most important building at the centre and the remaining structures radiating out from it. The eight outer buildings also symbolize the principal directions of the Buddhist cosmology. Late 18th century, central or eastern Tibet. Gouache on cotton, h. 53.3 cm (21 in)

57 Plan of Yeshe Od temple, Tholing, late 10th century

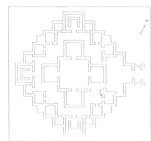

58 Finial at the Jokhang. Chinese and Indian motifs remain a part of the Tibetan decorative vocabulary, as in this gilded *makara*, a mythical elephant-trunked crocodilian deriving from India and found atop the mandorlas of paintings as well. 18th–19th century, Lhasa, Tibet

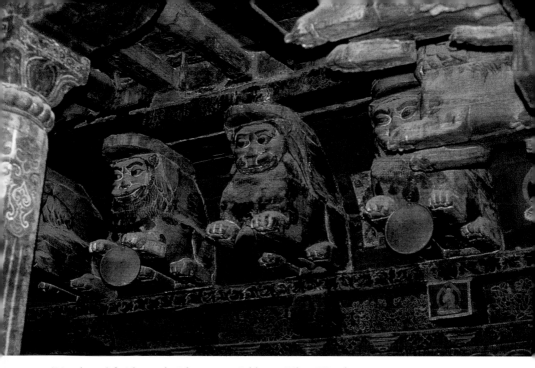

59 'Lion beam' finials, *c.* 7th–8th century, Jokhang, Tibet. Wood

can be gained by comparing the modern temple, in its mostly rebuilt state – often over the old foundations – with earlier paintings of the temple. Some of the original seventh- and eighth-century details, such as individual wooden pillars and capitals, are preserved under layers of paint. Frequent rebuilding and the wholesale destruction of the mid-twentieth century have limited the evidence available to reconstruct Tibetan architecture from the early periods. The early temples in the west are likewise now in a ruinous condition; at Tholing, site of what was once the area's largest temple, built around 1000 AD, portions of only two of the original buildings are preserved, and the remaining metal objects were carried away during the cultural revolution.

The chorten

The Indian stupa, originally a solid structure symbolic of a burial mound, was without usable interior space. It underwent stylistic changes during Buddhism's path across Asia and assumed a variety of forms and expanded functions, including the addition of functional interior and vertical 60–64

60 (*above*) *Chortens*, Lamayuru, Ladakh

61 (*right*) Shwedigon Stupa, 1044–77, Pagan, Burma

forms, as in the Japanese pagoda. Within Tibet, as in each Buddhist culture, one particular style came to be favoured, and stylistic changes did not radically alter that traditional form once it was established. Due to the need for a structure with interior areas, some Tibetan *chortens*, such as the Gyantse Kumbum, did vary from that basic formula. At least one example remains at Alchi of a *chorten* enclosed within another structure, in the manner known among Buddhist constructions in Sri Lanka and in the earliest caves at Ajanta.

130

The dome-shaped stupa early assumed a special position within Buddhism, distinct from buildings that housed monks or received devotees for worship. This sepulchral monument was worshipped directly, especially during the several hundred years before the making of Buddha images became acceptable, and it remained the most venerated of the popular aniconic images, which also include representations of the Buddha's footprints, the bodhi tree under which he attained enlightenment and an empty throne. Stupas continued to be donated after the completion of a temple, and active monasteries include many, of various sizes. Portable votive stupas, which could also include a relic, were

84

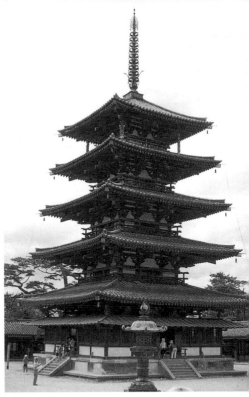

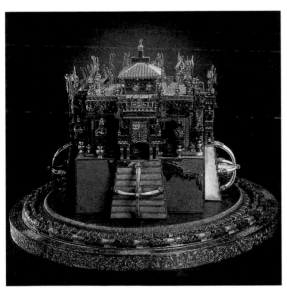

62 (*above left*) Great Goose pagoda,
8th century, Xian, China

63 (*above right*) Horyuji Pagoda,
7th century, Nara, Japan

64 (*left*) Palace mandala, 18th century
(Qianlong period), Beijing, China.
Gilded and enamelled bronze, h. 50 cm
(19.7 in)

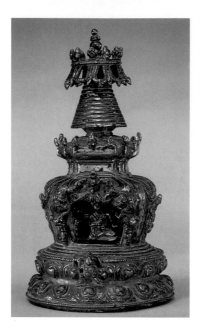

65, 66 The goddess Ushnishavijaya, worshipped for long life, is believed to reside in the *chorten*. She is portrayed inside this 16th-century brass *chorten* (*left*), and on this tangka, where she is surrounded by miniature *chortens*. These illustrate the Newari rite of dedicating a hundred thousand *chortens*, an act of great religious merit. *Left* 16th century, Tibet. Brass, h. 21 cm (8.25 in). *Right* Dated 1488, Tibet or Nepal. Tangka, gouache on cotton, h. 75 cm (29.5 in)

commissioned and acquired as acts of merit. The best-known such donation was a group of 84,000 votive stupas offered by India's first great Buddhist king, Ashoka, in the third century BC. The practice of dedicating auspicious numbers of stupas continued, as in the placing of 108 separate *chortens*, in even rows, in western Tibet – 108 being the traditional number of delusions people have, according to various scriptures, and 84,000 the number of deities, the latter really standing for an infinitude.

In northern Asia the popularity of certain materials helped determine the distinctive forms for the stupa. In China, with its long ceramic tradition, the favoured material was brick. Korean stupas are often made of granite, and Nepalese and Japanese stupas, in the pagoda form, were most often constructed of wood. The choice of material invites changes and also places limitations on the design, giving each a distinctive profile. The relative scarcity of wood throughout much of Tibet, as well as the absence of a monumental building tradition in stone, ensured that the Tibetan *chorten* would be constructed of the same materials used for farms and temples: sun-dried bricks or squared stones, with plaster facing, the surface often renewed as an act of merit. Continuing donations over long periods of time meant that a monastic complex would contain *chortens* of various sizes, placed throughout the compound.

Chortens range in style from near-replicas of Indian models, particularly of Kashmir and the Pala kingdom, to large, multi-tiered buildings of

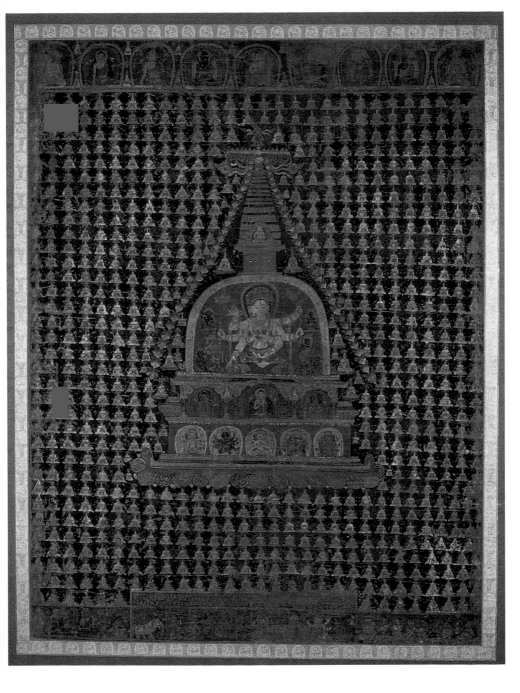

great elaboration, with multiple doorways and interior spaces for worship, the best example being the famous *chorten* at Gyantse, the largest in Tibet. Numerous wall paintings and tangkas repeat the basic design, as do the many small brass *chortens*, dated as early as the eleventh or twelfth century, a style that continued to be popular despite evolving into ever greater elaboration.

66

Despite literary records which describe various designs, such as one for each of the eight great events in the life of the Buddha, most all Tibetan *chortens* adhered to one standard formula. This particular model is closest in style to the stupas of northern India, especially the Kashmiri type, and consists of three primary parts, beginning with a wide base, rising to a round, main body, with a profile that expands upwards (*anda*), atop which is placed the second major part, a construction of supporting elements (*harmika*) that marks the transition to the final portion consisting of a pillar with rows of circular disks or umbrellas of diminishing size, either seven or thirteen in number (*chhatraveli*). A popular variation adds a taller, stepped base which rises through a series of diminishing levels, with stairs leading up to the central drum.

The earliest votive *chortens*, made of cast brass in the eleventh and twelfth centuries, have a gentle profile, with a bell-shaped, ever-diminishing form that rises from a wide base into the *anda* (the transition, marked by encircling bands) and into the small area for the *harmika* which supports the tower of umbrellas. Known as the Kadampa *chorten*, after the order associated with Atisha, this style is joined by later examples with a pronounced swelling of the central *anda*, a style associated with Sino-Tibetan *chortens*. The repetitive and symmetrical design of Tibetan *chortens* in squares and circles has been noted for its similarity to the mandala, reaching its most elaborate expression in the multi-storeyed Kumbum at Gyantse.

68

60, 69

Despite the dominance of one stylistic formula, the importance and inherent sanctity of the *chorten* in Tibetan Buddhism meant that it embodied a wide range of fundamental values associated with the religion. The great Tibetologist Giuseppe Tucci defined the complexity and levels of significance that were associated with this critical element of Tibetan worship, including the fundamental purpose of the *chorten* as the essence of the Buddha himself. While the temple houses scriptures and images, the *chorten* itself is sacred, as embodying the dharma, the essential quality of Buddhism, and when it contains sacred scriptures or the ashes of an esteemed lama, they became part of the structure, bonded as a sacred unit. Votive tablets, *tsa-tsas*, were placed inside a *chorten*, as emblems of the potency of the structure. Appropriately, *tsa-tsas* often

67

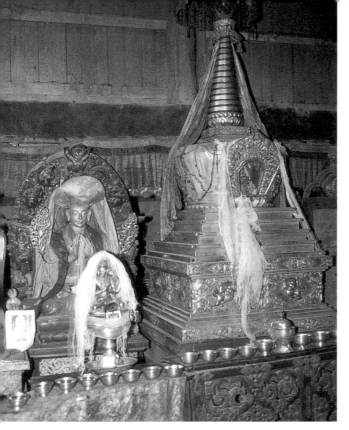

67 (above) This altar has a brass portrait-statue of the order's founder and, to the right, a richly adorned brass *chorten* said to contain his remains. While not as inspiring as the sculpture of Milarepa (*ill.* 73), such remains offer the worshipper multiple links with the actual person and are typically accorded a greater degree of veneration than a statue or a painting. 18th–19th century, Hemis monastery, Ladakh

68 (above right) *Chorten, c.* 1230, Tibet. Cast brass, h. 34.3 cm (13.5 in)

69 (right) In later centuries elaborate votive *chorten*s were created at the Chinese royal workshops, many covered with gold and silver and inset with precious stones. The typical design has lotus petals around the base and decorative elements on the spire of umbrellas, including banners, a lotus bud and petals, and emblems of the sun and moon. Sino-Tibetan, 18th century (Qianlong period), China. Gilded bronze with inlays of pearls and jewels, h. 139 cm (54.7 in)

70 This clay tablet, or *tsa-tsa*, displays five images of 11-headed, 1000-armed Avalokiteshvara, positioned to suggest the four cardinal directions and the centre, appropriate to the *chorten* as embracing all dimensions. There are *chorten*s beneath the central figure in place of Mt Meru. 17th–18th century, Tibet. Clay, h. 21.6 cm (8.5 in)

70 include representations of *chorten*s. The opportunity to donate such a small object is a universally accessible means to gain merit, much like the mounds of countless inscribed, flat *mani* stones which are found all across the Tibetan landscape.

Ritual objects

Despite its visual richness and vast complexity, Tibetan art remains at the service of the most simple of acts within the religion, as an implement of meditation. Buddhism consists primarily of a number of widely differing systems of meditation, and Tibetan ritual meditation is far removed from the practice of the Zen monk, who seeks the ultimate meaning of existence unencumbered by either the accumulation of a lifetime of mundane experiences or by ceremony. Tibetan practices seek to evoke a particular deity as a transcendent aid to help clear away the obstacles to ultimate understanding. A difficult and lengthy programme of mental generation and progression is needed in order to learn to create and utilize detailed visualizations of the deity. The process requires an array of supporting implements ranging from enormous paintings displayed one day a year to small ritual objects made of a variety of materials from precious metals to carved bones. This institutionalized need for Buddhist

ritual objects was also promoted by the traditional shamanistic heritage of Tibetan culture.

Broadly speaking, the category of the ritual object in Tibetan religion includes nearly all objects that serve a religious function. More specifically, most are small, hand-held and often found upon altars and tables within the temple. The extensive variety and uses of ritual objects should be noted as one of the defining elements of Tibetan art, for no other culture has generated so wide a range of such implements. The great breadth also holds true for the materials they are made from. These include precious metals, especially silver, jewels, wood, sculpted butter, and even human bones and ashes, taking the ritual object well beyond the usual range of materials familiar among most religious traditions.

Most of the ritual objects derive from Indian religions, including the most widely known of all, the thunderbolt (*dorje* in Tibetan and *vajra* in

71 (*below left*) Ritual axe, *c.* 18th century, Tibet. Bronze with inlay, h. *c.* 36 cm (*c.* 14.2 in)

72 (*below right*) *Phurpa* or ritual dagger, Sino-Tibetan, early 15th century (Yongle period), China. Gilded bronze, h. 23.8 cm (9.4 in)

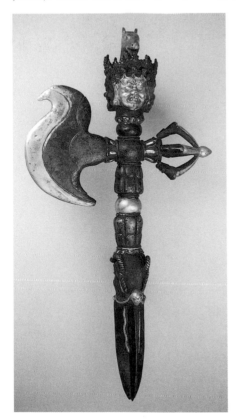 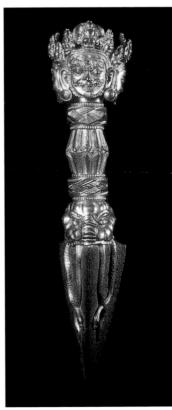

Sanskrit) and the bell (*ghanta* in Sanskrit). Such objects are frequently displayed in deities' hands, especially the *vajra* and the bell, and several deities not only hold the emblem but have *vajra* included in their name, for example Vajrapani and Vajradhara. Typically a single *vajra* is held, as in images of Padma Sambhava, although some deities hold several. Other images display both *vajra* and bell, ranging from the highest cosmic bodhisattvas, such as Vajrasattva, to lamas and adepts, or *mahasiddhas*.

When the *vajra* and bell are displayed together, the symbolism forms about paired opposites, such as the *vajra* as emblem of the male aspect of action and the bell as the feminine expression of knowledge, together representing the union of those two essential aspects of enlightenment. The primary meaning of *vajra* as thunderbolt, the most powerful element in nature and an unstoppable force, ensured its central place in Tibetan religion. The symbolism can be heightened further with the addition of other elements, such as faces about the handle of the *vajra* or the bell, elaboration of the *vajra*, or the incorporation of skulls or a knife blade and handle. The *vajra* may be merged into or joined with other ritual implements, such as ceremonial daggers, or choppers (in Tibetan *phurpa*, literally 'peg'), that are associated with deities and ceremonies expressing power and extraordinary strength, thus further enhancing its quality of awesome power. The dagger also played a central role in Tibetan ritual, and it appears in many paintings in various forms, in some mandalas taking an important position. Unlike most ritual implements, which originated in India, it seems to be known only in Tibetan religion.

71, 72

Few Tibetan ritual implements can be more difficult to understand than the human skull cup (Sanskrit *kapala*), filled with blood or sometimes with brainmatter. It is held by a variety of figures, including Padma Sambhava, Vajravarahi and Mahakala, as well as a number of the *mahasiddha*s, and it is an important ceremonial implement. The traditional ceremonial use of human bones, including skulls, bone aprons and human thighbone trumpets, often to frighten away evil spirits, was a practice found throughout much of Asia, including in pre-Buddhist Tibetan ancestor worship. The Tantric Buddhist practices followed in Tibet likely had an Indian source, although the Tibetan use of human bones in ceremonies was more extensive than in India. The Tibetan custom of disposing of the dead by offering the cut-up body to be devoured by vultures meant bones were plentiful, while their use in ritual further enhanced the belief in the transient nature of human life.

The use of such materials, composing or applied to an image, is known in other areas of Asia; for example, some portrait sculptures of Japanese Buddhist figures have real hairs added to the chin, or are composed in

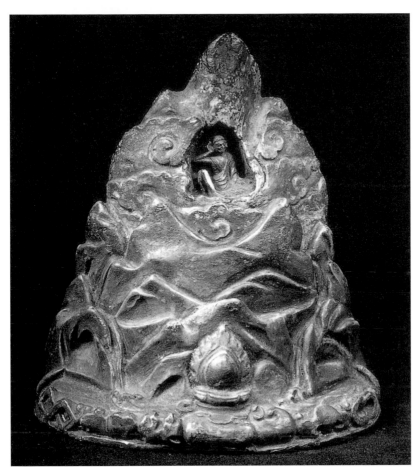

73 This small image of Milarepa is a remarkable example of the extent to which a ritual object can express the core of a belief system. The mountains forming the base are made of ashes, while the figure itself is carved from bone. To a believer, the ashes and bones are the saint himself. Date uncertain, Tibet. h. 16.5 cm (6.5 in)

part of the ashes of the deceased. One famous Chinese Daoist monk for years consumed certain tree barks and related materials thought to enhance preservation of the body from within, and when he died his body was covered in layers of lacquer and placed within a shrine so he could be worshipped in as close to an eternal form as possible. Tibetan sculpted figures made of bones and ashes take the ritual object to a level of reality beyond that of a symbolic image, bringing the worshipper as close as possible to the venerated personage.

73

74, 75 Even daily utensils can be brought into service as religious objects. This flint pouch (*above*), although not properly an implement of ritual, includes in its decoration the emblems and symbolism found on liturgical objects such as this richly adorned water vessel (*right*). *Above c.* 19th–20th century, Tibet. Leather, brass and silver with inlays, *c.* 18 cm (*c.* 7 in). *Right* 18th century, central Tibet. Silver, crystal, turquoise and opal, h. 29.2 cm (11.5 in)

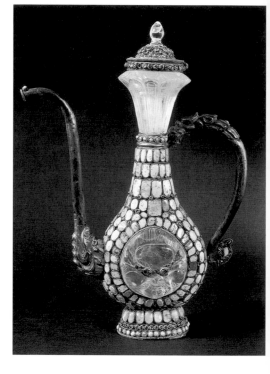

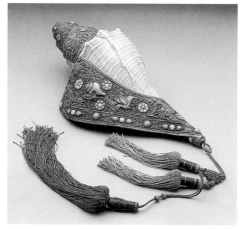

76 (*left*) Conch shell, 18th–19th century, Tibet. Silver, jade, coral and turquoise, h. 39.4 cm (15.5 in)

77 Lamas at Drepung sit beside two richly decorated trumpets and a long-handled bell as they read a manuscript in preparation for a ritual that will involve music

Other important ritual objects are reserved for ceremonial practice and are not so intimately identified with images of deities. In addition to paintings, statues and miniature *chorten*s, Tibetan altars include silver bowls and butter lamps, and a variety of vessels. 67 74, 75

Another group of ritual objects are those associated with music. Drums, trumpets, bells and conch shells are a few of the major instruments that play an essential part in ceremonies. The conch is widely used, its distinctive sound believed to drive off evil spirits. Modern-day pilgrims still carry a conch shell, blowing it when approaching a Buddhist temple, a scene repeated often in Japan. 76, 77

Many ritual objects were mass produced and made of humble material, such as clay, paper and butter, by monks who then sold them to pilgrims to be used as offerings and carried as amulets. The *tsa-tsa,* the mass-produced votive plaque, is one of the most interesting. Some were gilded

and painted, their stamped images ranging from simple *chorten*s to groups of figures of Buddhas, bodhisattvas and various protector deities. Entire sets of the Vajrayana pantheon were produced, including inscriptions on the reverse that identified the deity portrayed, roughly duplicating the more expensive sets of gilded metal images of Tibetan deities made for eighteenth-century Mongolian and Chinese temples. Individual *tsa-tsa*s exist in great numbers, for once offered by the worshipper they were often enclosed within a statue or *chorten*, where many of them have been discovered by modern-day excavators.

THE IMAGE

Tibetan paintings and sculptures are considered offerings, prayers for the well-being of all living things. The inscriptions on paintings and sculptures repeat a general prayer, that the work benefit all sentient beings, in the manner of a bodhisattva seeking to bring merit to all; the inscription can be directed towards a particular deity, and the merit can be offered specially for the welfare of another individual as well as for the well-being of all. Commissioning and fashioning images are also meritorious

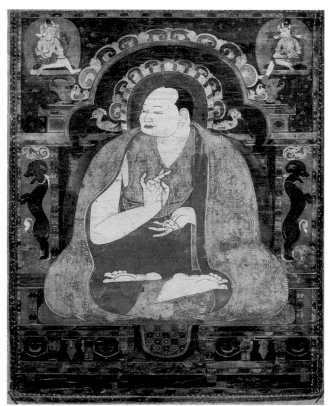

78 Portrait of a lama, early 12th century, Tibet. Tangka, gouache on cotton, h. 46 cm (18 in)

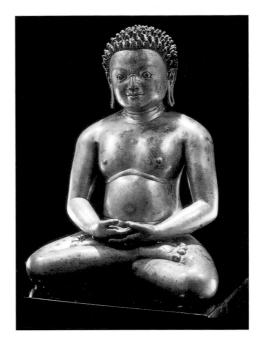

79 This compelling brass image of a seated yogi embodies many of the distinctive aspects of Tibetan figural art. The body continues the Indian tradition of showing powerful inner forces of breath control through taut, abstract forms, and the naturalistic details are part of Tibet's portrait tradition. 11th century, Tibet. Brass, h. 33.9 cm (13.3 in)

80 Two portraits, *c.* 13th–14th century, Alchi monastery, Lhakang Soma temple, Ladakh. Wall painting

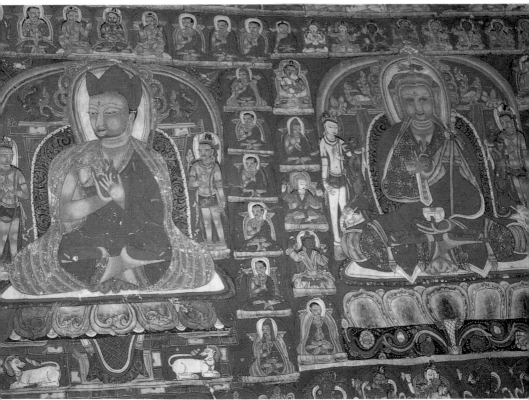

activities, for the artworks serve a variety of purposes, providing a visual focus for ceremonies and for meditation, both individual and group, and an educational tool to enhance understanding of the complexities of the Buddhist liturgy. In spite of the merit accrued, the artist's name is rarely found on a piece, but the names of many artists are known, gathered from lists compiled mainly over the last four hundred years. The traditional belief that the artist was the medium through which religious expression passed accorded with the Buddhist emphasis on the lack of a self, making the inclusion of an artist's signature at odds with a cardinal rule of the faith. Generally, as in most cultures during times of strong religious belief, the personality of the artist is not considered important; that position is reserved for the donor.

Portraits are especially significant, serving to sustain an order's lineage and thereby reinforce its particular teachings. Beyond such religious roles, images are broadly used to support nearly all aspects of human endeavour, from success in business, to recovery from sickness and enjoyment in private life. Many paintings are commissioned when a death in a family occurs, to help ensure rebirth in ideal circumstances. Despite the universal Buddhist claim to disavow the grasping ego, almost every desire an individual might have at one time or another has likely been brought before a painting or sculpture for assistance in securing that end.

Portraits

The representation of a particular person is one of the most compelling subjects in the history of art. The modes of portrayal range from nearly abstract, idealized images, as in Old Kingdom Egypt, to more accurate physical likenesses, as in seventeenth-century Dutch portraits. Asia also produced a range of portrait styles, with an emphasis on social and historical stature, respect, age and religious sanctity, qualities more valued there than the traits most often favoured by Western artists, especially after the Renaissance, when personality and physical likeness became paramount.

Portraiture has played a major part in Tibetan art since at least the eleventh century, and its subjects include venerable religious leaders, whether living or legendary, individuals from the royal class, and countless lamas and monks. The concept of reincarnation, or emanation, not only linked important personages to particular spiritual lineages, but also increased the sheer number of figures to be portrayed. Tibetan painting differed from that of other Buddhist cultures in having compositions mixing images of divine and mortal figures who share in the spiritual lineage process that defines the various sectarian orders. The primary goal of the artist in Tibet remained the visualization of inner qualities, the

2

78, 80

98

81 Sketchbook with
Tibetan subjects,
17th–18th century,
Tibet or Nepal. Opaque
watercolours on paper,
h. 20.3 cm (8 in)

transcendent nature of the subject, rather than the creation of a record of
a time-bound world. Some portraits nonetheless reveal details of physical
likeness clearly based on first-hand observation, and so reach beyond the
idealized imagery associated with the classic Indian and Chinese formu-
lae. A few artists' sketchbooks have been preserved, and although most 81
are filled with iconographic drawings to be used as guides and records
for formalized painting and sculpture, some include drawings that were
likely made from life. A degree of realism is found in a great number 79
of Tibetan portraits, and these artists' sketchbooks point to an abiding
interest in the genre.

Few images better capture the essence of Tibetan culture than the
inspired portrait of a religious figure. These revered teachers and saints, 83
their history and myth formed from the legendary exploits of dedicated,
striving individuals, are, like the bodhisattvas, lessons of Buddhist devo-
tion. Because their role was integral to the development of Tibetan

99

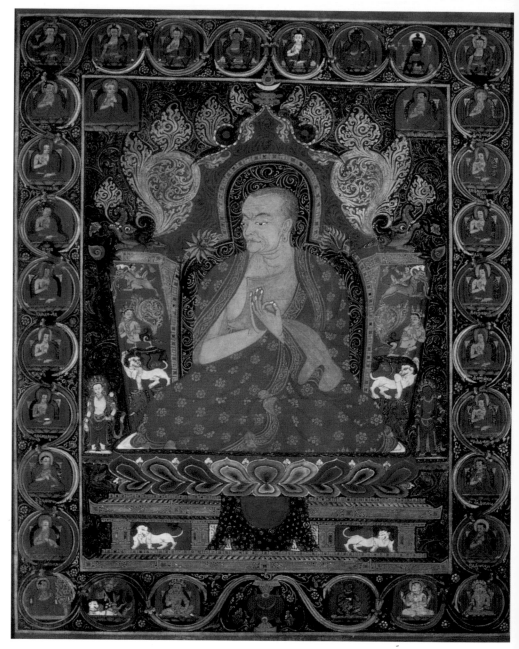

82 The unidentified teacher in this small tangka embodies the essential qualities of Tibetan portraiture. He is seated like the transcendent Buddha, displays the gesture of teaching and is surrounded by an elaborate mandorla with mythical beasts and floral designs, but the stern face and intense averted gaze bring the portrait into the human realm of intense devotion, dedication and individuality. Late 15th century, Tibet. Tangka, gouache on cotton, h. 37.6 cm (14.8 in)

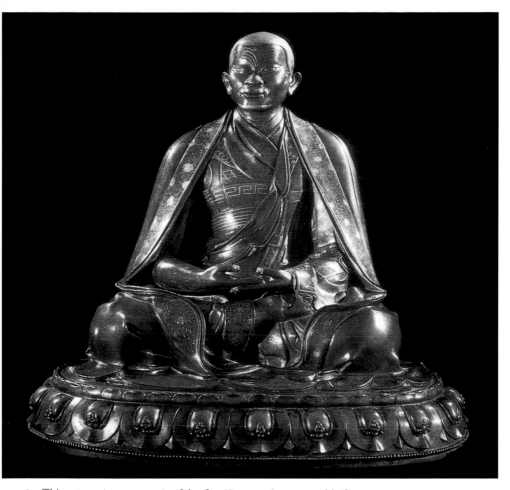

83 This extraordinary portrait of the first Karmapa Lama, possibly from eastern Tibet, embodies both the traditional idealized image and suggestions of a particular individual, the latter seen in details in the face – the nose, goatee and receding forehead – and the taut body expressing inner strength and control. 14th–15th century, Tibet. Brass with gold, silver and lapis lazuli inlay, h. 33 cm (13 in)

Buddhism, to a greater extent than in other Buddhist cultures, images of philosopher-teachers were one of the favourite subjects, with portraits of the major figures, such as the venerable Atisha, continuing to be an important part of the artistic tradition for centuries. Some portraits went so far as to elevate their human subjects to godly stature, presenting them seated and gesturing in the manner of Buddhas.

82

The portrait, like the rest of Buddhist art, was incorporated within the religious fabric of Tibet to a greater degree than in either China or India, Tibet's two primary artistic sources, and serves as another measure of comparison between the major Buddhist artistic traditions. The religious setting is retained in Tibetan paintings of historical figures, such as lamas, saints and kings, with the subject typically portrayed as if a deity, as the largest figure at the centre of the composition, surrounded by other, smaller religious figures. The oldest portraits, to judge from the limited number of paintings that remain from the early period, the second diffusion, had fewer figures surrounding the primary subject. By the fourteenth and fifteenth centuries, the host of supporting figures had increased in number, in a format that was followed whether the subject was a historical personage or a deity.

Portraits of the *mahasidda*s, and the mystical and eccentric teachers who have already reached the highest level of spiritual achievement, are among the favourite subjects, usually placed within a landscape setting without the usual surrounding religious figures. Two of the most beloved are the Indian Marpa and his disciple Milarepa. Marpa came to Tibet from India in the eleventh century and became one of the best known of the many religious figures influencing early Tibetan culture. Milarepa has long been especially venerated, for he was the first ordinary Tibetan to achieve such stature. As with most of the mystics and teachers, he is portrayed in a familiar manner, with gestures and attributes that recall popular aspects of his life. Milarepa's unique gesture, which immediately sets him apart from other images of mystics and yogis, is his right hand raised to his ear, likely a reference to his life amidst nature, listening to its message, as well as a reference to Tantric practices, where the instructions of the guru are transmitted orally.

84, 85

One of the most important categories is the image of a recently deceased hierarch, a major religious figure whose likeness could then be displayed in the monasteries he had frequented. According to the *Blue Annals*, an important early Tibetan text translated in the fifteenth century, when an esteemed lama died:

> At the time of the funeral rites, there appeared numerous sounds, lights, rainbows, as well as a quantity of images, letter signs, stupas and other relics....They also erected numerous images symbolizing the Body, Speech and Mind of the teacher at various big and small monasteries, where he used to stay and preach the Doctrine.

This practice is in line with that of other Buddhist cultures, such as China and Japan, where entire halls would be erected to house the image

84 Milarepa, 15th century, Tibet.
Solid terracotta, h. *c.* 18 cm
(*c.* 7 in)

of the founder. In Tibet, building upon the traditional, pre-Buddhist
esteem such religious figures were accorded, these images assumed the
level of an icon, not only worshipped but also believed to retain the
spirit, the sacred presence of the deceased. The devotee could approach
such a consecrated image and be in the spiritual presence of the individ-
ual depicted, receiving the same benefits as if in the presence of a living
master. As sectarian divisions grew, and with that competition among
orders, the personalities of founders and masters of an order assumed ever
greater importance, for integral to the success of individual monasteries
was their ability to provide evidence of proper lineage, of the legitimate
transmission of the dharma. More than one order, at least through the
fifteenth century, can be shown to have deliberately manipulated the
placement and choice of some of the historical individuals portrayed in
lineage paintings in order to establish and justify its position. As the
centuries passed, it remained imperative to reinforce the legitimacy of
the line of descent of an order as far back as possible. Arranged about
the borders of paintings of major deities and mandalas (which were not

portraits but religious icons) were small portraits of former lamas and founders, whose placement and identities repeated and reinforced that order's historical succession.

Wall paintings

The interior walls of Tibetan monasteries are remarkable for their elaborate paintings, that by covering entire walls transform those rooms into spiritual environments which surround and even overwhelm the worshipper with large, expressive displays of the many Buddhist worlds. The impact of these interiors is made all the more dramatic by the sudden contrast they present with the often barren, windswept Tibetan landscape outside. Many of the world's religious structures are designed to heighten the religious experience through visual effects, such as the overwhelming displays of gold of a Baroque church, the dramatic play of coloured light from stained-glass windows, or mosaic-covered walls. In the Asian world, there can be few more spiritually effective transitions than the dramatic experience upon entering a Tibetan monastery, where one is suddenly enclosed by rows of paintings and images that proclaim the space to be sacred, transporting the viewer into an otherworldly, transcendent environment.

Tibetan wall paintings are typically composed from a mixture of tempera and glue, prepared from boiled animal skins and applied with a brush. The paints are spread over a thin, white layer of priming, often made of gypsum with a binder of glue and starch, that covers a final layer of fine clay, sanded smooth with flat stones. The walls themselves, often consisting of clay bricks, are covered by a rough coating of loam mixed with straw, small stones and other organic material to resist cracking and help obtain a suitable bond, over which the clay and priming are applied. Two different techniques, borrowed from northern Indian methods, were usually followed in the painting of figures. Faces and areas of bare skin were given illusionistic dimensionality with shading and highlights, including the use of tiny dots and bands of solid colours to achieve three-dimensional effects, while the clothing was rendered as a contrasting, flat plane, often with detailed, rich, decorative patterns, but without the illusion of dimensionality. These methods remain in use into the present, as artists continually 'improve' existing walls with new paintings.

86

85 Milarepa, like Shakyamuni Buddha, resisted demonic temptations through his dedication and steadfast powers of meditation. In such paintings of Milarepa the demons are portrayed just as they are in images of Shakyamuni, running and gesturing in their futile efforts to break the master's concentration. Late 15th century, western Tibet. Tangka (detail), gouache on cotton, h. 130.8 cm (51.5 in)

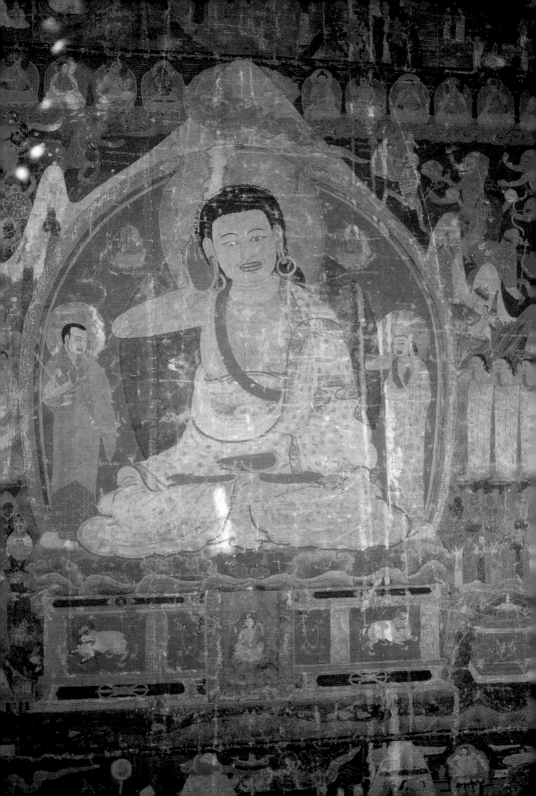

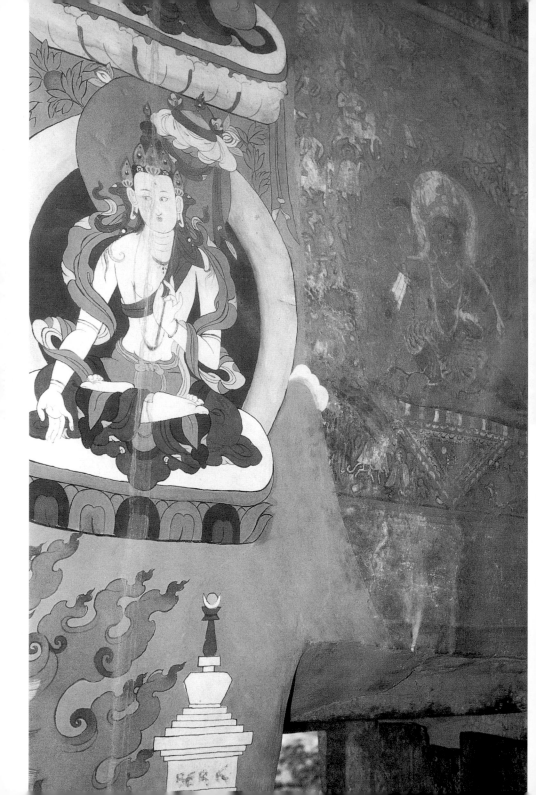

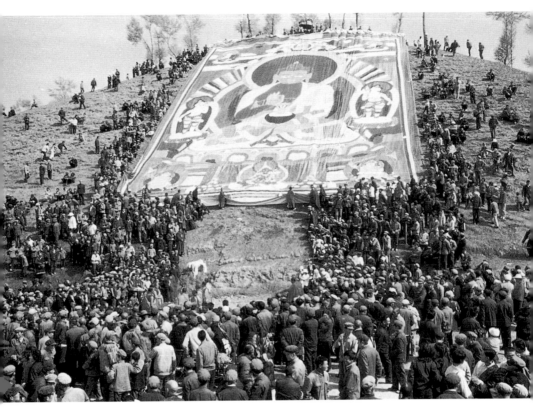

87 'Sunning' the Buddha, Kumbum, Xining, China

Tangkas

Tibetan paintings are best known in their portable form, the cloth hangings known as tangkas. Like wall paintings, tangkas function as intermediaries between the mortal and divine worlds. Religious paintings are consecrated, after which they are believed to be occupied by the deity they depict, thereby becoming an accurate reflection of the essence of that divinity. Tangkas repeat a visual formula, with few basic changes over time, for their purpose is to convey both the spiritual essence and the timeless presence of the deity portrayed.

Tangkas are vertical in format, in a size easily rolled up, most often about one-half to one and a half metres high, although huge tangkas for special ceremonies can require dozens of people to display them. Such
tangkas are actually appliquéd banners so enormous that they are visible

87

86 Old and new wall paintings at Alchi monastery, Ladakh

to thousands of worshippers and convey a special spiritual presence befitting their size. The fabric of a tangka is typically cotton, stretched within a wooden frame, with the outlines of the subject taken from a stencil, then filled in with colours and additional details.

The portability of rolled tangkas ensured their movement throughout the wide area of the Tibetan cultural sphere. For example, the cache of paintings found by Russian explorers at Khara Khoto early this century has a stylistic and technical diversity which suggests both local methods and methods imported from Tibet, the source of the dominant style of these paintings. Many of them were brought from Tibet across Central Asia and into the Chinese Xixia kingdom by pilgrims and merchants, but others undoubtedly originated there. A checked pattern in the weave of the cotton fabric of some tangkas has not been found within Tibet but does have an older history in Central Asian painting. It has been suggested that this may be more than just a regional technique; it may perhaps have been a special method reserved for important religious paintings.

Although some idea of the preliminary under-drawing can be seen in portions of tangkas where the paint has been eroded, a complete early drawing is rare. A masterful twelfth-century drawing of the goddess Ushnishavijaya, also an important document illustrating the influence of Pala style on the emerging Tibetan painting tradition, does display a skilful drawing technique. The two standing attendants in it are similar to the few remaining tangkas and wall paintings from the eleventh century, such as at Drathang, their swaying stances contrasting with the more iconic, frontal image of Ushnishavijaya. The subtle changes from that eastern Indian style of figure drawing towards a more Tibetan style can be seen by comparing the attendant figures in a thirteenth-century tangka of Amoghasiddhi. The figures in the later tangka are more precisely defined, more stylized, moving away from the sensual lines that define the attendants in the earlier drawing.

One of the most interesting variations in technique is represented by the so-called black paintings. The oldest examples of these have been dated to the second half of the seventeenth century, the time of the Fifth Dalai Lama. Their aesthetic power derives from the contrast of powerful lines against a black background, making them one of the most effective

88 Ushnishavijaya. This early, small finished drawing reveals an entire composition, unobscured by paint. The skilled drawing is enhanced by subtle washes of colour which accentuate the details of lotus petals, mandorlas and jewellery, while the bodies of the deities are defined solely by assured lines. 12th century, central Tibet. Ink and opaque watercolour on silk, h. 21.5 cm (8.5 in)

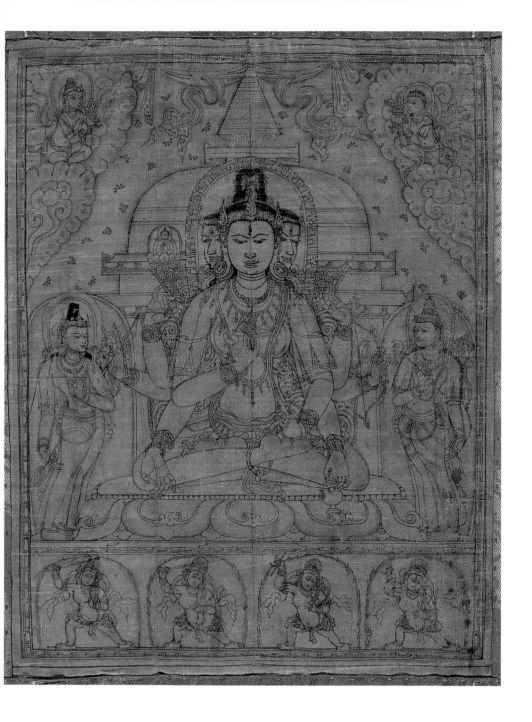

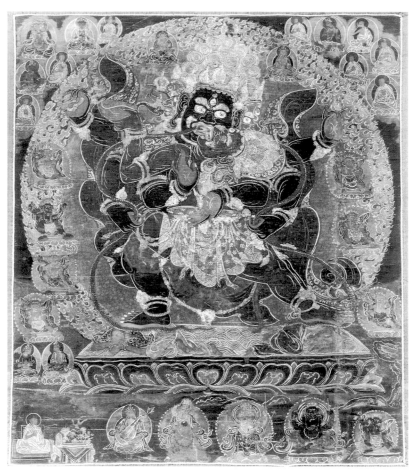

89 Vajrapani and consort, 18th century, Tibet. Tangka, gouache on cotton, h. 53.3 cm (21 in)

means to appreciate the Tibetan mastery of line work. There is a range of variations in the technique, beyond the boldness of gold lines over a black background, with large figures and settings and a variety of colours, and orange, flame haloes. Black paintings, a relatively late appearance in Tibetan art, have added yet another means by which Tibetan artists can conjure up visions of mysterious, transcendent worlds. Like the fierce

89 deities who are often the subject matter of these tangkas, the blackness signifies the darkness of hate and ignorance as well as the the role these qualities have to play in the awakening of clarity and truth.

Manuscripts, silk embroidery and religious furniture

Illuminated manuscripts and their decorated covers are also widely known. The earliest, from western Tibet and dated to the eleventh century, are fully in the Kashmiri style. Those created after the twelfth century share subjects and composition with tangkas, though on a smaller scale. Despite the introduction of paper from China, which allowed artists greater latitude in size and shape, manuscripts retained the format which had been imported from India, with the same long, narrow designs which had been required by bark or palm-leaf materials. Tibetans artists innovated only in the size, not the proportions of this formula. Later Tibetan manuscripts are typically twice the size of Pala examples, but the arrangement of lines of text divided by individual illustrations closely mirrors the Indian models, as do the richly saturated colours, decorative motifs, throne and style of the figures. The manuscripts were used in various monastic ceremonies, with each page read, or chanted, in succession. In addition, the books themselves were sacred, much like a consecrated image, in line with the great importance vested in the written word in

90 Ratnasambhava, 11th century, Tibet. Manuscript page, ink, watercolour and gold on paper, h. 9.2 cm (3.6 in)

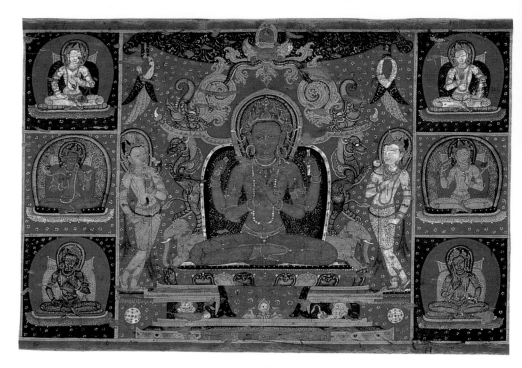

91 Prajnyaparamita, 13th century, Tibet. Manuscript cover painting, h. 26.7 cm (10.5 in)

Buddhism. Many are treated like ritual objects and kept in bookcases that form part of the main altar, adjacent to the most revered images.

92, 93 Silk, invented by the Chinese, was used in Tibet to create embroidered images of such fine detail that many seem at first glance to be paintings. The subject matter is usually Tibetan, and the technique and manufacture Chinese, although Tibetan manufacture of liturgical silks can be documented from at least the fifteenth century. Pillar inscriptions in Tibet, along with fragments of silk, indicate that Chinese exports were known as early as the Tang dynasty. From that time, Tibetans sought silks from China and from Central Asia and, later, from Japan, Persia and Europe. Silk was used for secular purposes as well as liturgical and was greatly prized by aristocracy and clergy alike. Fine silks were also among the objects sent to Tibet, along with the distinctive gilded bronzes, as gifts to esteemed lamas, especially during the early Ming (1368–1644) and Qing (1644–1912) periods, and are included in the body of works known today as Sino-Tibetan art (see pages 183–88). The uses found for silk

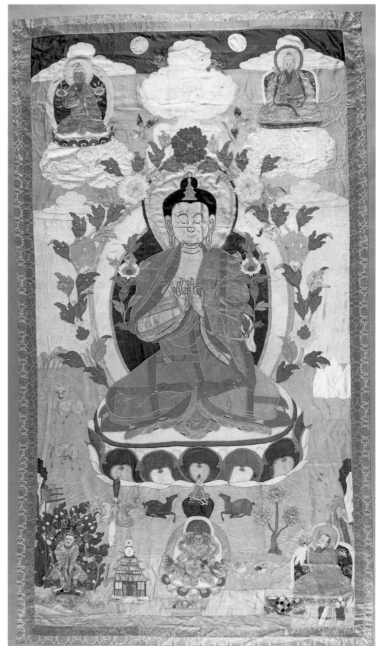

92 Maitreya (detail). This enormous silk tapestry of the future Buddha, clearly identified by the golden stupa on his head, includes a portrait of the seventh Dalai Lama in the upper right corner, and the inscription indicates that it was made during his lifetime. 18th century, Tibet. Silk embroidery, h. 343 cm (135 in)

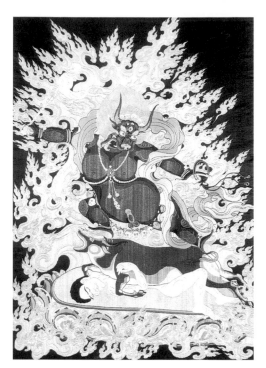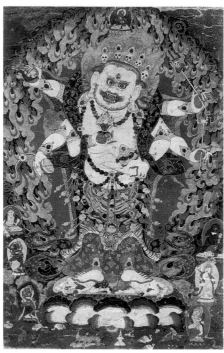

93, 94 The technical brilliance of silk embroidery can be seen by comparison of this 18th-century Sino-Tibetan tapestry of Yama Dharmapala (*left*), likely made in southern China, with a contemporary tangka painting of Mahakala. Despite the different method of manufacture, the colours and detail of the latter are scarcely more refined. *Left* Qianlong period, China. Silk embroidery, h. 66 cm (26 in). *Right* 17th century, eastern Tibet or Mongolia. Gouache on cotton, h. 59 cm (23.2 in)

varied widely, from articles of daily liturgical clothing to hangings and other decorations which were created for special events and then packed away. Narrow pillar banners and a variety of coverings for thrones and temple furniture were produced, as well as garments for monks, all of which maintained the demand for silk. Many such objects have found their way into collections in the West, and though hundreds of years old, often appear newly made.

In addition to silk embroidery, one of the most popular traditional crafts was appliqué, in which cut pieces were sewn on to a cloth background to create an image similar to a painting. Appliqué has a long history in Tibet as a method of decorating articles of daily need, including tents and domestic furnishings. Such refinements as stuffing portions with cotton batting to achieve a relief effect were originally Chinese

inventions, as were many of the other techniques of the craft which, like porcelain manufacture, long remained a closely-guarded Chinese monopoly, not mastered by other cultures for many centuries.

Tibetan religious furniture includes a range of wooden pieces, often brightly painted and carved, including tables, chests, and smaller stands and objects for the altar. Cabinets were constructed with scenes painted on large panels, often repeating those found on tangkas. The subject matter embraces wrathful figures and their insignia, although some cabinets and chests made in the last two hundred years are decorated with familiar Sino-Tibetan emblems, such as dragons, that have long been in use and retain little symbolic connection with their original purpose.

Sculpture
Examples of sculpture dating from the period of the early dharma kings (mid-seventh to mid-eighth century) are limited. They include some wooden reliefs, clay figures and stone lions. But with the exception of a few repainted clay images that remain at Kachu and in the Potala, they are highly derivative, with strong Nepalese and some Central Asian and Chinese influence, and provide little help in the study of later Tibetan

95 Altar table, probably 18th century, Tibet. Wood, h. *c.* 65 cm (25.6 in)

sculpture. The period of the second diffusion, beginning in the late tenth century and inspired by royal leadership and the arrival of Indian Buddhists, can be seen as the real beginning of what is known as Tibetan sculpture.

A great many Tibetan sculptures are called bronzes, but the label should be understood as a generic name for metal images; strictly, they are of brass and copper, which along with clay are the primary materials of Tibetan sculpture. Metallurgical testing indicates that roughly half of the so-called Tibetan bronzes are in fact made of brass, which is copper with zinc alloys. Bronze — copper alloyed with tin — has been found in only about 10 per cent of images tested, with slightly more found to be made of copper with both tin and zinc and relatively few trace elements, such as arsenic or nickel. Along with zinc, tin needed to be imported into Tibet; Afghanistan, China and Burma were the most likely sources.

Buddhist temples adorned with large stone carvings, a central feature of the Indian tradition, were almost unknown in Tibet, although there do exist some skilfully carved small stone images (see *ills* 99 and 100). Like Japan, Tibet did not develop a lithic tradition beyond modest levels, such as large, flat stone reliefs on monumental slabs of rock, though even these were typically produced without the skill found in other media. Likewise, with a few notable exceptions, woodcarving was generally reserved for architectural decor and ritual objects, a vast category whose demands resulted in the use of many materials ranging from gold and silver to butter, ashes and bone. The great number of stucco images suggests that the relative ease of working with clay, added to its greater availability than wood, made it the obvious choice for such three-dimensional images.

The technique of making unfired clay images, built up over a wooden armature or held in place against a wall by wooden pegs, is widely found across Buddhist Asia. At Bamiyan, in Afghanistan, the drapery of the colossal fifth-century Buddha images, the largest more than fifty metres tall, is held in place by such pegs, and images made entirely of clay built up over wooden and metal supports are widely known from Central Asia through China and Japan. About one third of the material used in Tibetan clay images is actually other substances, mainly paper. This served to reduce the weight and increase ease of working, for the material can be formed and built up, or forced into moulds. Details, such as jewellery, are made in wooden moulds and then applied to the figures. So fine is the workmanship that finished clay and metal images often appear identical. Moulds are also used for *tsa-tsas*, the countless flat, votive plaques, which are then painted and gilded like the statues.

96, 97

116

A high degree of realism is possible with painted clay statues, and major Tibetan temples such as the complex at Gyantse contain over seventy groups of sculptures. One of Tibet's most revered statues is a much-reconstructed clay image in the Potala of Songtsen Gampo, possibly dating from the seventh or eighth century. Many temples include rows of clay images of bodhisattvas mounted along the middle of the side walls of a shrine, positioned below paintings of deities of the highest celestial realms and above earthly, narrative scenes. The brightly painted clay figures are affixed to the wall with wooden pegs and surrounded by separate and slightly raised mandorlas. They are seated on lotus pedestals, that are also attached with pegs to the wall. Once painted, the faces of clay images differ little in appearance from those of painted and gilded

96, 97 Large, unfired clay images are rare; this well-preserved 15th-century *Vajravarahi* (*left*) may have originated from a Newari workshop. Although missing the two usual attributes, the skull cup and chopper, in details, pose and sheer presence it is the equal of the more numerous versions of this popular deity in metal (*right*). *Left* Tibet or Nepal. Unfired clay, painted, h. 102 cm (40 in). *Right* Early 14th century, central Tibet. Gilt copper, h. 28.6 cm (11.3 in)

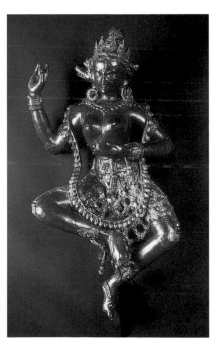
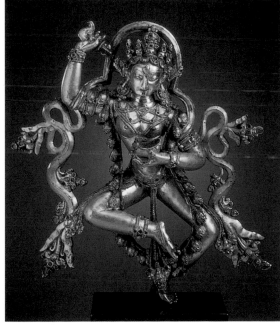

bronze figures, and examples of both are often grouped on altar plat-
forms. The elegant *tribhanga* posture, widely found among Nepalese
statues, in which the torso of a standing image forms a pronounced S-
curve, is typical among Tibetan metal images, but it is less often seen
among those made of clay, which generally remain stiff and frontal.

Most metal and clay images were portable, painted and gilded,
although large metal statues are mentioned in the literature and clay fig-
ures of colossal size do remain from the early period. The Indian practice
of joining sculpture into an overall architectural design, as seen at Ajanta
or among the temples of Indian-influenced cultures, such as Indonesia or
Cambodia, is seldom part of the Tibetan system. The wooden carvings
that surround the doorway of the Dukhang at Alchi, for example, are
similar to those of the Indian architectural tradition, but more the excep-
98 tion for Tibet. The large figure of Manjushri in the Sumtsek at Alchi is
one of three colossal images which, despite their size and importance, are
not integrated into the architectural scheme of the temple. They appear
to be uncomfortably wedged into the wooden structure, peering over a
supporting brace, as if trapped in their niches.

A limited number of small stone images have been attributed to
Tibetan artists, both in relief style, as in India, and fully carved in the
round, with some of the finest dated to around the thirteenth and four-
teenth century. One of the most impressive is of the popular deity
99 Mahakala, dated to 1292. It is thought to have been inspired by the work
of the famous Nepalese artist Anige (1245–1306) and commissioned by
the Mongols, for whom Mahakala was an especially revered deity.
100 Another black stone carving, of the god of good fortune, Jambhala, is
carved fully in the round. Like the Mahakala, it was originally painted,
but the fortuitous absence of the colour now reveals the brilliance of the
carving and its attention to minute details. Jambhala is another of the
deities borrowed from the Hindu pantheon, in this case from Kubera,
god of wealth. Both the Hindu Kubera and the Buddhist Jambhala are
portrayed as corpulent figures trampling upon the body of Vaishravana,
the guardian of the north and one of the favourite deities in Central Asia,
especially Khotan. Like Kubera, Jambhala holds a mongoose, which
spews jewels from its mouth. His ferocious face and the skull cup he
holds in his right hand give this example a particularly Tibetan flavour.

Very little Tibetan stone carving exists. Given the durable nature of the
material, this suggests that the medium played little part in the Tibetan

98 Manjushri, *c.* 1200, Alchi monastery, Sumtsek temple, Ladakh. Painted stucco

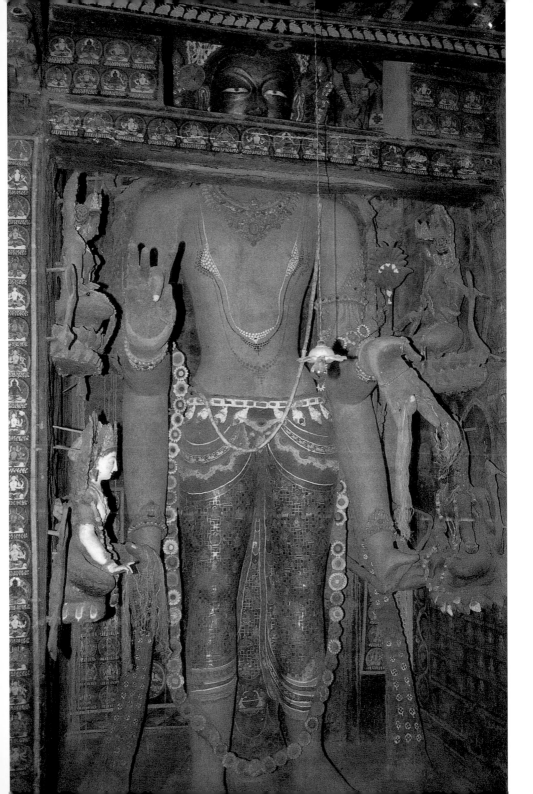

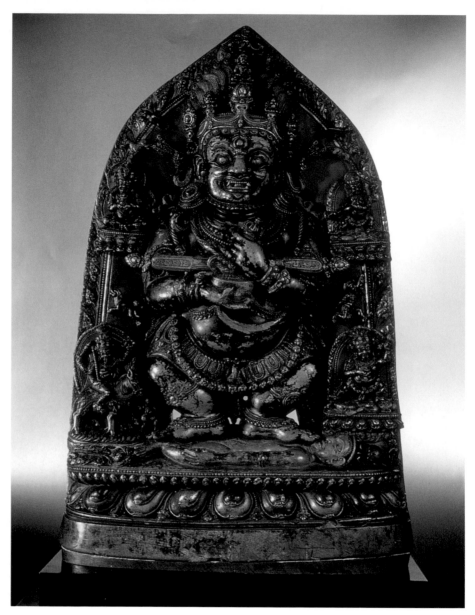

99 Mahakala. Areas of black stone are now visible, but originally the surface was gilded, against a background covered in red. Enormous power is conveyed, yet the details are rendered with great precision, from the flaming hair to the bone apron. 1292, attributed to school of Anige, Tibet. Stone, h. 48 cm (18.9 in)

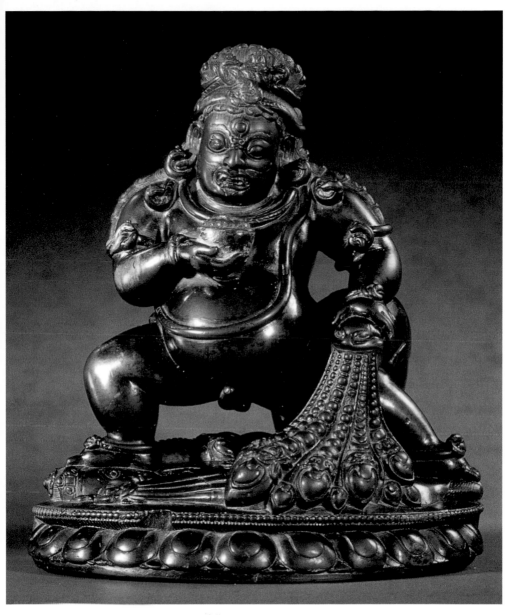

100 Jambhala. The detailed carving, fully in the round, is clearly visible as a result of the wearing away of the original paint. The stone itself likely derived from northeastern India, but the dynamic energy and style are typically Tibetan. 13th century, Tibet. Stone, h. 21 cm (8.3 in)

artistic tradition. The high standards exhibited by the few pieces that do remain, however, indicate that stone carving was in fact one more form of art at which Tibetan craftsmen did excel, although the scarcity of large and workable stone in Tibet certainly appears to have hindered the development of artistic expression. It is of interest that the small carvings illustrated here are made from a hard black stone; in the case of the statue of Jambhala (*ill.* 100), it may be the black chlorite found in the northeastern regions of India.

The majority of Tibetan metal images are hollow rather than solid cast. The technically more difficult hollow cast process, the 'lost wax method', was practised from ancient times in the Western classical world and across much of Asia. In this method, once the moulds have been broken to remove the image they cannot be reused, unlike a solid casting, in which moulds can be utilized several times. One of the lost wax methods followed in Tibet consists of building a clay model, covering it with thin layers of wax, then following that by an outer layer of clay. After the wax is melted out, molten metal is poured into the space between the clay model and the outer mould. Once cooled, the outer and inner clay layers are removed and the image is completed by careful chasing and finishing, which includes the cutting away or disguising of the chaplets that separated the two original layers of clay, the addition of any inlays that may be required and, finally, gilding.

Solid cast images were also made, although they too presented difficulties, first, requiring a far greater amount of metal and second, being harder to fashion with a hole, as was required by the Tibetan custom of inserting sacred objects into a consecrated image, though a space could also be reserved within solid cast objects by using a clay plug. Despite the technical difficulties of the method, most Tibetan images are cast in a single pour, often with the base included, rather than being assembled from pieces, although assembly methods did become increasingly necessary as images became larger. The relative softness of copper and the technique of hammered metal were well suited to assembly methods, which were widely practised, especially where Newari artists worked. The large mandorlas behind the images in many temples were often constructed in this way, with the images themselves made of individual pieces of beaten metal which, once joined and gilded, appeared the same as cast sculptures. The elaborate mandorla behind the eleventh-century, life-sized figure of Amoghasiddhi at Kyangphu, now destroyed, was likely made by this method.

There are two main techniques of gilding in traditional Tibetan craft. In a delicate process known as fire gilding, involving gold and mercury,

118

101 Butter sculpture, Thiktse
monastery, Ladakh

the metal to be gilded is first covered with mercury and then carefully 102
heated to evaporate the mercury. This process prepares the metal to bond
with the gold, which is often applied as a paste. The whole is then care-
fully heated again and the gold adheres to the metal as the remaining
mercury evaporates. If only limited areas are to be gilded, such as the face,
gold paint is generally used, a process known as cold gilding, although
entire figures may also be painted in this fashion. Most of these tech-
niques were learned from and perpetuated by Newari artists, for the
tradition of casting and gilding metal images was long established in
Nepal, where it continues to flourish today. Typically, the backs of metal
images from western Tibet are only roughly finished, whereas those from
the central and eastern regions are fully detailed.

102 Seated lama. This portrait, with the entire figure fire gilded, also reveals another favourite technique for ritual objects, that of inlays. The separate, ungilded base is set with semi-precious stones. 15th century or earlier, Tibet. Gilt bronze, h. 18 cm (7.1 in)

Many of the objects better known in bronze were also carved in wood, such as the ubiquitous *phurpa*, the mystical ceremonial dagger. The substitution of a lesser material for a more precious one, such as replacing gold with a less expensive metal, can be traced through most cultures. In the case of Tibet, some unusual materials were used, such as butter for sculptures. In some situations, as with a sand mandala, the skill required by the 'simpler' medium was even greater than for the original, more costly, version, and the efficacy accorded the finished product was correspondingly superior.

The Development of Tibetan Styles (11th–14th Centuries)

The diverse sources which inspired early Tibetan art, growing along with the establishment of the Buddhist religion by the end of the tenth century, remained prominent during the next three centuries, throughout most of the period known as the second diffusion. The artistic styles of northeastern India, Nepal, and the Kashmiri, Central Asian and Chinese areas continued to reach Tibet and to influence Tibetan artists. As a result, there there are very often no ready solutions to questions of origin, especially of works created during the eleventh and twelfth centuries. Newari craftsmen worked in Tibet, and at the same time Tibetan pilgrims carried back objects they had commissioned in Nepal. The pilgrimage sites of the Pala lands of northeastern India continued to provide images to devotees, and the growing demand for Buddhist objects within Tibet created a job market for many of those same craftsmen, and also for Central Asian and Chinese artists as well. Adding to this artistic activity were the Tibetans themselves, many of them learning their craft from this array of foreign masters. It is little wonder that scholars have been both intrigued and frustrated by what has been described as a style with more convolutions than a Byzantine court intrigue.

It was not until near the end of the tenth century that a clear direction for Tibetan history began to develop. The earlier formation of a ruling monarchy and the introduction of Buddhism into the area had generated a backlash, a persecution that delayed the development of monasteries and orders until near the end of the millennium. The goals and achievements of Tibet's first great king, Songtsen Gampo, in the seventh century, as well as those of the pioneering Indian masters of the following century, Padma Sambhava and Shantarakshita, were not fulfilled until the era of persecutions ended, late in the ninth century. The name given to the period of the Tibetan renaissance that followed, from the end of the tenth and into the fourteenth century – the second diffusion – defines both the end of an era of religious disorder and the establishment of Buddhism as the Tibetan faith, although competition among the orders themselves would continue. The events of this period, which shaped much of the subsequent history of Tibet, occurred principally in two areas: the central

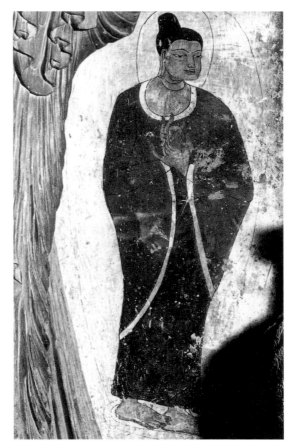

103 Buddha, 11th century, Yemar (Iwang) monastery,
Tibet. Wall painting (destroyed)

and southern regions of Ü and Tsang; and western Tibet, under the rule
of the Guge kings.

During the early eleventh century, two masters were especially influ-
ential in propagating the Buddhist religion and establishing it in Tibetan
culture. One was Atisha, the most influential of the gurus invited from
eastern India, and the other was the Tibetan Rinchen Sangpo, sent by the
western Tibetan king Yeshe Od to study in India. His several trips, three
to Kashmir and at least one to northeastern India, filled seventeen years
and resulted in the founding of numbers of temples in western Tibet.
The continuing motivation to seek inspiration from the homeland of
Buddhism was in part prompted by the preceding era of persecutions,

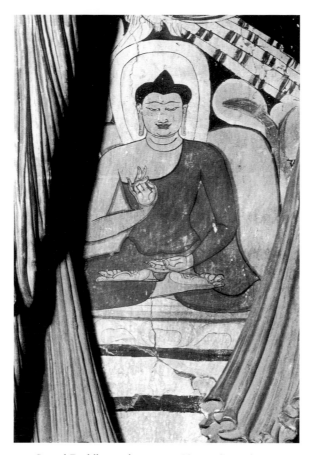

104 Seated Buddha, 11th century, Yemar (Iwang) monastery, Tibet. Wall painting (destroyed)

but also echoed the ambition of Songtsen Gampo back in the seventh century to build a kingdom around the Buddhist faith by seeking the inspiration and leadership of masters from India. Along with the religious guidance provided by such masters came artistic styles, and the development of early Tibetan art evolved primarily from two sources, the Pala kingdom of eastern India, which included the art of neighbouring Nepal, and the Kashmiri region to the west. The impact of the Chinese artistic tradition was to become more evident during the latter half of the second diffusion, beginning with the rise of Mongol influence during the thirteenth century, another foreign tradition that had even greater impact upon China's history than on Tibet's.

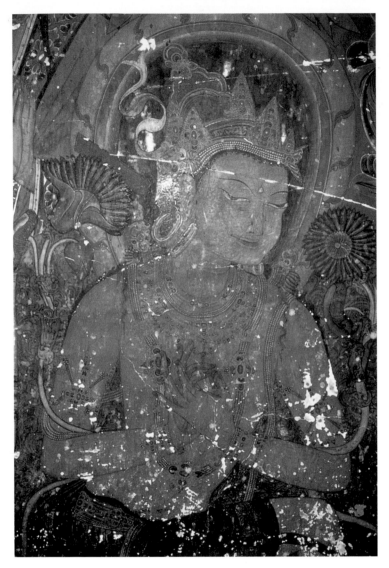

105 Manjushri (detail). Many of the decorative patterns are similar to Central Asian motifs, seen also in clay figures from Kyangphu of about the same date (*ill.* 118). The mythical animals, thrones, floral medallions and various patterned backgrounds are also well documented among the less perishable metal sculptures from the same period. 12th century, Drathang, Tibet. Wall painting

106 This portrait of a lama repeats, though in a provincial manner, such familiar central Tibetan motifs as the back-to-back mythical animals and decorative floral designs flanking the throne. The subject himself may well be a Tibetan. Late 12th century, Khara Khoto, Central Asia. Tangka, gouache on cotton, h.38 cm (15 in)

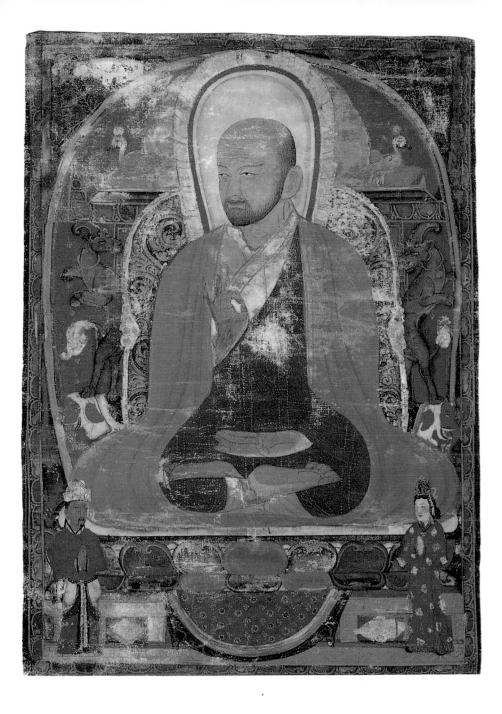

Very little remains of the monuments of this early period. Entire monastic establishments, along with their wall paintings and sculptures, were destroyed during the decade of China's cultural revolution, which ended in 1976. Recent publications have chronicled what does remain, mainly at Shalu and Drathang monasteries, the early sites with the best-preserved paintings still extant; for the others, such as the stunning eleventh-century sculptures at Yemar (also known as Iwang), little more than Tucci's black-and-white photographs remain of what had been one of Tibet's richest displays of early art. Even the early western Guge sites, such as Tholing and Tabo, were not spared, and despite the Chinese rebuilding programmes, nothing can replace what has been destroyed. Ironically, portable bronze sculptures have been coming out of Tibet in great numbers during the past forty years, most finding their way into collections in the West. Among them are many originally produced in eastern and northwestern India, areas which once suffered their own periods of artistic destruction; preserved for centuries in Tibet, those images have been carried back once again, by fleeing Tibetan refugees.

There is a basic formula to the buildings of early Tibetan monastic establishments, whatever the specific regional style, such as the mandala-like plan followed at Samye and at Tholing. This reliance upon symmetry, which is repeated in portrayals of the Buddhist cosmological vision of the universe, is carried out from the largest scale, the monastery itself, to individual buildings and paintings, to visions of the mythical paradise of Shambhala. This Buddhist view of the cosmos is repeated within individual structures, such as the Sumtsek temple at Alchi, whose three floors appear to carry the formula of the worlds vertically, the lower levels portraying aspects of the mundane world and the upper floors illustrating celestial realms.

Although the art of the early part of the second diffusion is formed by its outside sources, the developing Tibetan style was exported as well. The best preserved of the Pala-inspired wall paintings at Drathang and Shalu share stylistic features with paintings from Central Asian sites, including the caves at Dunhuang. Many of the Tibetan paintings, including the now lost murals at Yemar, are similar to twelfth-century examples found at Khara Khoto, an active artistic centre of the Central Asian Xixia kingdom which was composed of the Tangut and a variety of other peoples but culturally highly influenced by Tibetans. It was destroyed by the Mongols in 1227, but a cache of paintings was rediscovered by Russian explorers early in the twentieth century.

By the end of the eleventh century a relatively small area of central and southern Tibet, while absorbing influences from older traditions, also

105

103, 104
106

107 Minor deities, 11th century, Kyangphu monastery, Tibet. Stucco (destroyed)

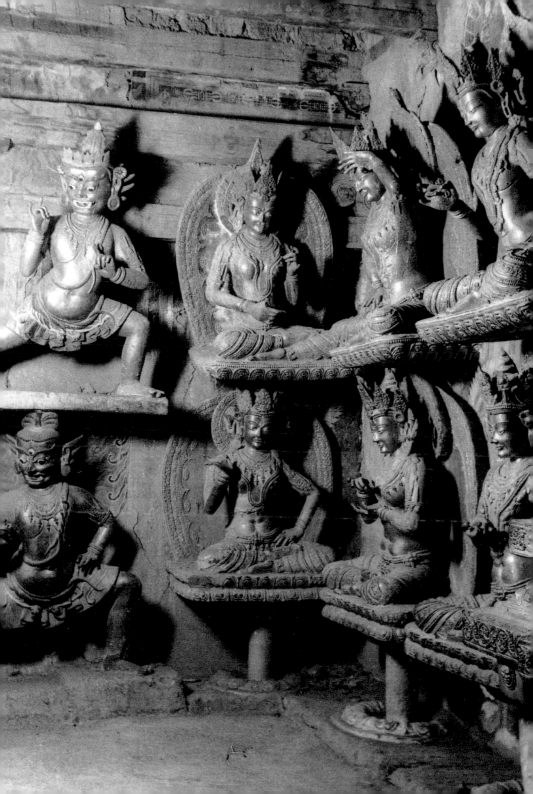

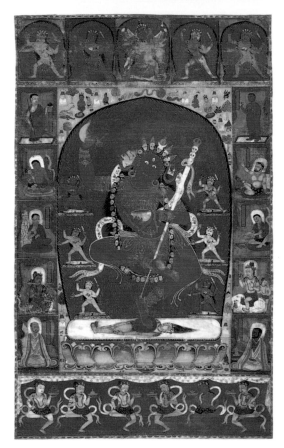

108 (*left*) This powerful, late 12th-century tangka of Vajravarahi, the personification of female energy and one of the most popular subjects in Tibetan art, is very much in the central Tibetan style, with the surrounding *mahasiddhas*, lamas, guardians and other deities arranged with the colours and symmetry of mandalas. Khara Khoto, Central Asia. Gouache on cotton, h. 38 cm (15 in)

109 (*right*) Tara. The similarities are remarkable between this Pala image and Tibetan art of a century or two later. 10th century, India, Pala kingdom. Bronze, h. 33 cm (13 in)

110 (*far right*) Green Tara. One of the best-known tangkas, so close in style to Pala imagery that its origin is an open question, and a critical early document of Tibetan art. It includes an early example of a bodhisattva as the primary subject and a figure that is likely Atisha – Tara is his tutelary bodhisattva – just above the arched shrine. 12th century, Tibet or Pala kingdom, India. Gouache on cotton, h. 122.5 cm (48.2 in)

exported its own artistic style to distant areas such as the Xixia kingdom. Well-established motifs, such as stylized mountains and Indo-Nepalese decorative subjects, along with deities of the Tibetan pantheon portrayed in their symmetrical harmony, are found in the Khara Khoto paintings. These surviving paintings provide an important document to augment the limited remains in Tibet itself.

108

INFLUENCE OF THE PALA AND NEPALESE TRADITIONS: CENTRAL TIBET

Atisha's homeland, the Pala kingdom, was the dominant early influence on the developing art of central Tibet, although the trading activity in and through this region ensured Nepalese, Chinese and Central Asian

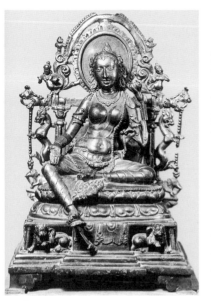

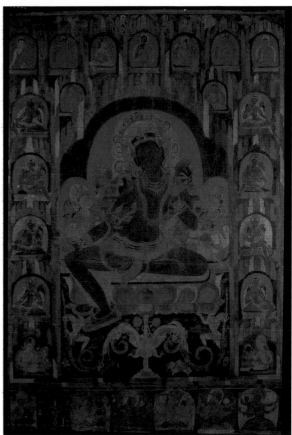

influences as well. Well before the eleventh century, Tibetans had been returning from their pilgrimages to the Pala region with votive objects that inspired local artisans, and the subsequent growth of Tibetan Buddhism attracted Pala artists to Tibet as well. Numbers of Pala and Kashmiri metal sculptures yet remain in major Tibetan temples, brought back from those primary sources of early Tibetan art.

The traffic between the two areas, inspired by the ongoing Tibetan interest in the Buddhist homeland and pilgrimage sites, ensured not only that Pala influence appeared early in central Tibet, but that many works from the two areas would be nearly identical in style. So complex are issues of attribution that several works of the eleventh and twelfth centuries have been assigned to both Pala artists and to Tibetan artists influenced by the Pala school, demonstrating the similarities between early

109, 110

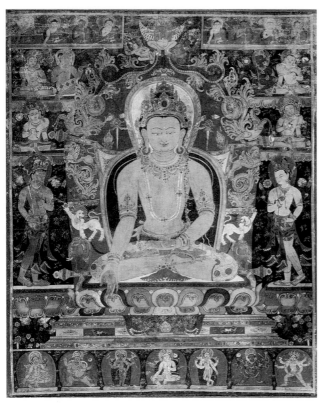

111, 112 These two images, one possibly the earliest known Nepalese painting on cloth (*left*), the other a tangka from Tibet but so close in style that it has also been attributed to Nepal (*right*), demonstrate the similarities between the early art of Tibet and adjacent areas. The paintings' meticulous details, fine line work, lively animals, decorative motifs and warm colours are among the finest in the Indo-Nepalese and early Tibetan style.
Left Ratnasambhava and acolytes, 12th century, Nepal. Gouache on cotton, h. 41 cm (16.1 in). *Right* Green Tara, early 13th century, Tibet. Gouache on cotton, h. 51 cm (20 in)

Tibetan art and objects from adjacent areas. There are Tibetan inscriptions on some ninth-century paintings found at Dunhuang, and in style these paintings are more similar to those from other Central Asian sites, such as Khotan, and to fragmentary remains from Tibet, than to the majority of Chinese-derived works from Dunhuang. The active commercial trade and sporadic military activity in these areas during the ninth century ensured that artistic exchanges would continue.

111, 112 Nepalese art served as both a conduit and a direct influence on the Pala-derived art which appeared in Tibet, and along with Pala art, Nepalese works can be readily cited as the model for many Tibetan paintings and sculptures from the early period. The close similarities between the wall paintings at Yemar and contemporary manuscript paintings from the Pala kingdom have often been noted. The best-preserved wall paintings are found at Drathang monastery; their style indicates their Pala sources and their relationship to the rest of early Tibetan art. Along with records from other central Tibetan sites such as

134

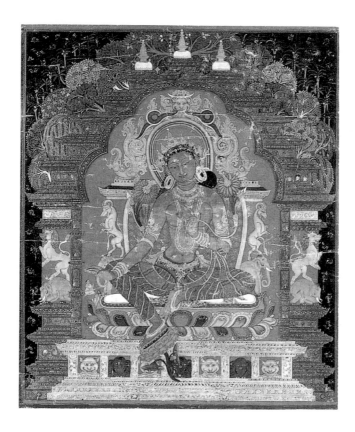

Ycmar and the fragments in the Jokhang, the Drathang murals primarily reflect the inspiration of the Pala schools, including a similar use of shading, although details of dress and racial types indicate additional sources, especially Nepal.

One of the prominent elements of the Indo-Nepalese tradition is a distinct decorative vocabulary, aspects of which continued essentially unchanged in the early art of Tibet. Among the most familiar is the *makara*, the mythical elephant-trunked crocodilian. As a symbol of auspiciousness, the *makara* enjoyed a long history in Indic cultures, ranging from its use as a purely decorative element to its function as the vehicle of the major river goddess Ganga. Typical examples can be found in both of the tangkas illustrated above – one Nepalese, one Tibetan – and often in sculptures, such as a bronze *makara* of exquisite refinement which was likely once part of an elaborate throne setting for a major deity. 113 Examples of such widely used Indo-Nepalese decorative motifs continue to appear, little changed, after the establishment of the fully developed

113, 114 The *makara*, a
mythical creature with
a crocodile body and
elephant trunk, derived
from Indo-Nepalese
sources. The foliate tail
was also used for other
animals, such as the paired
geese at either end of this
manuscript cover (*below*).
Left *Makara*, 13th century,
Nepal. Gilt copper,
h. 38.6 cm (15.2 in).
Below Bookcover,
12th century, Tibet.
Wood, painted and gilded,
l. 74 cm (29 in)

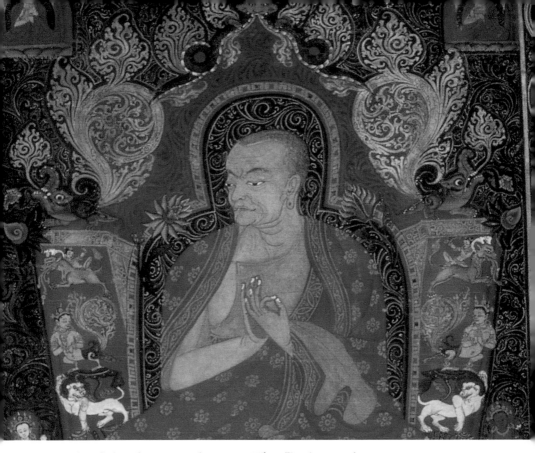

115 Unidentified teacher. Late 15th century, Tibet. Tangka, gouache on cotton, h. 37.6 cm (14.8 in)

Tibetan style. They remain in fifteenth-century paintings, and although 115 Chinese elements are evident by that time, especially in the palette and the foliate background patterns, most of the animal and decorative motifs are part of this earlier vocabulary.

Very little sculpture remains from before the eleventh century. There are some relief carvings on the bases and capitals of early wooden pillars within the Jokhang in Lhasa, and some clay statues at Kachu, although all are heavily overpainted. The best known of the early works, due in part to its location in the Potala, is the portrait statue of King Songtsen Gampo, reconstructed and often repainted, but thought to have been first completed in the seventh or eighth century.

116 Minor deities,
11th century, Kyangphu
monastery, Tibet. Stucco
(destroyed)

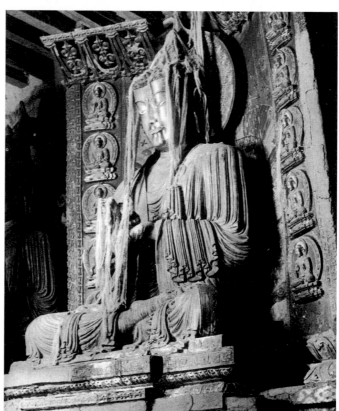

117 Buddha, 11th century,
Yemar (Iwang) monastery,
Tibet. Stucco with gold

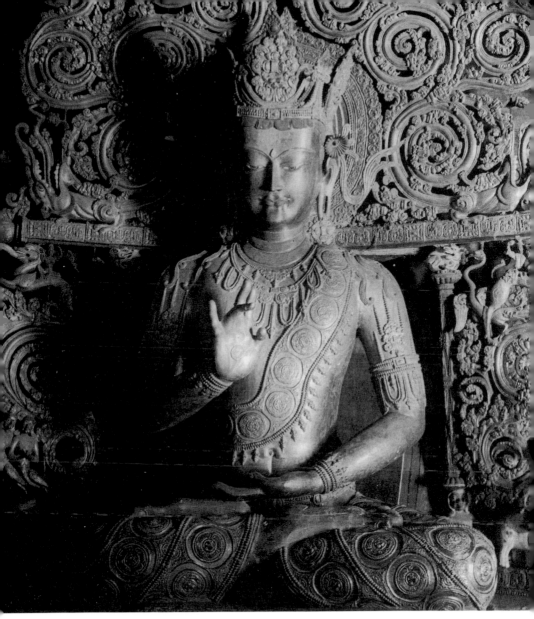

118 Amoghasiddhi. The Indo-Nepalese and Central Asian decorative motifs of the carved mandorla and the roundels on the garments are testimony to the varied stylistic influences on the early art of central Tibet. The delicate right hand of Amoghasiddhi forms one of the most exquisite examples of a *mudra* in all of Tibetan art. The entire stucco figure, including the richly carved mandorla behind it, was originally covered with gold. 11th century, Kyangphu, Tibet (destroyed)

Beginning with works from the early eleventh century, it is possible to begin to study a cross-section of early Tibetan art, a corpus of material that includes remains from the western regions as well. The finest assemblage of eleventh-century sculptures remaining in central Tibet, although now badly damaged, is the clay images at Yemar. Included among them are life-sized figures of the Five Tathagatas and a host of minor deities, best appreciated from photographs taken over sixty years ago. The similarities with Central Asian art have often been noted, especially the linear treatment of the faces and the method of portraying the layers of pleated garments, a technique seen in ninth-century paintings from Turfan. This particular mode of representation of stylized garments had a long history in East Asian art, dating back to at least the sixth century, and its appearance in Tibet five centuries later is not surprising. The early Tibetan activity in Central Asia, along with the well-documented activities of Khotanese monks in Tibet, indicates a likely source, rather than the more speculative connections with the Xixia kingdom of Khara Khoto.

Less than a century later at Kyangphu, another temple was filled with similar clay statues, even greater in number and including a remarkable tableau illustrating the temptation of Shakyamuni shortly before his transformative enlightenment. The array of creatures threatening and gesturing in their futile effort to dislodge the Buddha from his meditation recall Gandharan carvings of a thousand years before, but such sculptural energy, approaching the vivid textual descriptions of the event, is rarely encountered. Unfortunately, this entire body of sculpture has been destroyed and only remains in photographs. The brilliance of this early twelfth-century art is readily visible in Amoghasiddhi, one of the five life-size figures of the Tathagatas. Despite the nearly total loss of sculpture from before the twelfth century, the evidence indicates Tibetan artistic achievements of considerable skill, as well as the assimilation of foreign influences, pointing towards what would ultimately become a coherent Tibetan style.

The Pala and Nepalese styles were not quickly, or universally, replaced. The decorative motifs, stylized flames and vibrant colours, even the selection of particular deities, continued to be significant in Tibetan art. One of the best examples is the theme of Shamvara, known more fully as Paramasukha (Supreme Bliss) Chakrasamvara (Wheel Integration), and a subject found in Tibetan imagery at least as early as the twelfth century. Such images of paired figures in ecstatic union represent the highest goal, the joining of compassion (male) and wisdom (female). This subject poses a major challenge for the artist: the expression of the highest of ideals through the vehicle of the most fundamental action of human

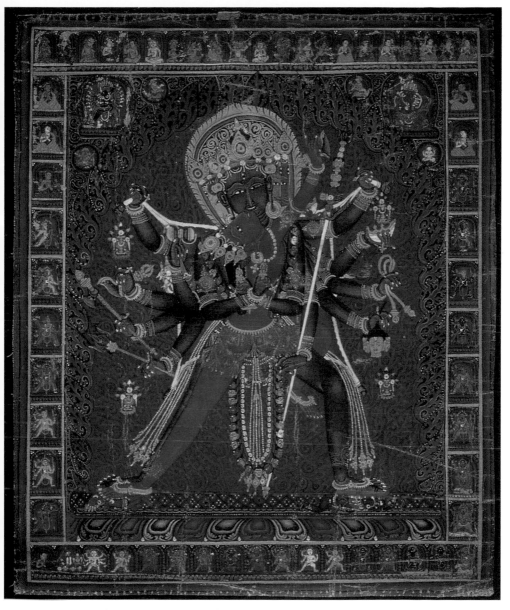

119 Chakrasamvara and consort. Were it not for the identities of the surrounding Tibetan monks and the lineage figures, the completely Nepalese style evident in the angular, primary pair and the vivid colours, including the bright red flaming nimbus, would be convincing evidence that this is a Nepalese work. 1450–1500, central Tibet. Tangka, gouache on cotton, h. 40.6 cm (16 in)

passion. The paintings of this subject are complex displays of a multi-armed central pair surrounded by a host of deities, lamas and protectors, often in vibrant colours that mirror the energy of the action portrayed.

INFLUENCE OF THE KASHMIRI TRADITION: WESTERN TIBET AND LADAKH

At the same time that Tibet's renaissance was occurring in the central areas, a slightly earlier, parallel development took place in the western region, an area crossed by the trade routes connecting the Kashmir-Ladakh region with the cities of the Silk Road, especially Khotan and Kashgar. The dominant kingdom in this area was Guge, whose late tenth-century king Yeshe Od was one of Tibet's great patrons of Buddhism; it was one of the two major centres of early monastic activity, along with central Tibet. As with the early material from central Tibet, most of the art created in the western region during this period has confounded attempts at a consistent arrangement by schools or by monastic orders, but stylistic comparisons show Indian models from the Kashmiri area clearly to be the primary source both for the earliest work and for the evolving Guge style.

The Kashmir region and also the Himalayan areas of Gandhara, Gilgit and Uddiyana, today in northern Pakistan, have a long history of Buddhist activity, including some of the earliest Buddhist images known. The area was never visited by the historical Shakyamuni Buddha, who lived within the Gangetic plain, but it was nevertheless considered a sacred region, containing many pilgrimage sites which were believed to have been visited during the Buddha's earlier incarnations and thus considered hallowed locations. Bronze images in the Kashmiri style con-
120 tinue the earlier influence of Gandhara, in an elegant blend of Gandharan naturalism and Indian medieval style. Similar characteristics are also found among images less directly associated with Kashmir, such as a well-
121 known Tibetan Vajrapani. The stylistic parallels between such pieces remain intriguing, leading to continuous reattributions to one region or the other. The near total absence of dated works and the destruction visited upon the monasteries of western Tibet ensures that questions of provenance and influence will continue, but what is most significant for the study of eleventh- and twelfth-century western Tibetan art is the continuing presence of Kashmiri elements, as also in the art of subsequent centuries, alongside the emerging Tibetan style.

The revival of Buddhism in western Tibet is synonymous with the efforts of the great king Yeshe Od and the two key religious figures

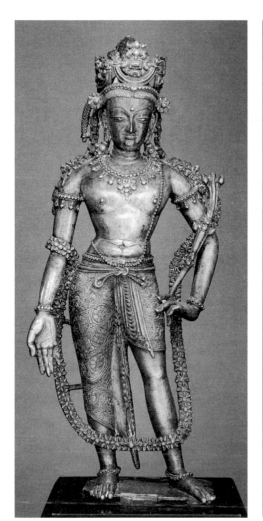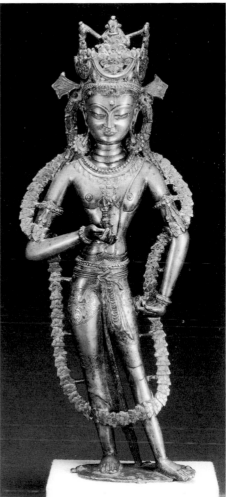

120, 121 The many similarities between the Kashmiri and early Tibetan styles can be seen in the elaborate crowns, facial treatment, decorative garments and looping garlands of these two bodhisattvas. But the abstraction and stylization of the Tibetan Vajrapani (*right*) distinguishes it from the greater naturalism of other figure, which is closer to the mature Kashmiri style, though it may have been made in Tibet, possibly by Kashmiri artists. *Left* Early 11th century, brass with inlays of silver and copper, h. 69.2 cm (27.2 in). *Right c.* 11th century, bronze, h. 69.3 cm (27.3 in)

Rinchen Sangpo and Atisha. Atisha stayed in Guge for just three years and then travelled to central Tibet, having an enormous impact in both regions. He was likely the most celebrated religious figure in India at the time, and he came to be revered as Tibet's greatest early spiritual leader. It may have been his prestigious example that shaped subsequent practices, rather than close adherence to his teachings, which were rather conservative and traditional.

Rinchen Sangpo not only made monumental translations and commentaries, he also brought back to Tibet more than twenty-five artists and artisans from his travels in northeastern India and Kashmir, thus ensuring the importance of the Kashmiri tradition in Tibet, and coincidentally perpetuating a style of art being destroyed within Kashmir due to Muslim conquests. The large number of early images of Vairochana in western Tibet is likely a consequence of Rinchen Sangpo's influence, for his translations of Vairochana texts helped establish a theme in Guge monasteries that is still evident among the statues and paintings at Tholing and Tabo. The Kashmiri forms of wooden architecture, such as the lantern roofs, styles of stupas, and palace and temple designs, as well as sculpture and painting styles which repeat Kashmiri fashions of dress, can all be found in the early art of western Tibet. A number of eleventh-century manuscript pages, the earliest from Tibet, which were recovered

122 Vairochana, 11th century, Tibet. Manuscript page, ink, watercolour and gold on paper, h. 9.8 cm (3.9 in)

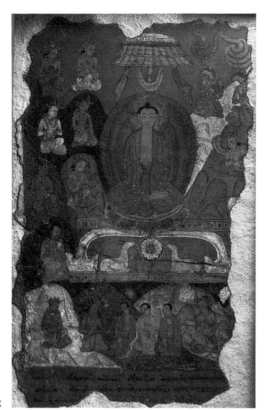

123 The Buddha's first sermon (detail). The relative absence of details in this painting can be attributed to the subject, a narrative scene; devotional images such as celestial Buddhas would necessarily include more deities and symbols. This work retains the figural style found among 11th-century manuscript paintings. 15–16th century, Luk monastery, western Tibet. Mural painting

by Tucci at Tholing, provide the best example of the painting style that inspired the long Guge tradition of western Tibet. Fragments of later wall paintings also brought out by Tucci still retain the elongated proportions seen in the paintings from the Guge monasteries of centuries before, illustrating the long continuity of the Kashmiri influence. Studies, as yet incomplete because of the sensitive geopolitical situation in this Indo-Chinese region, indicate that the early developments in western Tibet were separate from the sequence of stylistic development in central Tibet and also of exceptional quality.

122, 123

Tholing and Tabo were the most important early monastic establishments in the Guge kingdom. Recent studies have added other sites, including groups of caves at Dungkar and Piyar, where remarkable twelfth-century wall paintings, in a Kashmiri-Central Asian style, also include stylistic features found among wall paintings along the northern Silk Road, at Kizil. One of the most remarkable parallels between

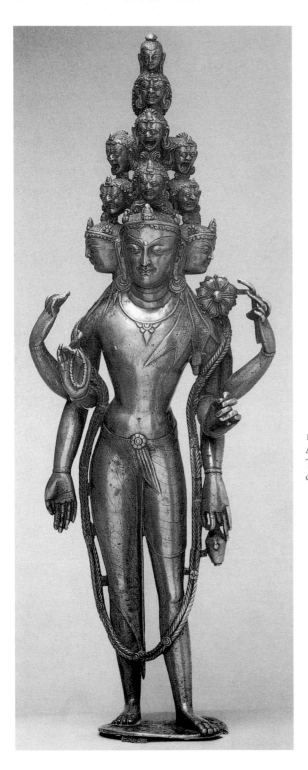

124 Eleven-headed, six-armed
Avalokiteshvara, c. 1000, western
Tibet or Kashmir. Brass with inlays of
copper and silver, h. 39.4 cm (15.5 in)

125 Alchi monastery complex, Ladakh

Kashmiri and western Tibetan art has been discovered in the wall paintings in the Dungkar caves. One painting is a nearly perfect match with one of the greatest bronze sculptures long thought to be of Kashmiri origin, the well-known eleven-faced, six-armed Avalokiteshvara, of about 1000 AD, now in the Cleveland Museum. The early twelfth-century Guge wall painting so closely matches the sculpture that the bronze itself is now thought to have been made in western Tibet, but likely by a Kashmiri artist. 124

The most extensive, and best-preserved paintings of this period of western Tibetan art are the remarkable wall paintings in the Sumtsek temple in the Alchi monastery complex, completed around 1200. Although smaller than the great monastery at Tholing, Alchi is the best preserved of the period's sites, and it provides an opportunity not only to study aspects of the artistic style, but to experience the milieu of an early Tibetan monastery. 125

147

126-129 These details from
the remarkably well-preserved
Sumtsek, at Alchi, capture the
visual richness of a Tibetan
temple. Nearly all wall and
ceiling surfaces are covered
with detailed line work and
rich colours, with clay images
projecting from niches on three
of the four walls. The subjects
of the paintings include textile
patterns, seen upon the ceilings
(*right*), architectural details
painted upon the garments
of the large bodhisattvas
(*below left*), large areas of the
walls that replicate illuminated
manuscripts (*below right*) and
vividly painted sculptures
(*opposite*). *c.* 1200, Ladakh

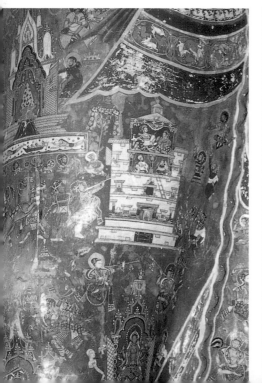

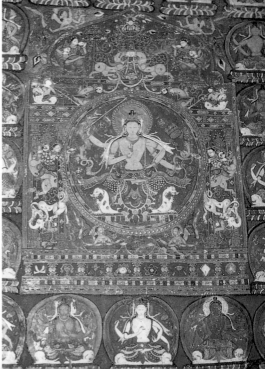

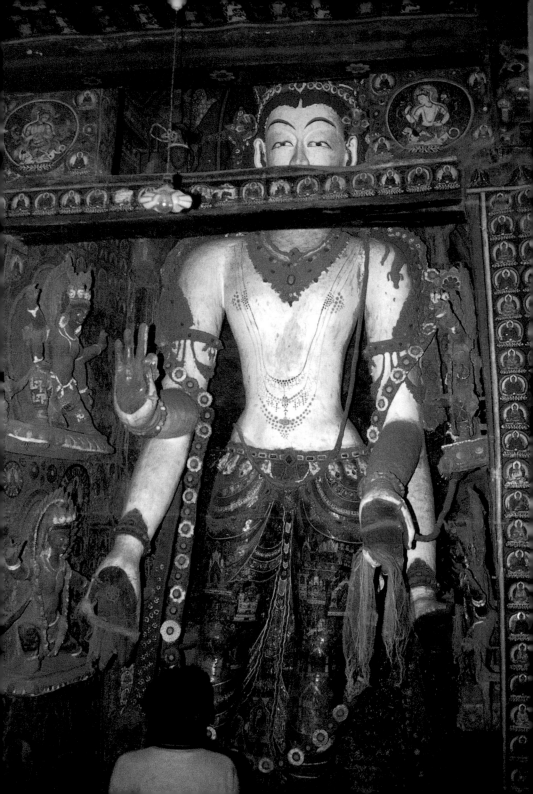

The Sumtsek, meaning 'three storeys', is the primary structure at Alchi, which is a small cluster of five buildings and two 'entrance' *chorten*s.

126–29 All the walls and ceilings of the Sumtsek are covered with paintings and sculptures, and the building is constructed around an atrium, which means the centre of the second floor is open. This opening allows a good view into the second floor, and most of the centre of the ground floor is occupied by a large *chorten*. The third level is simply a raised, square tower without a floor, and its wall paintings are only partially visible from the ground through the atrium, and from the floor of the second level. The roofs are flat and the façade is decorated with wood carvings in the Kashmiri style.

Colossal clay images of Avalokiteshvara, Manjushri and Maitreya occupy three of the walls of the ground floor. Each of these statues wears a traditional Indian lower garment, a dhoti, covered with paintings,

45 such as the images of the eighty-four *mahasiddha*s on the dhoti of Manjushri, or various portraits and architectural details on the statue of Avalokiteshvara. Numerous clay statues are affixed to the walls which enclose the three large figures, and the remaining walls and ceilings are covered with paintings of a variety of subjects, including royal portraits, bodhisattvas and other deities, with remarkable details of Kashmiri dress, textiles and architecture documenting a tradition almost entirely destroyed in its land of origin. The structure suffers from the elements, especially rain, and the original work also succumbs to continuing painting and repainting since some of the monks favour the traditional and meritori-

86 ous practice of covering over old paintings with fresh, but contemporary, replacements.

Although the architectural style of the Sumtsek itself is anomalous, the paintings that cover the dhoti of the figure of Avalokiteshvara are of considerable importance as documents of early architectural styles. The detail of a multi-storeyed white palace reveals a type of structure with similarities to Nepalese construction, especially the wooden headers over doors and windows. The figures seen in windows join with others scattered about the painting to provide evidence of dress, especially the richness of textiles that would be expected in this region, with its wealth and its connections via trade routes with Central Asia.

The two *chorten*s at Alchi are also of interest, both architecturally and

130 for the paintings inside. The larger of the two, entered through a broad central doorway, is of a design which differs markedly from the more traditional Tibetan *chorten* found in countless monasteries, in paintings and in bronze votive models. It has been suggested that this outer building is not actually a *chorten*. The structure is topped by five towers – a cosmo-

130 Gateway *chorten*, 12th century, Alchi monastery, Ladakh

logical arrangement – and has a circumambulatory path inside which creates a passage about a large, Kashmiri-style stupa filling nearly all the interior space. In addition, the subjects of its wall paintings, perhaps forming a lineage group, suggest that this structure may have a cosmological and ritual function. The major structure at the Yeshe Od temple, at Tholing, has four *chortens* placed at the corners which, along with its once extensive wall paintings, indicate common regional characteristics, lending support to those who feel the so-called *chorten* at Alchi may have originally been a major structure in its overall plan. It is possible that one of the paintings may be of Alchi's founder and another one of Rinchen Sangpo, and the outer structure itself may function like a protective cover over the real *chorten* inside, that is worshipped by walking around it in the traditional manner. So the entire construction, as well as inscriptions, indicate that this was one of the major buildings at Alchi, meant to be a representation of Akshobhya's heavenly paradise, and that the *chorten* inside – which is elevated above the floor by a wooden base – is the spiritual core of the building.

INFLUENCE OF THE CHINESE TRADITION: EASTERN AND NORTHERN AREAS

Less is known of early developments in the eastern Tibetan regions of Kham and Amdo, which are historically more closely linked to the neighbouring Chinese culture. The limited remains thus far discovered suggest a later evolution than in the other two Tibetan cultural areas. Evidence of Chinese influence is more significant in eastern Tibet, especially by the latter part of the period of the second diffusion, coinciding with the Song dynasty (960–1279). The Tibetan portraits of arhats are clearly similar to Chinese *lohan* paintings, a genre that was well established by the time of the Song dynasty, and the traditional Chinese style of landscape painting is also found in Tibetan painting in both the eastern and central regions.

The influence of China had always been present in Tibet, ever since the religious kings of the seventh century. The famous stone lions and inscribed pillars that still remain in the Yarlung and Lhasa areas are testament to a relationship that was inevitable, given the proximity of the two states and the size and cultural history of China. The few sculptures that remain from before the second diffusion, at Kachu, reveal stylistic influences from China, similar to the later painted clay figures in the Chinese monastery of the Lower Huayan-si. By the end of the thirteenth century, evidence of Tibetan-style art can also be found in China, in the

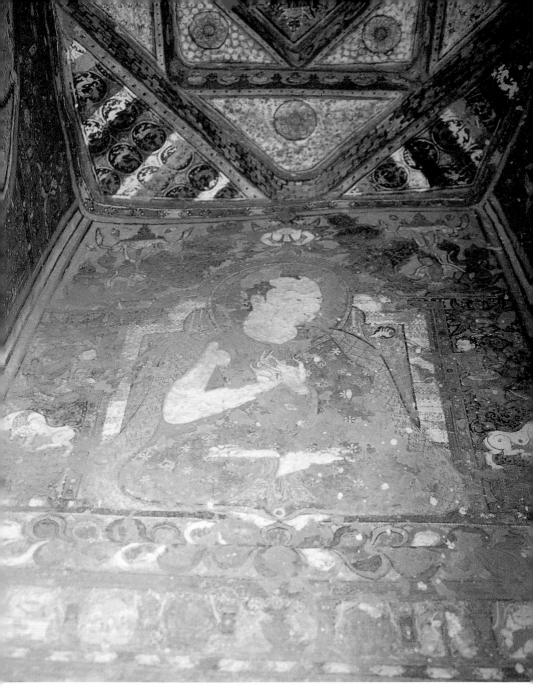

131 Portrait, possibly of Rinchen Sangpo, 12th century, in the Great *Chorten* of Alchi monastery, Ladakh. Wall painting

so-called Sino-Tibetan style, which became increasingly influential in the succeeding centuries.

Tibet had had earlier periods of military conquest in China and Central Asia, even capturing the Chinese capital of Changan in the eighth century and controlling portions of Central Asia, especially the important Dunhuang oasis. Between the tenth and the end of the twelfth century, the Chinese were relatively little involved with Tibet politically, while within Tibet there was growing competition among the monastic orders, as well as between royal families backing the various orders as they in turn competed for greater control. Political events of the thirteenth century, however, proved a turning point in the relationship between the two countries. The Mongol ascendancy, beginning with the rule of Genghis Khan early in the thirteenth century, had immediate impact on China and far-reaching consequences for the future of Tibet. When Ogadai, the successor to Genghis, became the Great Khan in 1227, the Mongols gave more attention to Tibet. Mongol raids prompted increased diplomatic exchanges between the two kingdoms, and ultimately an offer of full submission by the grand lamas of the most powerful order, the Sakyapa. With that a new chapter in Tibet's relationship with its northern neighbours was opened.

The head of the Sakya Order, Sakya Pandita, was summoned to the Mongol court in China at Liangzhou, in modern Gansu province, in 1244, and he brought his brilliant nephew Phagpa (1235–80) with him. Both were a success with the Mongol leadership. When Phagpa was appointed Imperial Preceptor, a position of great influence at the court of Kublai Khan (r. 1260–94), now at Dadu (modern Beijing), Tibet found itself in a new relationship with China, by then under direct Mongol rule as the Yuan dynasty (1260–1368). By swearing allegiance to the Mongol rulers, the Sakya lamas not only helped consolidate their political power within Tibet, but they gained religious influence among the new rulers of China. Tibet assumed both a semi-vassal status to Mongol-controlled China and, through the Sakya lamas' role as advisers, a position of religious influence and even oversight of the imperial Chinese throne. This quasi-formal relationship left Tibet essentially autonomous in domestic matters, beyond taxation and some administrative involvement, and no longer in military conflict with its much larger neighbour, while enjoying a prominent voice in spiritual matters at Beijing.

Phagpa brought the extremely talented Nepalese artist Anige into the service of the Mongols, which provided the impetus for the development of Sino-Tibetan art that followed. Anige arrived at the Chinese court together with the group of artisan-assistants with whom he had

worked in Tibet, as is evident from the later programme of painting at Shalu in central Tibet, begun after 1306. Anige's diverse talents embraced many of the artistic forms that were known in Nepal and Tibet, including metal casting and architecture as well as painting. The White Pagoda in central Beijing and the rock carvings at Feilai Feng, near Hangzhou, and album-leaf paintings of Kublai Khan and the empress Chabi, dated 1294, have been considered examples of his work, attesting to his role in bringing Tibetan artistic styles into the heart of China. The later, mid-fourteenth century archway of the Juyong Guan, north of Beijing, is another example of this continuing Nepali-Tibetan style. Anige's achievements formed a foundation for the distinctive Sino-Tibetan style that flourished in the early fifteenth century and again in the eighteenth century.

The evidence of Chinese influence by the early fourteenth century, the end of the period of the second diffusion, can be seen clearly in individual portraits of arhats. With Indian sources being almost exclusively literary, the Chinese tradition of *lohan* painting remains the main derivation for Tibetan arhat portraits, and the Chinese and the Tibetan characteristics of eastern Tibetan painting of the era can be contrasted by comparing Tibetan and Chinese arhat paintings. In keeping with one of the pictorial trends of the end of the second diffusion, the large central-Tibetan-style figure of the arhat Vanavasin is essentially flat, defined by 133 colour and line rather than by shading or a sense of space. Within this idealized figure, details of the face are treated with a degree of naturalism that is accentuated by the large size, giving it a very human expression. The technique of the projecting, further eye is found in Indian paintings and is repeated at Alchi, in western Tibet. One of the most famous of Chinese examples, on a handscroll dated to 1180, shows Chinese *lohans* 132 in typical placements in caves, on rocks, or beneath gnarled trees. The exaggerated faces of the *lohans* are stereotyped, with their bald heads, intense gazes and rough beards, and the conventional long, drooping eyebrows also found in the Tibetan tangka.

The tiled roof and brackets behind the figure of Vanavasin are likewise borrowed from the Chinese tradition. The landscape setting, so prominent in this handscroll, has a long, rich history in Chinese art, and in *lohan* portraits is often given as much attention as the figures themselves. One key difference between the styles is the Chinese preference for individual rocks or trees, almost as companions to the sitter, rather than the flowing, broadly rendered landscape style seen in the Tibetan painting. The Tibetan emphasis remains on the figure, with the subject placed forward, outside of a surrounding group of figures, animals, fanciful trees

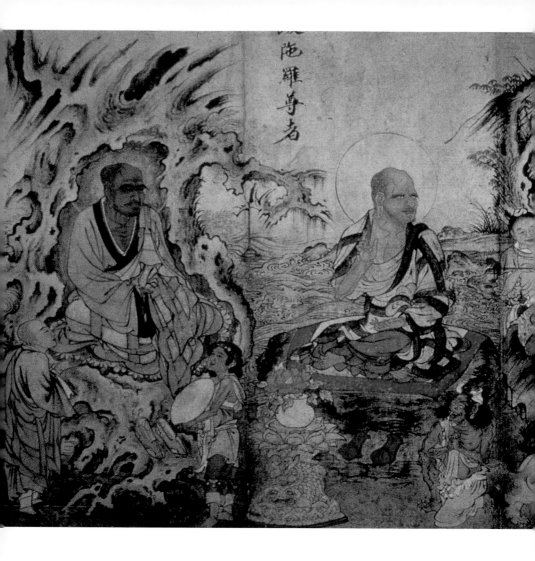

and the roundels that enclose various deities, although early Chinese 'blue and green' landscape style influenced the choice of colours. Since Vanavasin resided in the forest, the schematized and limited areas devoted to that essential aspect of his image further distance this Tibetan painting from what a Chinese artist, steeped in landscape painting, would likely have done with the same subject. Within a short time, features of Chinese landscape painting would become more important in Tibetan arhat portraits, although never to the level of sophistication found in China. By

156

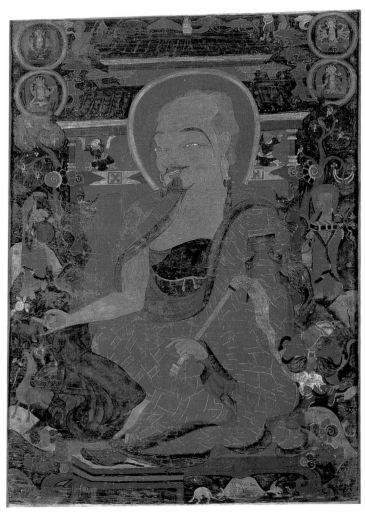

132 (*above left*) *Lohan*s in a typical Chinese landscape setting, dated 1180, China. Handscroll, h. 30.4 cm (12 in)

133 (*above right*) This lively portrait of the arhat Vanavasin, tentatively identified by the fly whisk in his left hand, was likely painted in central Tibet, although details in the robe and design patterns may reflect some western Tibetan styles, as found among wall paintings at Tabo. Late 14th century, central Tibet. Tangka, gouache on cotton, h. 71.1 cm (28 in)

134 Hvashang, early
15th century, central Tibet.
Tangka, gouache on cotton,
h. 63.5 cm (25 in)

134 the fifteenth century, Tibetan arhat painting had adapted more to the Chinese formula for these figures, including the gnarled tree limbs which form a canopy over the seated figure.

ART OF THE 13TH AND 14TH CENTURIES: THE CULTIVATION OF TIBETAN STYLE

The Tibetan renaissance was well under way by the year 1200, after centuries of productive engagement with Indian Buddhism, which was now coming to an end as Muslim rule and religion replaced Buddhism in its homeland. The monastic centres of the then-major orders were well established in central and western Tibet, where they continued the translation of Buddhist literature and provided instruction no longer available

158

directly from Indian monastic centres. In much of Asia, with a few notable exceptions in Southeast Asia and Sri Lanka, Buddhism was no longer the paramount force it had been for over a millennium. The long period of assimilation was ending, and measured by textual and artistic activity, Tibet was becoming the greatest single area of continuous Buddhist activity.

A portrait of a Taglung lama from the early thirteenth century, one of the foremost of a number of similar portraits, reveals the Tibetan technical mastery in a subject beginning to assume great importance. The even line work, masterful down to the smallest details, the harmonies achieved through the balance of flat areas of colour, and the guardian animals and various decorative subjects surrounding the throne all reveal continuing Indo-Nepalese styles. But the Tibetan synthesis has moved painting beyond the close dependency on Indo-Nepalese sources of a century before. The lama gazes directly at the viewer, his face and hands drawn with consummate skill, and areas that would once have been flat colour are filled with floral motifs, mythical animals and opened lotus petals. The prominence given to the order's spiritual lineage, seen in the row of figures along the top register, was to expand further during the thirteenth century.

Increasing interaction between the Mongols and Tibetans, led by the lamas of the Sakya Order, dominated political events and artistic achievements through most of the thirteenth and fourteenth centuries, the era of Mongol rule in China. Subtle but important changes appeared in Tibetan painting during the period. Compositions lost some of their vitality, becoming more ordered and more predictable, while narrative elements and attention to spiritual lineages continued to grow in importance. The latter were especially critical at this time, when the orders were in competition both to authenticate their claims to spiritual legitimacy and also to justify their position in the eyes of the Mongols, who were now becoming a primary source of support.

Many of the finest Tibetan works produced during this period of Mongol rule in China and Sakya domination in Tibet reflect the taste and preferences of the Sakya order. A painting of the popular *mahasiddha* Virupa indicates some of the changes occurring in Tibetan art after the twelfth century. Instead of the usual symmetry of Tibetan painting, Virupa is given an off-centre position, with his feet reaching below the pictorial frame, though the unorthodox subject might explain this deviation from the typical hierarchical and frontal presentation of the major figure. The stylized rocks that surround the central group and the fanciful trees above are a continuation of the Pala style.

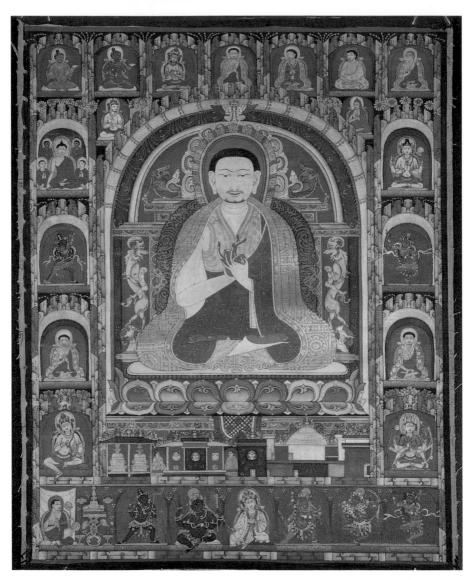

135 Taglung Lama Thangpa Chenpo. The rich colours and decorative forms push the lama forward – a technique repeated in the matching, arched openings that surround the centre – and establish the motif of the rest of the composition. The stylized rocks, long a favourite Pala device, form colourful backgrounds for the arched openings on three sides of the painting, and finally a border along the bottom in alternating colours. Early 13th century, central Tibet. Tangka, gouache on cotton, h. 31.8 cm (12.5 in)

136 The *mahasiddha* Virupa, especially important to the Sakyapa, is portrayed in a humorous manner, holding a cup of beer and pointing at the sun, halting its passage so he could keep drinking beer through a very long day. The importance accorded the *mahasiddhas* is evident in this masterful composition, for they occupy the entire space surrounding the central image. Early 13th century, Tibet. Tangka, gouache on cotton, h. 54 cm (21.3 in)

Changes occurring by the fourteenth century can be seen in a painting of Shakyamuni Buddha with scenes from his life. The image of the Buddha has an iconic feeling, which is repeated with the side figures in their two-dimensional directness (see also *ill.* 135). The greater abstraction of the central image and an increase in ornamental embellishments are styles which will remain popular in the succeeding period. Likewise, the earlier emphasis on sectarian lineages continues, but now begins to share space with sets of deities and, in this tangka, with narrative scenes as well. Many of the Indo-Nepalese decorative elements, the mythical figures and foliate designs above the Buddha, are retained, but the distinctive, stylized rocks that frame the niches in the earlier work are no longer used. Instead, the once carefully defined niches enclosing each figure are now limited to two vertical rows of figures, and in those the subject extends beyond the surrounding frame, a variation noted above in the image of Virupa. The shapes and the shaded colouring of the large lotus petals supporting the throne are in a different style, now treated in a more decorative fashion, almost like textile patterns, although the older format also continued in other paintings. The narrative scenes are more freely drawn, especially along the top register and beneath the Buddha's throne, aided by the darker, but more neutral and less restrictive background which replaces the intense colours and borders of the earlier work. The numerous figures in the narrative scenes are less refined, lacking the careful line work that marked the earlier painting, but their prominence is indicative of a growing Chinese influence.

A similar evolution can be seen in sculpture. An early brass image of Shakyamuni Buddha combines elements of both the western (Kashmiri) and central (Pala) Tibetan traditions. Kashmiri technical methods are evident in the copper and silver inlays, but the figure, pedestal and decorative cushion reflect Pala sources more closely than the soft naturalism of Kashmiri figures. Despite the initial differences between central and western Tibetan art, by the thirteenth century the process of assimilation had evolved to a point where elements from both areas are often found in the same piece, suggesting not only the movement of artists and workshops, but the greater unity of Tibetan culture itself. Later in the period of the second diffusion the blurring of sources became even greater, the increasingly interwoven style making attribution to one area or another even more difficult.

Portraiture continued to predominate, with traditional devices, such as gestures, postures and symbols, used to indicate spiritual accomplishments in preference to recourse to physical likeness. The most venerable of saints and lamas came to be portrayed in the manner traditionally

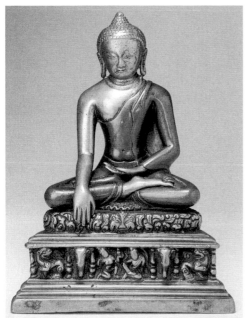 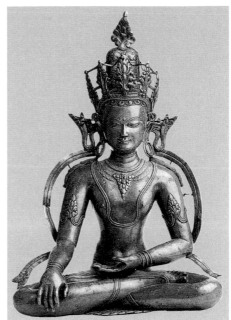

137 (*left*) Shakyamuni Buddha. His earth-touching gesture signifies the attainment of enlightenment. In style this work reflects the Pala traditions that were the dominant influence on the early art of central Tibet. 11th century, Tibet. Copper with silver inlays, h. 14.3 cm (5.6 in)

138 (*right*) Akshobhya. This later image reveals a combination of Pala and Kashmiri styles. Its taut, somewhat abstract style is typical of the Kashmiri-influenced art of western Tibet, while the modelling of the torso and proportions of the figure are closer to the Pala school. 13th century, Tibet. Brass with inlay, h. 42 cm (16.5 in)

reserved for images of the Buddha, with elaborate thrones and attendant symbols representing supernatural stature. But within those parameters the best of Tibetan portraits include facial details suggesting a continuing fascination with elements that must have been taken from studies of individuals, as recorded in artists' sketchbooks.

The icon-like quality of much late fourteenth-century Tibetan painting is well suited to the mandala. The visual and religious complexity of these cosmological diagrams is complemented by the directness and the even, flat colours typical of tangkas of this period. A style of painting from the Sakyapa monastery of Ngor is associated with tangkas from there dated between about 1390 and 1430, each of which is composed of four separate mandalas. The style would continue well into the sixteenth century, as can be seen in an interesting series of portraits created during

the second half of the century. Inscriptions on these paintings provide evidence of a donor, names of several prominent Sakya lamas, and the information that they were commissioned on the death of a famous lama who had been a teacher of the great Tsong Khapa (1357–1419). A remarkable visual litany of deities, mostly female, emerges from amidst all the details, a programmatic sequence that can be traced back to specific texts.

The complexity of the Ngor mandalas mirrors the complexity of Vajrayana ritual. The combination of the intricate image and the equally involved literary texts associated with the mandala, as for all Vajrayana ritual, means that the task facing the devotee would be overwhelming without the direct involvement of the guru as a guide through these layers of religious worship.

In one of the Sakya multi-mandala paintings from Ngor, the mandala 139 in the upper left, with the twelve-armed goddess Mahapratisara in the centre, also contains images of a set of goddesses who protect against sickness and other calamities, the Pancharaksha goddesses. The other three mandalas, also featuring female deities, are drawn from initiation rites, as spelled out in texts. In the upper right, the central deity is Vasudhara, the goddess of wealth. Ushnishavijaya is at the centre of the lower right mandala, in her three-faced, eight-armed form. Surrounding the two-armed Bhagavati Mahavidya in the last mandala are the nine planetary deities, with Surya, the sun, placed atop a circle of the other eight. On the main field, outside the four mandalas, are the five Pancharaksha goddesses, located at the four cardinal directions and at the centre, with the thirty-five Buddhas of Confession placed around them. Along the top register are the five Tathagatas, a golden Shakyamuni and the ten directional Buddhas. The line of figures along the bottom row is composed of Buddhist forms of the world gods, Hindu images now encompassed by the Buddhist dharma. An inscription names the last figure in the row, the donor, lama Kunga Sangpo.

139 Four Mandalas. The impeccable drawing and brilliant colours of this tangka, which by themselves bring a vibrancy to the surface, and the clarity of the lines and meticulously worked decorative subjects are qualities associated with Nepalese paintings as well as Tibetan. *c.* 1400, central Tibet. Tangka, gouache on cotton, h. 91.5 cm (36 in)

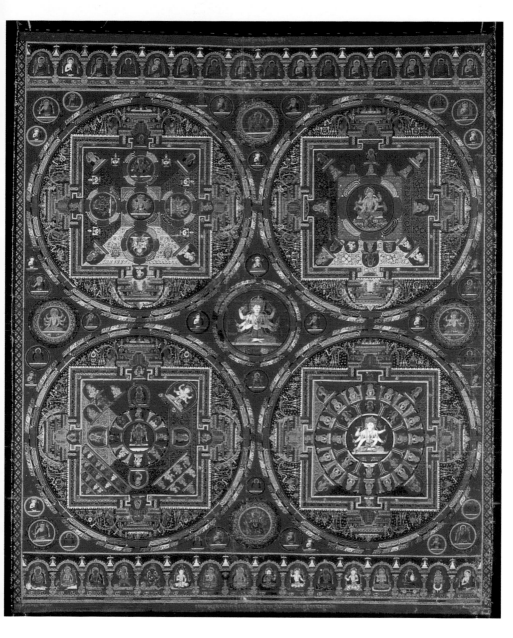

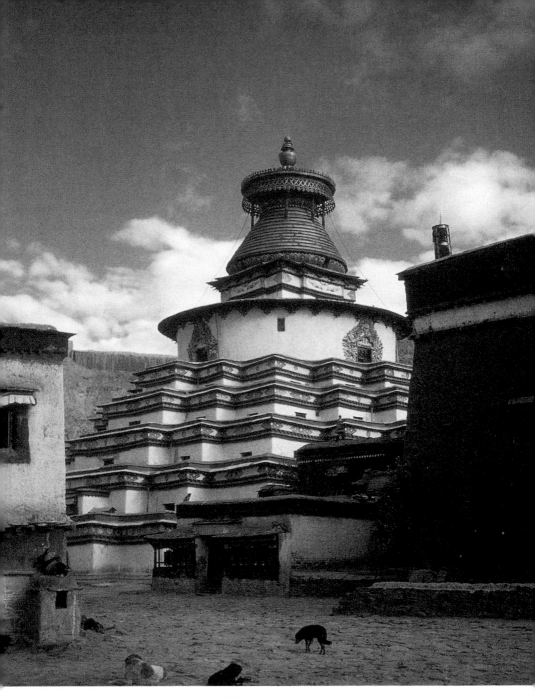

140 Kumbum, 15th century, Gyantse, Tibet

The Refinement of Tibetan Styles (15th–19th Centuries)

The powerful artistic traditions that shaped the early development of Tibetan art remained an influence over its later evolution. Fifteenth-century sculptures at Gyantse and Tashilumpo continue to reflect the earlier Nepalese-influenced styles of central Tibet, and sixteenth-century western monuments, such as Tsaparang, retain Kashmiri elements. Records confirm that Nepalese and Kashmiri artists continued to work in Tibet, and the well-established, familiar styles, together with the inherently conservative nature of religious art, ensured that these imported traditions remained the staple of local artists. Generally, the art of western Tibet contains fewer different sources, although elements of its primary source, the Kashmiri-derived style, did endure, unlike in central Tibet, where artistic influences were more varied and diverse.

The artistic relationship between China and Tibet continued, though the greater Chinese artistic heritage meant it was certainly not equal. Chinese involvement in Tibetan affairs expanded, and Tibetan lamas' influence on spiritual activities within China continued, of greater importance to the Tibetans than to the more pragmatic Chinese. The reigns of two Chinese emperors, the Yongle emperor (r. 1403–24) and the Qianlong emperor (r. 1736–95), were eras of particular interest and patronage for Tibetan religion and art, especially for the distinct Sino-Tibetan style, elements of which had already appeared in the later fourteenth century. By no means all Tibetans embraced the arrangements agreed to by the Sakya leaders in the thirteenth century. However, these paved the way for further power struggles among the major Tibetan religious orders, resulting in appeals for first Mongol and then Chinese intervention on behalf of the competing monasteries, invitations that ensured continuing outside involvement in Tibetan affairs.

By the time these struggles were essentially resolved, the Gelug Order was supreme, and early in the seventeenth century a leader of great skill assumed the position of Dalai Lama, as the fifth in the succession, his 14 achievements earning him the sobriquet of Great Fifth (1617–82). His efforts helped create a national system of cohesion, if not a balance between secular and religious forces, and a great age began for the

country. The charismatic Gelug Order spread beyond Tibet into Mongolia, and it enjoyed various levels of patronage at the Chinese court during the Ming and Qing dynasties, especially during the eighteenth century. Today's Dalai Lama, fourteenth in the succession, is accorded such respect that, along with the Roman Catholic Pope, he is regarded as one of the world's two most honoured religious leaders.

THE MIDDLE PERIOD (15TH–16TH CENTURIES)

The fifteenth century was the era of one of Tibet's greatest religious figures, Tsong Khapa (1357–1419), the foundation of the order which followed his teachings and one of its finest monuments. Both the Gelug Order and the Sakyapa monument, the Kumbum at Gyantse, have survived into the present time, gaining stature as Tibet's most powerful order and its most artistically important structure. This was also a period of increased communication with the Chinese throne, the artistic consequences of which can be seen in technique as well as style, as in the creation of technically the finest of gilded metal images. The central regions, especially the Tsang area, and western Tibet, at Tholing and Tsaparang, enjoyed periods of high artistic achievement during this century, and the paintings of this era remain among Tibet's greatest artistic achievements.

The regional characteristics which had been significant throughout Tibetan history remained evident during the sixteenth century. The Sakya Order continued to produce much of the finest art, but a subsect of the Kagyupa, the Karmapa branch, gave rise in the late sixteenth century to a distinct and influential style of painting known as the Karma Gadri style, which developed further in the succeeding centuries. Based on the colours and spacious settings of the Chinese landscape tradition, this style represents a major development in eastern Tibet.

The broad influence of Chinese art in Tibet and the demand for Tibetan objects in China increased in the fifteenth century, under the Ming dynasty which followed the Mongol Yuan period, encouraged by the Yongle emperor's interest in Tibetan religion. Along with other Chinese artistic influences, particularly in landscape motifs and portraiture, as well as the growing Tibetan interest in the technique of silk embroidery, this movement in art reflected an increasing Chinese engagement with Tibetan culture.

Tsong Khapa's immediate impact on Tibetan religion was similar to that of Atisha in the eleventh century (see page 18). Both were actually traditionalists in their religious practices, adhering to Tantric rituals and meditations, and both had tremendous, rejuvenating impact on Tibetan

140

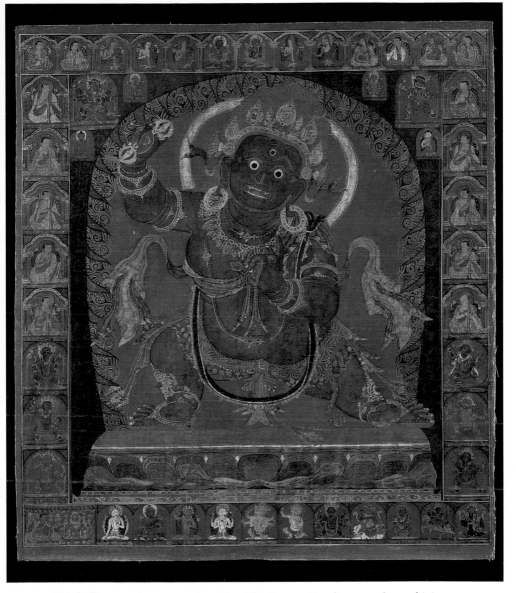

141 This brilliant tangka captures the style of the Gyantse Kumbum murals, combining monumental scale with precise line work and flat colours. Vajrapani, his red body set against a blue background, pulsates with energy, barely contained within the narrow flaming halo, which is set apart from the surrounding roundels of deities and lineage figures. The donor is seen in the lower left corner. Late 14th–early 15th century, central Tibet. Gouache on cotton, h. 83.8 cm (33 in)

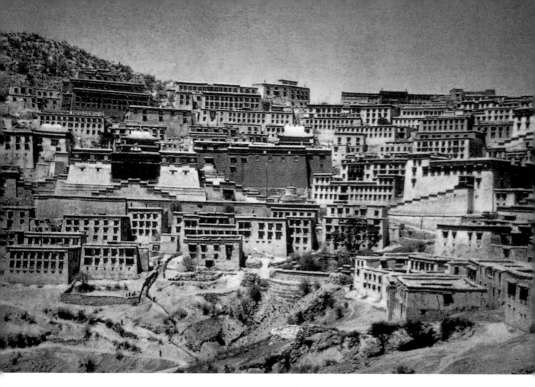

142 Ganden monastery before 1949, Tibet. Destroyed

Buddhism. Tsong Khapa espoused a monastic discipline that lent greater structure to the religious life, and the order that developed around him became renowned for the dedication and excellence of its practice. This deeply committed Gelug system served as a model for the other orders and, at least initially, its strict discipline distinguished it from their materialistic tendencies. Tsong Khapa's disciples, the best known being the Dalai Lamas, continued to develop and champion the Gelug Order, which soon became the dominant religious order in Tibet. Images of Gelugpa lamas are easily recognized by their distinctive yellow hats, just as those of Karmapa lamas are by their black ones.

By the late fifteenth century, the Gelugpa had founded a number of monastic establishments, including Tashilumpo, which in the next century would become the headquarters of the lineage of the Panchen Lamas. The size of some of these large monasteries, which housed thousands of monks, can be appreciated from this pre-1949 photograph of the complex at Ganden, founded by Tsong Khapa in 1409.

142

170

Growing Chinese influence in central Tibet

In the early fifteenth century, a multi-storey temple and *chorten* was constructed at the Sakyapa complex at Gyantse and filled with paintings and statues. Known as the Kumbum, literally 'the hundred thousand images', its programme follows the familiar progression through ever higher levels, with paintings and clay figures indicating the ascending order of the cosmos. The stucco figures are lacquered and painted, and their broad faces and magisterial forms suggest the growing influence of Chinese naturalism. With their vivid colours, dynamic energy and technical skill, the murals in the Kumbum remain among the finest examples of wall painting in Tibetan art.　143

A stronger Chinese influence is found among some early fifteenth-century paintings, including now those from the central regions, such as a painting of Vaishravana, defender of the north and the favourite among　144 the guardians of the four quarters, the *lokapalas*. Despite strong Chinese stylistic influences, he is shown riding a Tibetan snow lion. The colours are intense, especially the turquoise blue, rare in later Tibetan painting, with the figures crisply drawn and arranged in the compressed, two-dimensional space typical of Tibetan style. Vaishravana wears the armour of the *lokapalas*, likely derived from both Central Asian and Chinese

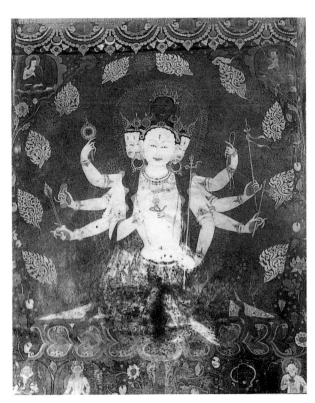

143 Sitatapatra, early 15th century, the Kumbum, Gyantse, central Tibet. Wall painting

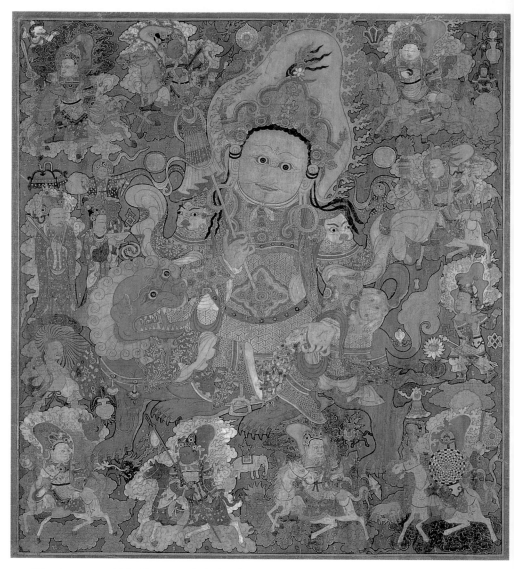

144 The degree to which Chinese style had influenced Tibetan painting is clearly evident in this masterful version of the guardian Vaishravana. However, its Tibetan origin can be determined from similarities to the Gyantse murals, from the halo and flames, and not least from the Tibetan snow lion that Vaishravana is seated upon. Early 15th century, Tibet. Tangka, gouache on cotton, h. 81.3 cm (32 in)

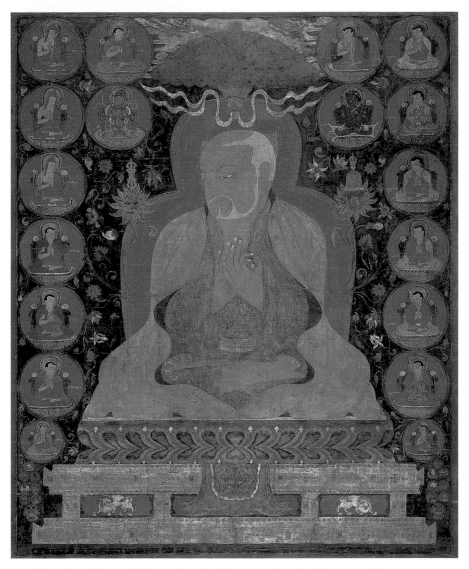

145 Sakya Lama Kunga Nyingpo. Rendered in a broadly painted style, the figure is infused by a warm naturalism, seen in the hands, the garments and especially the very human face gazing off to the left as if lost in thought. He is framed by familiar decorative motifs, detailed flowers and peacock feather canopy and throne, here enriched with raised areas of gesso covered with gold. *c.* 1429, Ngor monastery, central Tibet. Tangka, gouache on cotton, h. 114.3 cm (45 in)

sources, and many of the subsidiary figures in the composition display Chinese-style garments. The haloes, and the pointed flames emanating from Vaishravana's green halo, are also found among Persian paintings, further evidence of the broad cross-currents feeding Tibetan art by the middle period.

In 1429 the Sakya monastery at Ngor was dedicated, and its painting atelier, along with other Sakya establishments, went on to produce most of Tibet's finest tangkas during the fifteenth and early sixteenth centuries. The styles of art within that tradition are varied, not only differing from one monastic centre to another, but adopting innovative changes almost as they occur. The portrait of one of the early masters of the Sakya Order, Lama Kunga Nyingpo, comes from the rich Ngor tradition and also illustrates influences from other potent artistic centres, in this instance, that of Gyantse. The son of the founder of Sakya monastery, Kunga Nyingpo was said to have been an emanation of Avalokiteshvara and to have received special guidance from Manjushri, and he followed the teachings of the *mahasiddha* Virupa along with those of the Sakya Order. Virupa is the dark-skinned figure in the upper right, just above the ritual bell, and Manjushri is placed to the left, above the *vajra*. The grandeur of the tangka also matches the wall paintings in the Kumbum at Gyantse, especially the portraits in the chapels of the fourth level. This tangka, very much in the style of a monumental wall painting, bears comparison with the almost contemporary Ngor mandala discussed on pages 163–64, to demonstrate the range of styles of Sakyapa artists.

The naturalistic portraits and mandalas that issued from the Ngor monastery by no means exhausted the rich and varied Sakya production of the fifteenth and sixteenth centuries. Lineage portraits, which could portray one or more individuals, although more conservative in style than the portrait of Kunga Nyingpo, retain the exquisite details and consummate brushwork associated with the finest painting of the middle period of Tibetan art. Two portraits, spanning more than a century and belonging to a group of well-preserved, detailed tangkas, reveal areas of change and others of constancy over the period. The earlier is one of the finest Sakya lineage portraits of the fifteenth century, particularly in its exquisite drawing, decorative details and sumptuous colours. The floral roundels surrounding the entire image are painted with an eye to creating contrasting forms, rather than simply enclosing the figure. If this technique is compared with similar subjects from western Tibet, whose fine line work is certainly equal to this painting, the dramatic boldness of the roundels in this tangka is almost startling. There is another departure in the way traditional symbols, such as the thunderbolts (placed in the

145

147, 148

174

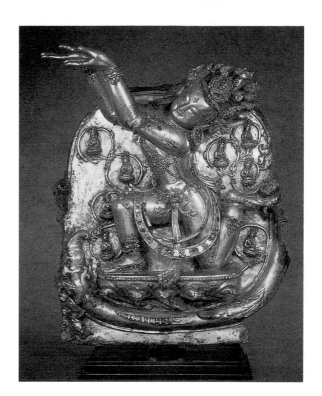

146 Nagaraja, early 15th century, Densatil, central Tibet. Gilt bronze, h. 60 cm (23.6 in)

middle of the three lotus stalks), water pots and the flaming mirrors (at the top of each stalk) are integrated into the design. The two primary subjects, on the other hand, are little differentiated: their stereotyped facial details, *vajras* and bells, and teaching gestures are identical. The portrait of the Pandit Gayadhara, a guru of the Sakya Order, was likely done a century later, and the formal, essential flatness noted in the Ngor mandalas remains.

Another remarkable example of early fifteenth-century art is a group of gilded copper reliefs at the Kagyupa complex at Densatil, near Samye. 146 At that time Densatil was one of the wealthiest monasteries in Tibet, but today it is totally destroyed. Its only remains are gilt copper plaques, done in repoussé technique and set with semi-precious stones, which originally were attached to the outer surfaces of eighteen *chortens*. In one of the tragedies of history, the only record of their placement beyond written descriptions by scholars such as Tucci is a few photographs taken in 1948. At a time when the Gyantse images were introducing more naturalistic styles of portrayals, the artisans at Densatil were continuing to produce essentially decorative, technically brilliant images in the Newari styles

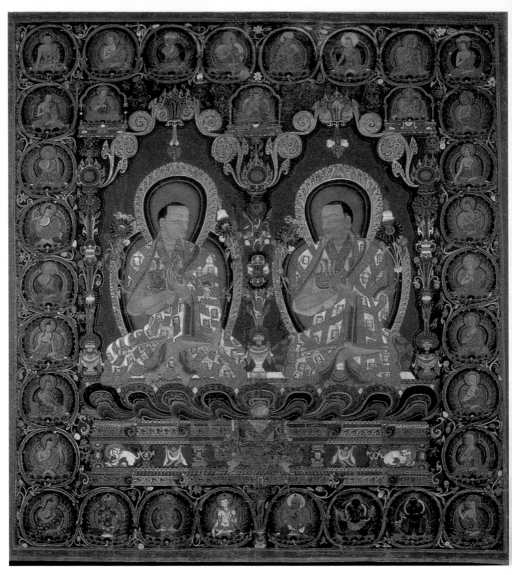

147 The contrasting colours, fine drawing and integration of subjects and decorative motifs make this Sakya lineage tangka one of the finest known. Its richly saturated orange and yellow and added gold move a conservative format into the realm of brilliance. 1450–1500, central Tibet. Gouache on cotton, h. 87.6 cm. (34.5 in)

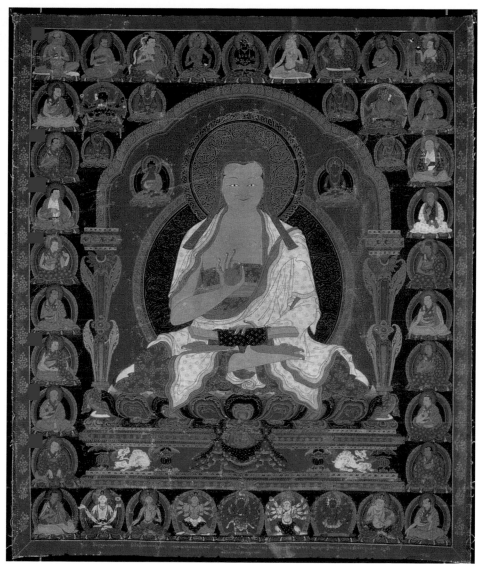

148 This individual portrait of the Sakya guru Pandit Gayadhara, slightly later and rendered in flat, unmodulated colours and fine, rhythmical lines (especially evident in the white robes) continues the earlier Ngor tradition and illustrates the aesthetic and technical brilliance of the mature Tibetan style. 16th century, Tibet. Tangka, gouache on cotton, h. 78.8 cm (31 in)

that had continued since the early period of the second diffusion. The faces, even many of the subjects portrayed, as well as the abundant decorative details, the tendrils and the mythical creatures all point back to the long-established Nepali schools of art. A number of these plaques consist of long rows of beautiful celestial goddesses, captured in measured, rhythmic harmony, which seem to flow across a flat, undecorated surface. With the exception of the skull cups, the Tibetan ceremonial staffs they hold and their Newari dress, they could belong to the famous rows of celestial nymphs which are carved into the stone walls at Angkor Wat, in Cambodia.

Continuity in western Tibetan styles
The monasteries of western Tibet enjoyed a revival of their own during the fifteenth and sixteenth centuries, and despite influences from central Tibet, paintings from the area continue to be produced in a regional style distinct from that of the central regions, such as at Ngor and Gyantse.

This linear, detailed style continues through the sixteenth century, as seen in a small group of tangkas from the region. The surface of these paintings is composed of densely packed roundels linked together by detailed foliate designs interspersed with both mythical and naturalistic animals, such as the four playful figures beneath the throne in a fifteenth-century painting of Vajradhara and Vajradharma. Close study reveals, however, that the decorative motifs are not merely repetitive, stereotyped forms, but a rich variety of lively and creative designs which provide a background for the roundels and their lineage subjects. Instead of landscapes and scenes requiring spatial depth, Guge artists preferred to emphasize the two-dimensional surface, with precise patterns that give the paintings a transcendent, less naturalistic quality. They also adhere to a more limited, subdued palette, especially compared to the often pastel colours of eastern, Chinese-influenced painting.

This more abstract treatment, including the fine details that serve to accent the ethereal quality of fifteenth-century paintings, can also be found among Guge sculptures of the fifteenth and sixteenth centuries. In a remarkable brass portrait of the founder of the Drug suborder of the Kagyupa, Lama Gyawa Gotsangpa, the artist has captured the ideal of the yogic master in the softness and bulk of the body, the figure of one devoted to relaxation and control of the physical body while cultivating the inner, higher world through years of meditation. In its mix of naturalistic and more abstract details, this image invites comparison with figures from the central and eastern regions.

Many of the attributions of early sculptures to western Tibet are being questioned by scholars, and western Tibetan images of later dates are

151

149

178

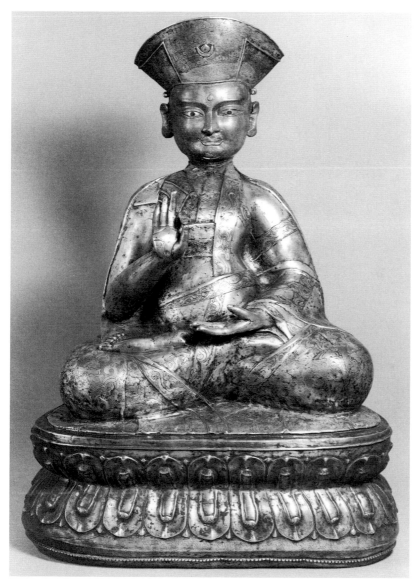

149 Lama Gyawa Gotsangpa (1189–1258). Fine linear patterns, seen on the drapery, are here blended with realistic details, such as the naturalistic features of the face, and with the abstract form of the wide hat, worn by members of this suborder of the Kagyupa. The position of both hands is especially successful, held just apart and animated, against the background of the fully relaxed figure. 15th–16th century, Tibet. Brass with copper and silver inlay, h. 66 cm (26 in)

even more likely to reveal the growing interactions between the three major artistic areas. During the fifteenth century, increasing Chinese influence can be seen in both eastern and central Tibet, and aspects of those styles were carried into the western regions, an area no longer receiving contemporary influence from Kashmir. One of the means used to establish regional characteristics has been the stylistic parallels between the painting and sculpture produced in a given area. However, sculptures, especially traditional images that continued to be in demand, were now more likely to be transported to other areas, and their variations lead to ever more difficulty in determining their place of origin.

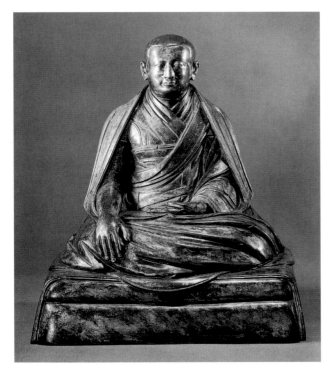

150 A late fifteenth-century portrait of Lama Karma Dudzi is very close in style to images in the Kumbum at Gyantse. Deriving much of their naturalism from Chinese portraits, these figures are solidly three-dimensional, not only in the facial features but in their proportions and postures of convincing realism even beneath the layers of robes. Their style as a result is distinct from that of western Tibet, seen in Guge figures such as the fifteenth-century Padma Sambhava (*ill.* 10) with its mixture of linearity

150 Lama Karma Dudzi, 15th century, eastern Tibet. Gilt bronze, h. 28.6 cm (11.3 in)

151 This brilliant, 15th-century tangka is dominated by the two large figures of Vajradhara and Vajradharma, celestial progenitors of the Sakya Order. The red-hatted lama above the two deities clearly represents the order, the remaining images coming from the lineage's traditional group of deities, protectors, adepts and lamas. Guge, western Tibet. Gouache on cotton, h. 89.2 cm (35.1 in)

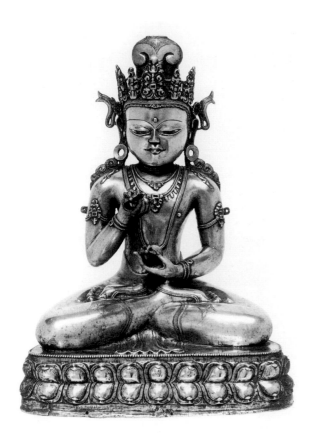

152 Vajrasattva, 15th century,
Tibet. Brass with inlays of
copper, silver and jewels,
h. 45.5 cm (17.9 in)

and a three-dimensional naturalism, abstraction and earth-bound volume, characteristics found in both the painting and sculpture of western Tibet.

152 A large and well-preserved Vajrasattva exemplifies this problem of assigning regional attributions. The deity was a major figure in the pantheon, like the celestial bodhisattvas Avalokiteshvara, Tara and Manjushri, and he is frequently embracing the goddess Prajnyaparamita or his female Buddha counterpart, Vajradhara. He holds his usual attributes, the *vajra* and the bell, emblems of the compassion and wisdom that must be joined for true understanding to occur. Some of the technical features of this piece, especially the inlays and the unfinished back, have been confidently identified with metal casting in the western regions. The overly large head, with its wide eyes and brow, and the unusual headdress have also usually been included as western styles but without as firm a basis. The rest of the headdress, the foliate crown, the jewellery and inset stones, and

the exaggerated and elongated proportions of the body, which imparts a transcendent, mystical quality, are associated with images from central Tibet, deriving from the Indo-Nepalese schools. Whatever its source, this synthesis of regional characteristics and styles has resulted in a compelling figure, one of a great many that belong not to any specific region but to the ever-broadening Tibetan culture. 138

The Sino-Tibetan style

The uneven and often fractious relationship with China was nevertheless influential through most of Tibet's history, since at least as early as the reign of Tibet's first king, Songtsen Gampo, who conducted diplomatic exchanges with the Chinese court in the seventh century and received the famous image of Shakyamuni (*ill.* 3) which, symbolically at least, initiated the flow of artistic influence. Artistic communication between the two cultures is known to have existed from an early date, for Tibetan records indicate that one of the first monasteries, Samye, was at least in part constructed in the Chinese style. Influence had begun to flow the other way as well by the late thirteenth century, when the Nepalese artist Anige and his assistants from Tibet went to the Chinese court, under the auspices of the Sakya hierarch Phagpa. Their work provided the impetus 155 for the development of the Sino-Tibetan style.

The fully refined Sino-Tibetan style emerged during the reign of the Yongle emperor, the third Ming emperor, in the early decades of the fifteenth century. A devout follower of Buddhism, he returned the capital

153 This *c.* 8th-century stone lion at Chonggye, in Tang Chinese style, remains one of the earliest examples of Chinese influence in Tibet, and also one of the few examples of monumental stone sculpture, a tradition little developed in Tibet

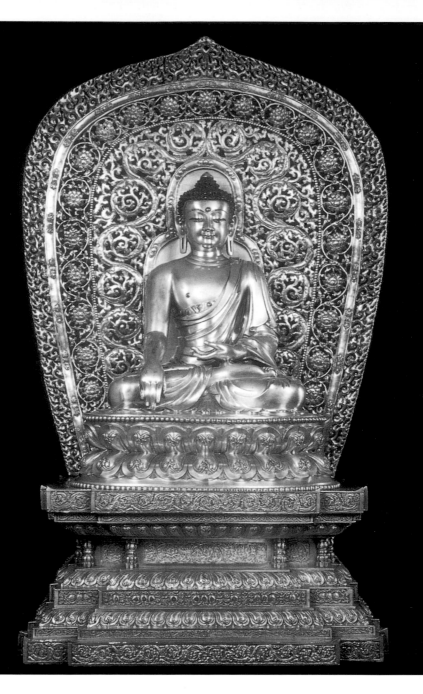

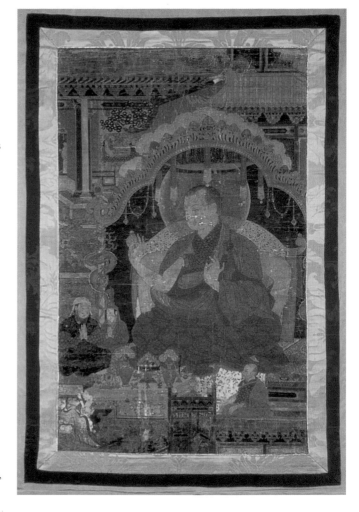

154 (*left*) Shakyamuni Buddha. This seated Buddha, surrounded by an elaborate aureole, is in the Chinese tradition of frontal, hierarchical figures enhanced by a setting of golden splendour. Sino-Tibetan, early 15th century (Yongle period), China. Gilded bronze, h. 72.5 cm (28.5 in)

155 (*right*) Phagpa. In spite of his importance in the history of Tibet's relations with China, portraits of Phagpa are rare. This 15th-century tangka may be an image of the powerful Sakya monk, composed in the traditional Asian manner, with the politically – but not religiously – more powerful Mongol ruler Kublai Khan portrayed as a small, devoted figure below and to the left of Phagpa. ?15th century, Tibet. Gouache on cotton, h. 82.3 cm (32.4 in)

to Beijing and launched a building campaign that offered abundant opportunity to invited Tibetan artists to practice and extend their art at the Chinese royal court. The term Sino-Tibetan is often used loosely to refer to images of mixed cultural influence and to include the entire range of material shared by the two artistic traditions, such as portraiture or landscape painting. However, more strictly the definition refers to the art of two specific eras, first that of the early Ming dynasty, especially the gilded metal images which are a blend of the two styles, Chinese and 154 Tibetan, and were made under the aegis of the Imperial Chinese court.

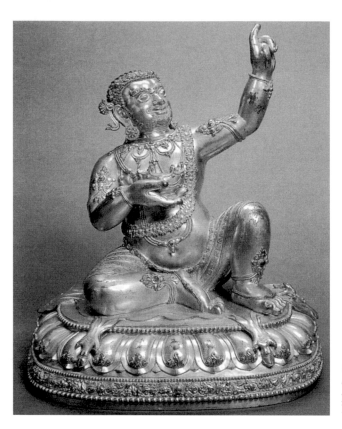

156 Virupa, Sino-Tibetan, early 15th century (Yongle period), China. Gilt brass, h. 43.8 cm (17.2 in)

In addition to their rich gilding, and their distinctively decorated lotus seats, such figures have a marked Chinese style, blended with Nepalese-style garments and ornaments. The work was inspired by Tibetan art and represents a late florescence of Chinese Buddhist sculpture, among the finest later religious sculpture produced in China. A similar blend of interests and styles appeared during the second era of Sino-Tibetan art in the eighteenth century, especially during the six-decade-long reign of the Qianlong emperor.

It was the Yongle emperor's devotion to Tibetan forms of Buddhism rather than Chinese Buddhism that initiated this remarkable outpouring of art, a body of works that brought Chinese technical expertise into the service of the exotic imagery of the Tibetan Buddhist tradition. Two bronzes, both of the *mahasiddha* Virupa and both dating to about the same period – coinciding with the Yongle period – demonstrate the differences between the Sino-Tibetan and the central Tibetan styles. Virupa

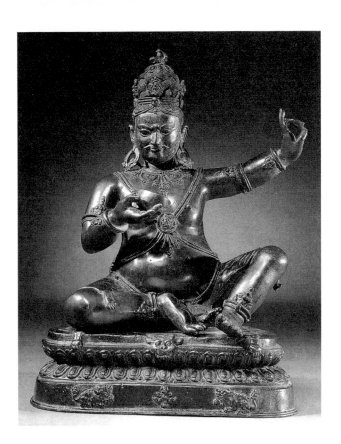

157 Virupa, *c.* 1400, central
Tibet. Bronze, h. 40.6 cm
(16 in)

is one of Tibet's most revered figures, as well as being especially esteemed
by the Sakyapa. The Sino-Tibetan figure derives from the Indian tradi- 156
tion and retains the animated pose traditionally reserved for this mystic,
yet it is rendered in the technically detailed, opulent manner of the
workshops of imperial China. When seen beside a Tibetan bronze of 157
Virupa of roughly the same date, the contrast in styles is notable. In this
Tibetan version, instead of a radiance achieved by rich gilding, more
human qualities are emphasized, such as details of hair and facial features,
as well as the intense gaze and elegant gestures that communicate a sense
of realism, attributes of Tibetan art already evident by the end of the
fourteenth century.

During the Ming dynasty, the Chinese encouraged continued inter-
action between the Mongols and the Tibetans, hoping thereby to reduce
their own problems with both, and this served to increase the Tibetan
artistic influence in Mongolia. In the second flowering of Sino-Tibetan

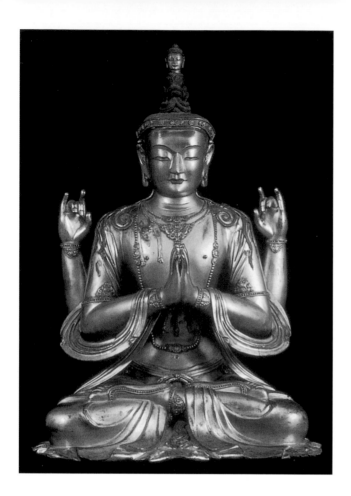

158 Shadakshari-
Lokeshvara, Sino-Tibetan,
18th century (Qianlong
period), Tibet or Mongolia.
Lacquered and gilded
wood, h. 91 cm (35.8 in)

art (during the Qianlong period), Tibetan stylistic influence would
extend into the art of Mongolia, as well as that of China, as is evident in
158 this eighteenth-century wooden statue of Shadakshari-Lokeshvara.

THE STATE AND THE ORDERS ASSUME THEIR FINAL
FORM (17TH CENTURY)

The ascendancy of the Gelug Order

The third Dalai Lama, who was the fourth-generation disciple of Tsong
Khapa, revived the political and religious relationship with the Mongols
that the Sakyapa lamas had forged two hundred years before at the time
when China itself had fallen under their rule. Now, the leader of the

Gelugpa sought to benefit his situation through alliance with Tibet's northern neighbours, and he visited the Mongol leader Altan Khan in 1578. The title of Dalai Lama was first bestowed upon this lama, as third Dalai Lama, by the Mongol khan – the titles of first and second Dalai Lama were awarded posthumously to his lineage predecessors. Upon his death in 1588 it was determined that his reincarnation was a great-grandson of Altan Khan, which united the power of the Mongol khans and the developing Gelug Order. This gain in power by the Gelug Order did not go unnoticed by the competing orders, and by 1610 the Gelugpa responded to rival orders' hostility by inviting the Mongols into Tibet, on their side. Nearly 250 years had passed with little foreign involvement for Tibet, but that now ended.

The fifth Dalai Lama came to his maturity at a time when China had again been overpowered by nomadic peoples from its northwest borders, this time the Manchus, whose dynasty, the Qing, would survive into the early twentieth century. The Tibetans found themselves in an advantageous position, thanks to their history of alliances with peoples on the western borders of China, prompting calls from the Manchus for assistance in negotiating on their behalf with peoples who posed a threat to China's rulers. This had the effect of pushing the Tibetans and Mongols even closer together, and the seventeenth and eighteenth centuries are an era of flourishing religious and artistic achievements in Mongolia and rich interchanges with Tibet.

Distinctive Tibetan styles
By the sixteenth century, Tibetan art had been an evolving, growing tradition for over five hundred years. During most of that time it could be regarded as a series of regional, often sectarian, styles that had first incorporated and then gradually refined a variety of foreign sources, most notably the Indo-Nepalese, Kashmiri and, since the fourteenth century, the Chinese style. These influences did not disappear, but continued to be reflected in the art of this later period in ever greater refinement, as can be seen in the Nepalese-style gilded plaques at Densatil, or among the more naturalistic, Chinese-influenced images associated with much of the art at Gyantse.

Nonetheless, the sixteenth century, which brought a transfer of religious and political power to the Gelug Order, also saw a maturing of artistic styles, which retained features of those earlier sources, but which could now be more readily labelled as distinctly Tibetan. The growth of the Gelugpa throughout the country also contributed to a greater uniformity among artistic styles.

Some of the works of the late sixteenth century provide both a link with the past and indications of the maturity that was to emerge during the following century. It has been suggested that some important new directions for Tibetan painting can be seen in a Sakyapa image of

162 Mahakala. He is a favourite protector deity of all the orders and is portrayed in a number of forms, several of which are illustrated in the corners of this tangka. Nowhere, however, is he more vividly portrayed than in this magnificent tangka. The earlier, somewhat muted, flat colours of the Sakyapa paintings from Ngor are replaced with a rich vibrancy of reds, blacks and whites (especially effective against the black figure) which serve to make Mahakala seem almost to jump off the surface. The central figure dominates the composition, not so much by his size in relation to the other figures as by the sheer energy of his form and colours, which push Mahakala forward almost as a separate painting. The formalism and orderly placement of the surrounding images has been modified, with the monks now freed from their roundels, and entire areas, as seen along the bottom, are enlivened by ferocious deities, lamas and *mahasiddhas* dancing, free of all boundaries. The figure still remains the primary subject, a characteristic found throughout Tibetan painting, but with a greater degree of naturalism, more fluid brushwork and more vibrant colours. In earlier paintings, even when the primary subject was this large, the sense of the presence of surrounding images sharing the space was far stronger. In this tangka, the artist has chosen to enhance the central figure, but the surrounding images are also given greater freedom of movement, breaking free from their formerly limited settings.

The more powerful naturalism that was gradually becoming ever more evident in the Tibetan art of the later centuries is also visible among some of the most complex subjects. Despite their multiple arms,

160 heads and myriad attributes, figures such as a bronze of Vajrakumara are imbued with massive, proportional forms and convincing movement. The greater abstraction found in similar subjects from earlier centuries can be seen by comparing this figure with a twelfth-century version of

159 the same deity, which is less complex and lacks the convincing, fluid movements and proportions of the later Vajrakumara, as also of the figure of Mahakala in the tangka discussed above (*ill.* 162).

Other sixteenth- to seventeenth-century sculptures more clearly follow the direction seen in images in the Gyantse style towards greater realism and naturalistic form. Such images of lamas seem more at ease, in relaxed poses instead of the frontally oriented position of earlier figures. This naturalism is also evident in the drapery, which follows the shapes of the body underneath.

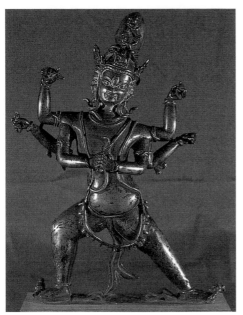

159 Vajrakumara. Although it lacks the complexity of the later version below, this 12th-century example yet radiates power and energy, befitting one of the favourite deities for revealing the deepest spiritual energies of the unconscious mind. Western Tibet. Brass, h. 33.5 cm (13.2 in)

160 Vajrakumara. Figures like this are cast in several parts; with the faces painted to heighten the contrast, the entire ensemble pulsates with power. 16th–17th century, central Tibet. Bronze, h. 39.4 cm (15.5 in)

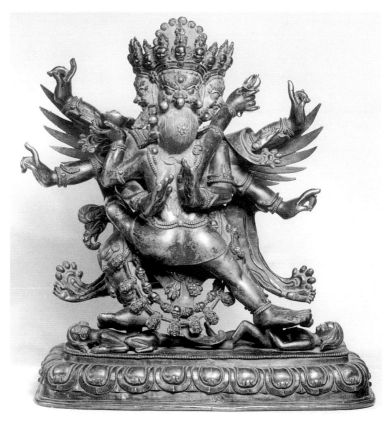

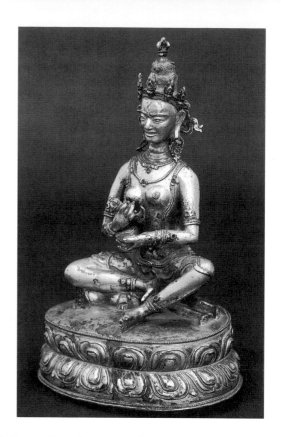

161 Nairatmya, late 16th
century, central Tibet. Gilt
brass, h. 23.5 cm (9.25 in)

The special Tibetan ability to blend aspects of the beautiful and the
terrible in the same image continues beyond the sixteenth century as
161 well. A late sixteenth-century image of Nairatmya is unusually posed,
for the goddess is typically shown embracing her partner or dancing,
very much like the goddess Vajravarahi. This singular image reveals
the remarkable synthesis of one of the dualities central to Vajrayana
Buddhism, the merging of the beautiful and the terrible. She is a tall,
elegant figure, seated in a comfortable pose and wearing jewellery
(originally encrusted with stones) that accentuates her regal presence.
Contrasting with these aspects conveying beauty are a number of sym-
bols of the opposite realm of meaning. Her tiara is formed from a row of
skulls, she holds the chopper and skull bowl filled with blood – symbols
of chopping up misconceptions that block the path to understanding –
and she sits atop the deity who represents egoism. Her elegance and
beauty is also balanced by her angry expression, third eye and red hair,
details associated with fierce deities.

192

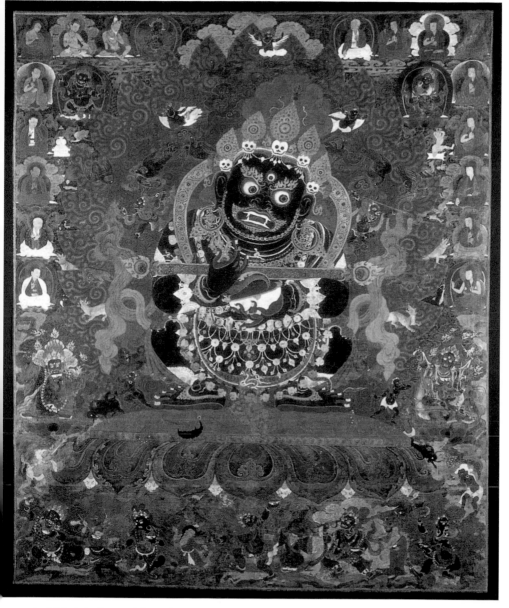

162 Mahakala. Exemplifying the greater naturalism of later Tibetan painting, the vivid colour and sheer energy of this 16th-century tangka make it a masterpiece. Early 16th century, central Tibet. Gouache on cotton, h. 161.6 cm (63.6 in)

The Great Fifth Dalai Lama and the Potala

By the middle of the seventeenth century the Gelugpa, under the leadership of the fifth Dalai Lama, and assisted by their alliance with the Mongols, had risen to become the dominant political authority and the most powerful religious order in Tibet. One means of measuring the success of the Great Fifth is his grand buildings. In the east, in Kham, he founded the great monastery of Labrang, and throughout the kingdom his vision of grandeur resulted in ambitious buildings. His penchant for hilltop locations, historically reserved for forts and palaces – monasteries usually being sited in more modest settings – culminated with the great Potala in Lhasa. By the middle of the century the consolidation and additional construction of the Potala was well under way, providing an appropriately regal setting for what had once been the palace of Songtsen Gampo, the first king.

1, 163

The enlargement of the cluster of buildings that had long occupied the hill, with its commanding view out over Lhasa, was not completed until 1695, thirteen years after the death of the fifth Dalai Lama. The Potala is more than just a monastery, serving also as a fortress and as the administrative seat of the country. It follows the traditional principles of Tibetan architecture (see Chapter 2), but its enormous size, elaborate staircases and walls – with, as some claim, a thousand windows – and the truly spectacular setting take it well beyond any other construction in the country.

This remarkable monument generates an imposing image:

> Even now it seems to float. The contrasts of colour are breathtaking: the dark red central mass hung with a black curtain; the long expanses of whitened stone with windows, outlined in black and tapering upwards, very small on the lower expanses and larger in the upper stories. The wide steep stone stairways enhance the effect of the sheer rock on which the palace is built, and the dazzling accents of the small gold canopies relieve the militant squareness of the flat roof-tops. If only this survived of all Tibetan achievements, they would have staked an incontrovertible claim to the unique genius of their own national culture. (Snellgrove and Richardson, p. 200)

The unity of spiritual and temporal power represented by the fifth Dalai Lama was physically and aesthetically communicated by what has come to be viewed as one of the world's most memorable works of architecture. The grandeur of the Potala derives from its size, its siting and its powerful simplicity when viewed from the plains below. As with portions of the nearby Jokhang, the most sacred of Tibetan monasteries,

194

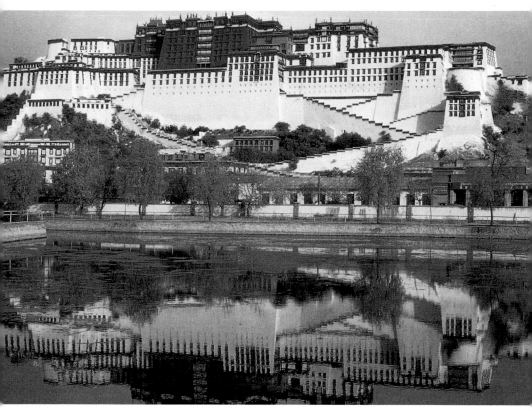

163 View of the Potala, Lhasa, Tibet

some of the architectural details in the Potala, such as wooden pillars and capitals, as well as fragments of deteriorating wall paintings, can be assigned to the formative periods, as early as the seventh or eighth century in a few instances. Most of the existing structures on the site were left intact, the considerable additional construction being erected around them. The majority of the architectural details of the Potala remain within the Tibetan tradition, but aside from the dramatic panoramic view accentuating the sloping walls, multiple storeys, roofs and window treatments, the native architectural manner is more readily appreciated within individual monasteries, such as Sera.

164

The red buildings at the centre of the complex comprise the Potrang Marpo, the red palace, the location of religious services in the Potala. It is built around an atrium, as are several of the other buildings, and it is

164 Sera monastery, Tibet

centred above a large assembly hall and flanked by four chapels, one with the burial *chorten* of the fifth Dalai Lama. The red palace was the largest single construction project ever undertaken in Tibet, with over eight thousand artisans and workers involved.

Although the site was suited for traditional fortress and palace architectural schemes, and these had previously been the primary uses for the hilltop, the builders were unable to follow traditional mandala plans for the arrangement of the numerous interconnected buildings because of the uneven terrain. As with many monasteries, the upper roofs display 58, 165 Buddhist emblems, such as the wheel and deer, symbols of the Buddha's first sermon after his enlightenment, and finials turned into mythical creatures. Such ornaments are of the finest materials and workmanship, as are many of the interiors, and a good deal of restoration is continuing to be done, for the Potala is the prime tourist destination in Tibet, and as such is endorsed by the Chinese government.

165 Detail of the roof decoration of the Jokhang, Lhasa, Tibet

THE MATURITY OF THE LATE PERIOD (17TH–19TH CENTURIES)

The central regions and the New Menri style

One style of Tibetan painting, often known as the New Menri style, continued the evolution towards a greater boldness. This can be seen in the increasing naturalism of figures, described by assured, confident line work, rich colours, especially orange and green, and elegant details, especially in the garments and lotus petals. Architectural details assume a greater proportion of the setting, largely replacing the formulaic niche-shrine compositions of older tangkas. In fact, with the ascendency of the Gelugpa, there is an increase in the number of architectural details in many paintings from the central regions. The energetic building pro-grammes, especially that of the fifth Dalai Lama, with its culmination in the gleaming splendour of the Potala, would seem to be reflected in the subject matter of paintings.

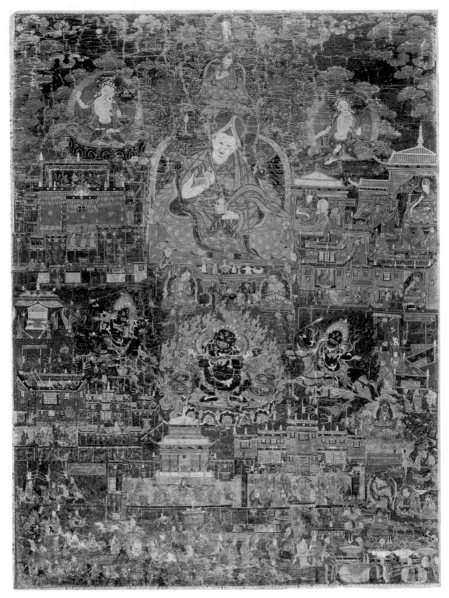

166 Kunga Tashi and incidents from his life. The posture of the central figure has an easy naturalism, no longer enclosed within a niche. The enthroned Kunga Tashi is placed comfortably above and outside the surrounding deities, buildings and peonies. Portions of this tangka reveal architectural details of central Tibetan temples, most of which no longer exist. Late 17th century, Tibet. Gouache on cotton, h. 94 cm (37 in)

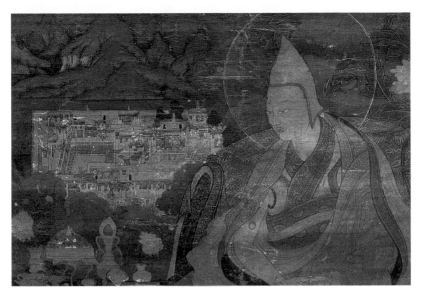

167 Grand Lama (detail), 18th century, Tibet. Tangka, gouache on cotton,
h. *c.* 75 cm (*c.* 29.5 in)

These features, especially the increased importance of the architectural
setting, can be seen in a late seventeenth-century tangka of Sakya Lama 166
Kunga Tashi. The architectural details show remarkably close views of 168–69
various temple walls and courtyards, including decoration still found
among today's monastic centres. Beginning with the completion of the
Potala at the end of the seventeenth century, the genre of combined
narrative-architectural scenes broadens, adopting a more distant view-
point and returning to the traditional view of a paradise scene, only this
time on earth.

This formula of an important lama situated outside his monastery and
depicted alongside narrative details of his life continued to be popular, 167
and is especially important now as a valuable record of early monastic
building. The paradise scenes of various deities from the same period also
include architectural settings, but, like their celestial occupants, they were 170
intended to illustrate a more perfect world, with details subordinated to a
grand scheme. Architectural interest had been visible in Tibetan painting
for over a thousand years. The wall paintings of Dunhuang, for example,
include narratives of the Chinese pilgrim Hsuan Tsang approaching
the gates of walled cities, as well as elaborate celestial palaces of deities,
such as the Pure Land of Amitabha. Interest in depicting buildings is also
found among earlier murals at Shalu, and the tangka of Samye (*ill.* 56) is

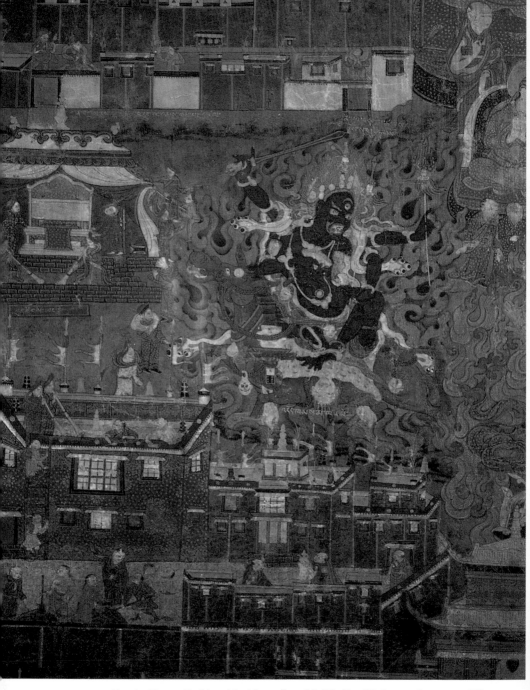

168, 169 Kunga Tashi and incidents from his life (details), late 17th century, Tibet.
Tangka, gouache on cotton, h. 94 cm (37 in)

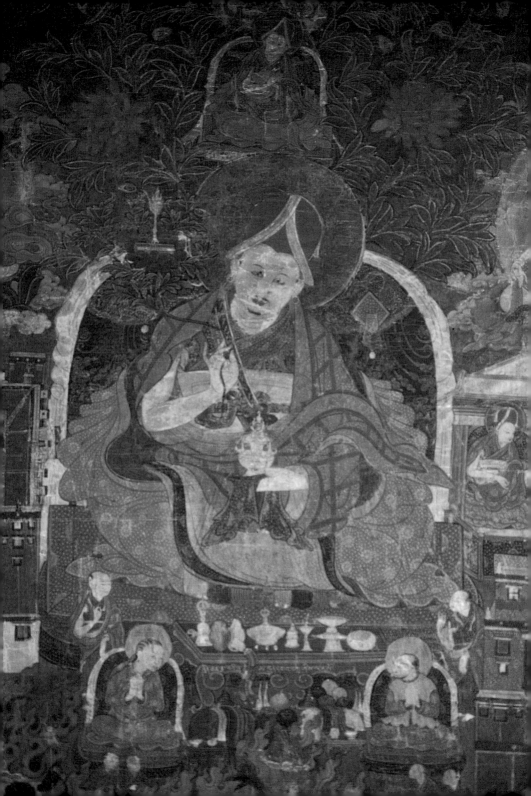

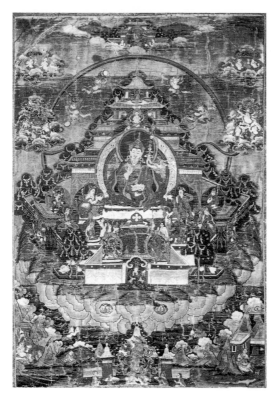

170 *(left)* Paradise of
Padmasambhava, 18th
century, Tibet. Tangka,
gouache on cotton,
h. *c.* 65 cm (*c.* 25.6 in)

171 *(right)* The Potala
and the monuments of
central Tibet, 19th century,
Tibet. Tangka, opaque
watercolour on cloth,
h. 98.5 cm (38.8 in)

one of the earliest known paintings devoted to a single temple. None-theless, the eighteenth- and nineteenth-century focus on earthly detail and brilliance, though still idealized, does suggest a greater awareness of landscape, even though Tibetan artists never developed a graphic appreciation of their physical surroundings to the degree that the Chinese did.

Many of these interesting panoramic views of the later period include several temples, with the actual locations of the monuments compressed within a single scene. One nineteenth-century painting, organized as a mandala, shows a conflation of temples and monasteries, including the clearly distinctive hilltop Potala and the Jokhang, in the lower right, which is allotted an equal amount of pictorial space, appropriate to its status as Tibet's most sacred temple. Along the top are three important Gelugpa monasteries, with the large Ganden complex in the upper right. In the lower left is Samye, founded by Padma Sambhava in the late eighth century. The combined architectural and narrative themes provide an opportunity to incorporate additional buildings as well as processional scenes celebrating the prestige of Gelug lamas.

171

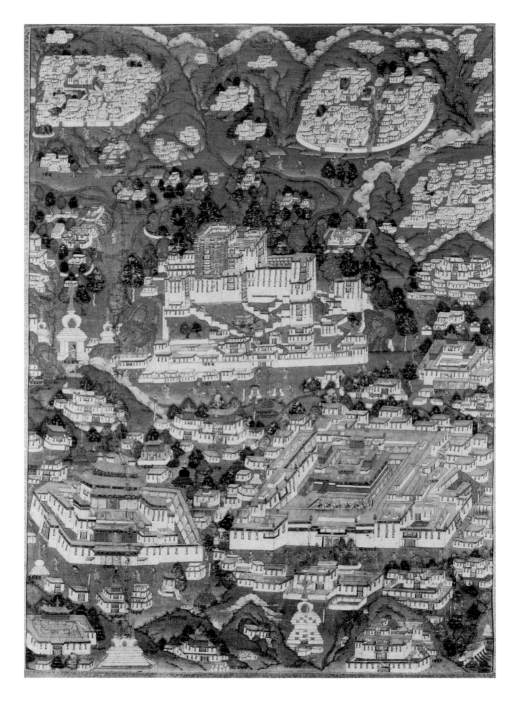

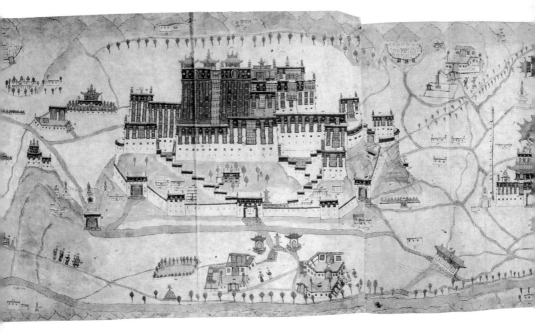

172 View of Lhasa, with the Potala and the Jokhang to the right, by a Tibetan lama, *c.* 1859. Drawing, h. 62 cm (24.4 in)

More detailed architectural records can be created when more precise tools are used, such as in this charming drawing of a similar scene, said to have been done by a Tibetan artist around 1859. The Potala, the Jokhang and many of the same elements are visible, but the lower angle of view, suggesting it was done on the spot, as well as the folk-art style of the figures and trees, have replaced the spiritual vision of the paintings with an image closer to that of a photograph, perhaps a drawing commissioned as a record of the two palaces.

A related subject, described in the literature and also known in paintings of the last few centuries, is known as Shambhala. A magical land, Shambhala is surrounded both by snow-capped, impassable mountains and by a powerful energy or force that is to remain until barbarism and warfare are ended. A few centuries from now, the world will be so completely overcome by war and negativity that the king of Shambhala will finally come forth with his armies and save the world, permitting the dharma to spread worldwide. This golden land is believed to be somewhere to the north of Tibet, but it can be found only by one pure in heart, free of the anger and ignorance that rule the current world. These beliefs bring the concept of the Pure Land within the comprehension

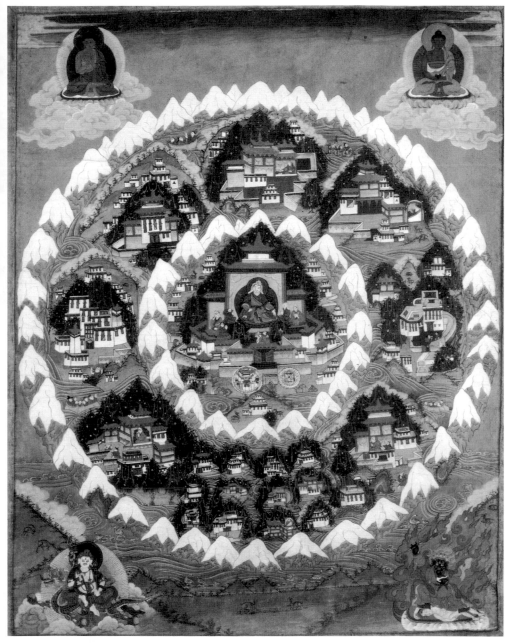

173 A typically mandala–like representation of the magical land of Shambhala, with its king at the centre, 19th century, Tibet. Tangka, gouache on cotton, h. *c.* 44 cm (*c.* 17.3 in)

of those living in the present, making the discovery and attainment of
Shambhala a conceivable goal. During the past two centuries the Panchen
Lamas have associated themselves with Shambhala, claiming rebirth there
as the kings of Shambhala.

173 The king is typically shown at the centre of the mandala-like repre-
sentations of Shambhala, with his palace placed at the centre of the king-
dom, much as the Potala is positioned in topographical paintings. In both
subjects, the primary structure is surrounded by important monasteries
and temples; in the case of Shambhala, rows of snowy mountains enclose
the kingdom. The text associated with the kingdom is the *Kalachakra
Tantra*, received according to tradition directly from Shakyamuni Buddha
and offering an explanation for the tragic times in which we now live.
The name Shambhala came to represent a romantic vision of the perfect
world and it has long captured the imaginations of Westerners and inspired
literature and motion pictures – it is the prototype for the Shangrila of
the novel *Lost Horizon*. Today, a Kalachakra mandala is sometimes created
out of sand particles, part of a traditional ceremony for peace according
to which a person with good faith who views the mandala representing
Shambhala will be reborn in a 'new age', the Golden Age of Shambhala.

The second flowering of the Sino-Tibetan style

By the eighteenth century, Chinese interest in Tibetan religion and art
could be seen in projects as vast as the recreation of entire Tibetan temples
on Chinese soil, complete with countless statues, paintings, and vessels
of porcelain, enamel and silver to decorate the shrines in the Tibetan
manner. The results were brilliant, incorporating a great variety of media,
including some of China's finest silk and textile objects (especially
appliquéd silks). Most were made for use by the imperial household, with
others presented as gifts to Tibetan hierarchs received at court. Crowned
Buddhas, a reference to the emperor, and richly adorned bodhisattvas
were among the favourite images. This relationship was highlighted by
periods of companionship between high-ranking Tibetan lamas and the
Chinese emperor, especially during the Qianlong period, the almost
sixty-year reign in the eighteenth century of the emperor most devoted
to Tibetan Buddhist practice.

 This second efflorescence of Sino-Tibetan art embraced a greater
range of subjects and styles, ranging from elaborate and technically per-
fect gilded bronzes to images in other media, such as a seated Shadakshari-
158 Lokeshvara, particularly notable for its material, lacquered and gilded
wood. This is almost identical to the fine gilded metal sculptures being
produced at that time, many of them in Mongolia, also the likely origin

of this piece. It reflects the mature Sino-Tibetan style in its technical accomplishment, precise details and bright gilding, presenting a Tibetan subject rendered very much in the Chinese style.

Many fine images of arhats had been created in the early fifteenth century as part of the first wave of Sino-Tibetan imagery coming out of imperial Chinese workshops. By the seventeenth century, Tibetan portraits of arhats had continued to evolve into a strongly sinicized style, including a Chinese landscape setting, and a similar style was also used for the more eccentric *mahasiddhas*. Tibetan artists favoured the contrast between the lyrical, peaceful Chinese landscape and the focused, inward gaze of the arhat.

The Chinese traditional art of silk embroidery was another prime medium in which Sino-Tibetan style and imagery were displayed, as seen in a masterful eighteenth-century version of Yama in ferocious form, like many images in this mature art. The artists' mastery of the embroidery technique results in the appearance of fine lines, as if the image had been painted. And in the work's intense colours – including four shades of blue, and of yellow – and dynamic lines, it rivals the achievements of Tibetan painting, as comparison with a contemporary tangka of Mahakala, likely from Mongolia, makes clear. The dynamic subjects are similar, both outlined by flames, and exhibit some of the technically advanced achievements at the end of the centuries of Chinese and Tibetan artistic interaction. Like images in metal created during this period, eighteenth- and nineteenth-century appliquéd silks combine Tibetan subject matter and iconography with Chinese technique. The technical brilliance of Chinese silk appliqué included such nuances as three-dimensional sculptural shaping, achieved by stuffing cotton batting under the fabric of such areas as facial details or hands to achieve a relief effect to complement the richly coloured composition.

The Karma Gadri school and Chinese influence

The greater use of bright colours and landscape elements, most notably the blues and greens that had long prevailed in Chinese art, are an essential aspect of the topographical paintings that became popular in the seventeenth through nineteenth centuries, including those of the mythical land of Shambhala. These qualities are especially prominent during the seventeenth and eighteenth centuries, often paralleling Chinese styles. Known as the Karma Gadri school, this style of painting first appeared in eastern Tibet in the sixteenth century, and now became a major school of Tibetan art. The style was developed by the Karmapa branch of the Kagyu Order; it was most practised in Amdo and Kham, but eventually

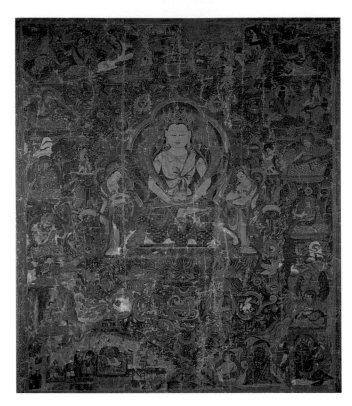

174 (*left*) Amitayus, god of endless life. Although this complex painting, with its rich landscape and vigorous details, derives from western Tibet, it also reveals the influence of central and eastern styles, evident in the brighter colours, general treatment of the landscape and the active forms beneath Amitayus. Early 17th century, Ladakh or western Tibet. Tangka, gouache on cotton, h. 78.1 cm (30.75 in)

175 (*right*) Shakyamuni Buddha with scenes of his former lives, late 17th–early 18th century, eastern Tibet. Tangka, gouache on cotton, h. 66 cm (26 in)

175 spread beyond these eastern regions. This Karma Gadri-style painting of Shakyamuni Buddha with scenes of his former lives from eastern Tibet is a particularly good example of the influences and complexities which constitute the later Tibetan tradition. If compared with similar, but earlier, compositions from the other two regions, the stylistic changes are dramatically clear. Western Tibetan paintings (see *ill.* 151) are richly detailed, with their muted colours, busy, decorative surfaces and fine line work which continue the styles and motifs passed on from Kashmir and incorporate aspects of the Indo-Nepalese traditions of central Tibet. Painting from the central area (see *ill.* 147) displays a more vibrant palette, but also elements of Chinese influence, not surprising given the area's political and geographic situation. Seventeenth-century paintings not only show strong Chinese influence in the overall landscape and in such details as the stylized, blue and green rocks; they also incorporate details from contemporary Mughal painting. In the upper and lower left corners of this tangka there are trees, stylized waves and playful monkeys, almost identical to motifs familiar in royal Mughal ateliers.

208

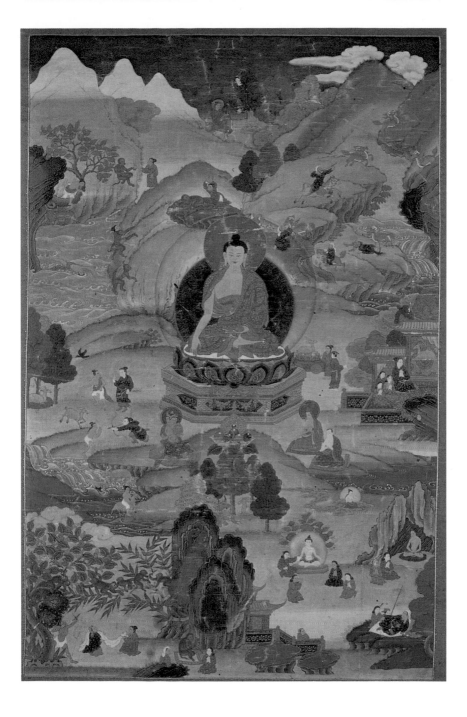

The continuously evolving relationship between Chinese and Tibetan art in this later period can be seen by comparing two favourite themes, landscape and portraiture. While there was a long tradition of portraiture in Chinese art, landscape was a subject at which the Chinese excelled, endlessly exploring without exhausting its limitless possibilities. In Tibetan art it was portraiture that was of critical importance, although both themes continued to grow in prominence, especially during the later periods, deriving most of their motifs and style from Chinese art. In the case of landscape painting, so strong was the Chinese school that Tibetan artists never developed a landscape tradition based on observation of their own surroundings, but remained rooted in the pictorial images learned from the Chinese, another example of the conservative pattern of art copying art.

Tibetan arhat images had echoed the Chinese fascination with capturing their eccentric appearance at least since the fourteenth century. In China, where the subject is best known in painting, the genre stabilized very early, retaining, as examples from at least the Song dynasty show, typical postures and garments, with the figures depicted surrounded by the distinctive blue and green Chinese landscape, including the favourite gnarled trees and fantastic rocks (ill. 132). In eastern Tibet, by the sixteenth and seventeenth centuries, Tibetan versions of arhats had become almost fully sinicized, including such details as Chinese fu-dogs, attendant figures and ritual objects. However, some Tibetan qualities, such as clarity of form and the preference for flattened, two-dimensional figures, are retained despite the reliance upon Chinese landscape styles and handling of spatial depth.

A great number of paintings are assigned to eastern Tibet, not all to the Karma Gadri school, but as part of a larger body of Chinese-derived styles of later Tibetan painting; elements of these Chinese-inspired styles are also found in the other regions. In some paintings from central Tibet, the blues and greens favoured by the eastern schools are somewhat muted, but the forms themselves become bolder and the setting even more fanciful. In one eighteenth-century tangka, Gampopa floats above just such a bold landscape, his face a sensitive study of old age and kindness. He was the chief disciple of Milarepa and the de facto founder and organizer of the Kagyu Order, and his disciples in turn founded several suborders within the Kagyu tradition. His robes and throne back are richly decorated in gold floral designs, and he looks out upon two unnamed monasteries, rendered in a generalized manner. The naturalistic portrait and the topographical setting typify the dominant themes of the era. The hats various figures wear denote their affiliations: Gampopa's

176 Arhat Kalika, late 14th century, China. Gilt bronze, h. 16.5 cm (6.5 in)

style of hat indicates the major Kagyu Order, and its orange colour that it belongs to the Shamarpa lineage; in the upper right and lower left corners the same style hat is rendered in black, emblem of the Karmapa, one of the important suborders founded by his disciples. Atisha is in the top row, second from the left, wearing his distinctive red 'pandit' cap.

By the end of the eighteenth century, Tibetan painting had lost most of the regionalism that been a hallmark of its development for centuries. Lineage tangkas continued to be popular, a staple of the monastic ateliers, although they often displayed larger numbers of figures arranged in pyramidal fashion. Numbers of Pure Land paintings were created in the nineteenth century and, in their architectural details and landscapes, can be associated with the topographical paintings discussed above. Paintings of ferocious protector deities continued to be called for, and such complex, traditional subjects did remain largely within their well-established stylistic format. The vigorous spirit, the sheer energy, of this painting belong to the long history of protector figures in Tibetan art, influenced by a Chinese image-type traced as far back as the Tang and Song dynasties.

178

One style of seventeenth- and eighteenth-century sculpture continues in the direction of greater naturalism first noted in the early fifteenth-

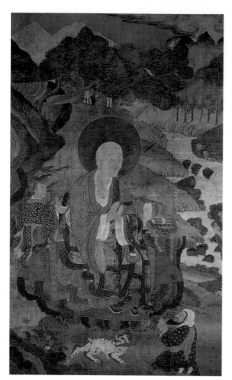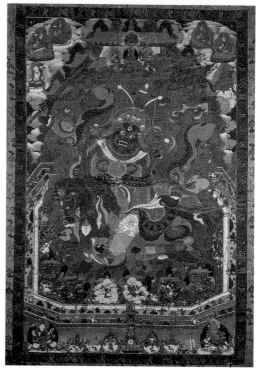

177 (*left*) Arhat Angaja. The solitary gnarled trees and fantastic rocks prominent in earlier paintings are reduced in size but still rendered in the blue and green style that remained a characteristic of Chinese painting after the Tang dynasty. 17th century, eastern Tibet. Tangka, gouache on cotton, h. 96.5 cm (38 in)

178 (*right*) Sertrap, late 18th–early 19th century, Tibet. Tangka, gouache on cotton, h. 143.5 cm (56.5 in)

century images in the Kumbum at Gyantse, and displayed in the sophistication of such images as the portrait of the Lama Karma Dudzi (*ill.* 150). To this realism was added a refinement in technical skill, such as chased designs that enliven the surface with fine decorative touches and, along with gilding, help create a refined beauty. These technical achievements can also be seen in the faces, with sharply delineated features sometimes adding a greater degree of naturalism. The same techniques had been one of the characteristics of the Sino-Tibetan bronzes of the fifteenth-century Yongle period and were to be revived in the second wave of Sino-Tibetan art of the eighteenth century. Some of the details, such as the sharply cut drapery, lend an artificial, mannered precision, yet this

180

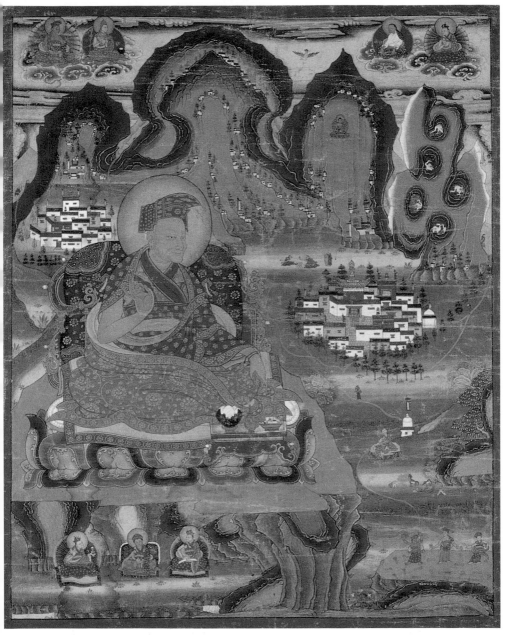

179 Gampopa, 18th century, central Tibet. Tangka, gouache on cotton, h. 61 cm (24 in)

180 Lama, 16th century, eastern Tibet. Gilt
brass, h. 31 cm (12.2 in)

also serves to enhance the naturalism of the face, creating an aesthetic,
dynamic tension between the abstract and the realistic, a balance of
opposites which benefits the resulting image.

Aspects of the synthesis of foreign styles that evolved into the mature
Tibetan artistic tradition can be traced from the period of the second
diffusion. By the thirteenth century, in parallel with the Tibetan mastery
of Buddhist religious practices, this artistic tradition began to assume a
national identity, one that matured over the following centuries, while
continuing to absorb foreign, now mainly Chinese, artistic influences.
The ascendancy of the Gelug Order, especially in the period of the fifth
Dalai Lama, brought most of the regional schools into an ever greater
national style, one that maintained its vigour into the twentieth century.
As the twenty-first century arrives, Tibet faces issues of spiritual identity
and ultimate survival as great as any in its long and colourful past. At least,
for the first time, a significant portion of the rest of the world is aware of
Tibet and its formidable task.

Glossary

Bibliography

Location of Objects and Acknowledgments

Index

Glossary

For the sake of simplicity a phonetic system of transliteration has been followed, eliminating diacritical marks (for example *prajnya* instead of *prajña*). For Chinese words, the pinyin system of romanization has been used.

Anige (or *Anigo*) (1245–1306) Nepalese artist invited to Mongol court at Beijing; directed various artistic projects, including the Tibetan-style White Pagoda of the Miaoyingsi

arhat (literally 'worthy one') a Buddhist saint who in life has fully realized selfless reality, thus being assured of nirvana after death, and who, like a bodhisattva, leads the way for believers; in Tibet a group of sixteen to eighteen is commonly portrayed

Atisha (c. 982–1054) a Bengali Buddhist master who came to Tibet in 1042; his followers founded the Kadam Order, one of the dominant orders in Tibet until Tsong Khapa's reforms in the 15th century and the ascendancy of the Gelug Order

Avalokiteshvara (literally 'all-seeing one') the most important bodhisattva, the embodiment of compassion, and Tibet's patron deity; also known as Lokeshvara, 'lord of the universe'; the Dalai Lamas are emanations of him

Bardo an interval or intermediate period of experience between death and rebirth

Begtse protector deity of Mongolia

Blue Annals written in the 15th century, a rich repository of detail on the early orders and the lives of individual lamas

bodhisattva (from Sanskrit *bodhi*, enlightenment; *sattva*, being) an altruistic being dedicated to the enlightenment of all other beings

Bon traditional native Tibetan religion, partly absorbed by Buddhism; linked to archaic kingdom of Zhangzhung, thought to be in western Tibet; its main monastery (founded 1405) was in Menri, central Tibet

Buddha ('awakened one') a completely enlightened being; originally referring to the historical Shakyamuni Buddha, founder of Buddhism, the term came to include numerous ahistorical figures

celestial Buddhas see chart pp. 36–37

chorten Tibetan version of the Indian stupa; originally a burial mound, it evolved into a separate structure with various symbolic meanings and uses, including as a reliquary; Tibet's greatest example is the Kumbum at Gyantse

cold gilding a method of applying gold colouration to metal images using a mixture of gold powder and gelatin, usually painted on with a brush

dharma a term with numerous meanings, but which most often refers to the law or truth of Buddhist teaching

Dromton native of central Tibet and Atisha's chief disciple; founder of Reting monastery in 1057, north of Lhasa

Gampopa (1079–1153) one of the founders of the Kagyu Order, to which he brought the mysticism of his teacher Milarepa; his own disciples founded suborders of the Kagyu

garuda a creature part bird, part human; in Hindu religion associated with Vishnu, and frequently incorporated into Tibetan art, especially Newari-inspired objects

Gelug Order reform order, the 'yellow hats', founded by Tsong Khapa; since the 16th century, the dominant religious order in Tibet

Green Tara the compassionate consort of Avalokiteshvara, often shown single-headed and eight-armed

Guge early kingdom in western Tibet; chief monasteries were at Tabo, Tholing and Tsaparang

Hvashang one of the eighteen arhats, added along with Dharmatala to the earlier set of sixteen

Jambhala Buddhist deity who bestows wealth and personifies abundance; related to a number of Indian deities signifying prosperity, the best known being Kubera. In Tibetan art Jambhala is often the peaceful, wealth-bestowing aspect of Vaishravana, protector of the north

Kadam Order founded by Atisha and largely absorbed into the Gelug Order by the 15th century

Kagyu Order founded by Marpa, Milarepa and Gampopa, and tracing its origin back to the Indian adepts Tilopa and Naropa, it originated the Tibetan practice of leadership succession by reincarnation

Karma Pakshi (1204–83) second Karmapa, Kagyu Order, who rebuilt Tsurpu monastery; in lineage of Gampopa

Kumbum (literally 'hundred thousand images') located in Amdo, Kumbum is one of the six great Gelug monasteries and the birthplace of Tsong Khapa; but the best known Kumbum is the great *chorten* at Gyantse

lama ('superior person') originally a highly revered person or venerated monk; later became an honorific name for all senior Tibetan monks

Lhasa capital of Tibet, settled and the centre of culture since the 7th century; site of the Jokhang and the Potala

Mahakala one of the most prominent guardians or protector deities in Tibetan Buddhism; especially identified with the Sakya Order, but common to all orders

mahasiddha (literally 'great perfected being') refers to eighty-four eminent Indian Tantric teachers; free-spirited yogis rather than monks, also referred to as great adepts, their

unconventional behaviour invited creative images in Tibetan art

mandala a sacred place, most often represented as a geometric, symmetrical arrangement of shapes with a particular deity at the centre, in complex two- or three-dimensional versions from small paintings to entire monastic centres

mandorla a halo behind an auspicious figure that conveys an added spiritual aura

Marpa (1012–96) Tibetan monk who studied in India with famous masters; origin of the lineage of the Kagyu Order, his disciple Milarepa became the greatest of Tibetan yogis

Milarepa (1040–1123) Tibet's most popular yogi, he passed Marpa's secret teachings to his disciple Gampopa

mudra a gesture, often associated with a particular deity, such as the historical Buddha Shakyamuni reaching down to touch the earth, an act symbolizing his enlightenment

Newari a people who settled in early Nepal, ethnically related to Tibetans and responsible for most of what is considered Nepalese art

Nyingma Order (literally 'the ancients') the oldest of the four main orders, founded in the 8th century; Samye monastery a main centre

Padma Sambhava also known as Guru Rinpoche; an 8th-century Indian yogi invited to Tibet by the Tibetan king Trisong Detsen, he founded Samye, possibly the oldest Tibetan Buddhist monastery

Pala powerful kingdom in northeastern India, homeland of the historical Buddha Shakyamuni and source for many of the artistic styles of Nepal, Tibet and Southeast Asia

Palden Lhamo fierce protector deity especially favoured by the Gelug Order, protector of the Dalai and Panchen lamas and the only female in the set of eight guardian deities of the law (Dharmapalas)

Phagpa (1235–80) nephew of Sakya Pandita and prominent at the Mongol court of Kublai Khan; important for promoting an art incorporating Tibetan, Nepalese and Pala Indian styles

Prajnyaparamita (from *prajnya*, wisdom, and *paramita*, perfection) title of an important body of literature as well as the female goddess of wisdom

Rinchen Sangpo (958–1055) translator and leading figure in the second diffusion of Tibetan Buddhism, associated especially with Tholing monastery; sent by King Yeshe Od to study in Kashmir and Bihar, he returned to western Tibet bringing Kashmiri texts and artists

Sakya Order (literally 'grey earth') one of the four main orders; arose mid-11th century and was critical to the second diffusion; its founders trace their lineage from the earliest disciples of Padma Sambhava and Shantarakshita

Sakya Pandita (1182–1251) one of Tibet's greatest lamas; instrumental in the establishment of the Sakya Order

Shambhala mythical kingdom north of Tibet

Shantarakshita 8th-century Indian teacher instrumental in the introduction of Buddhism to Tibet; founder of

Nyingma Order and teacher to the successor of King Songtsen Gampo; supported the invitation of Padma Sambhava to Tibet

Sino-Tibetan term traditionally applied to images made in China but strongly influenced by Tibetan style and iconography, especially early-15th to 18th century. Some prefer *Tibeto-Chinese*, particularly for those images most Tibetan in style, especially gilded bronzes, reserving Sino-Tibetan for more Chinese-style images, such as arhat paintings and silk embroideries

Songtsen Gampo (r. *c.* 629–*c.* 650) first dharma, or religious, king of Tibet, credited with introduction of Buddhism there; married Chinese and Nepalese princesses

stupa see *chorten*

Tantric a generic term common to Hindus and Buddhists which implies rituals leading to immediate results; includes a vast esoteric literature, *tantras*, and often incorporates practices outside mainstream religions

tangka from the Tibetan *thang yig*, 'written word', with the sense of a painted or written record; most often describes paintings on cotton cloth, usually with brocade borders

Tara a female bodhisattva, the feminine counterpart of Avalokiteshvara; like him she saves devotees from all difficulties; the tutelary deity of Atisha

Tathagata an epithet for Buddha that came to refer to all Buddhas; usually used for a set of five emanations of the supreme Buddha essence (see chart pp. 36–37)

Tilopa Tantric master from Bengal, later considered the first patriarch of the Kagyu Order

Tsang one of two major regions of central Tibet and the location of many of the most important monastic centres

Tsong Khapa (1357–1419) founder of the Gelug Order, usually portrayed in a pointed yellow philosopher's hat

Ü one of two main regions of central Tibet (see also *Tsang*)

Vaishravana militant guardian deity of the north, who assumed an identity separate from the guardians of the other three directions

Vajrayana (from Sanskrit *vajra*, thunderbolt or diamond, which cut through all materials; and *yana*, path or vehicle) the last major form of Buddhism to develop; the practices of the Tibetan orders

Virupa one of the *mahasiddhas* or great adepts, typically portrayed pointing to the sun

yab-yum (literally 'father-mother') refers to male and female deities in sexual union

Yama Lord of Death

Yarlung dynasty religious kings (*c.* 630–846) who promoted the integration of Buddhism into Tibetan culture

Yeshe Od late 10th-century king of Guge kingdom; intent on purifying Buddhism, he sent several missions to Kashmir Buddhist centres for training, their most important member being Rinchen Sangpo

yidam archetypal tutelary deity and protector, often a practitioner's personal deity, as for example Mahakala was the *yidam* for the Mongol ruler Kublai Khan

Bibliography

Any modern study of Tibetan art is founded on the growing wealth of the scholarship of others, and for those publications I remain openly grateful. In addition to those listed in the acknowledgments, and whose publications are included, here must be added the names of Gilles Béguin, Roberto Vitali, Robert A.F. Thurman, Philip Denwood, John Huntington, Terese Tse Bartholomew, Patricia Berger, Pratapaditya Pal, Roger Goepper and Thomas Pritzker.

Alsop, I. 1990. 'Phagpa Lokesvara of the Potala'. *Orientations* (April), pp. 51–61

Anninos, T. 1997. 'Painted Tibetan Furniture'. *Arts of Asia* (Jan–Feb), vol 27, no 1, pp. 47–65

Ashencaen, D., and L. Gennardy. 1995. *The Mirror of Mind: Art of Vajrayana Buddhism*. London

Bartholomew, T.T. 1995. 'Introduction to the Art of Mongolia', on the *Asian Arts* website, www.asianart.com

Béguin, G. 1984. 'Virupaksa, le gardien au regard torve', *Arts Asiatiques*, XXXIX, pp. 78–86

— , and P.V. Caffarelli. 1987. *Demeures des Hommes-Sanctuaries des Dieux*. L'Architecture tibétain. Rome/Paris

— 1990. *Art ésotérique de l'Himâlaya: La donation Lionel Fournier*. Paris

—, et al. 1993. *Trésors de mongolie, XVIIe–XIXe siècles*. Paris

— 1995. *Les Peintures du Bouddhisme Tibétain*. Paris

Bell, C. 1993 (reprint). *Religion of Tibet*. Delhi

Berger, P. 1994. 'Preserving the Nation: The Political Uses of Tantric Art in China', in M. Weidner, ed. *Latter Days of the Law*. Honolulu, pp. 89–123

—, and T.T. Bartholomew. 1995. *Mongolia*. San Francisco

Beyer, S. 1978. *Magic and Ritual in Tibet: The Cult of Tara*. Berkeley

Chakravarti, S. 1980. *A Catalogue of Tibetan Thankas in the Indian Museum*. Calcutta

Chan, V. 1994. *Tibet Handbook*. Chico, Cal

Chandra, L., ed. 1970. *Kongtrul's Encyclopaedia of Indo-Tibetan Culture*. New Delhi

Chö Yang. 1991. *Year of Tibet*. Ithaca

Copeland, Carolyn. 1980. *Tankas from the Koelz Collection*. Ann Arbor

Cozort, Daniel. 1986. *Highest Yoga Tantra: An Introduction to the Esoteric Buddhism of Tibet*. Ithaca

Cultural Relics of Tibetan Buddhism Collected in the Qing Palace. 1992. Beijing

Czuma, S.J. 1992/93. 'Some Tibetan and Tibet-Related Acquisitions of the Cleveland Museum of Art'. *Oriental Art* (Winter), n.s., vol XXXVIII, no 4, pp. 231–43

Denwood, P. 1971. 'The Tibetan Temple'. in W. Watson, *Mahayanist Art After A. D. 900*. London, pp. 47–55

— 1994. 'Sacred Architecture of Tibetan Buddhism: The Indwelling Image'. *Orientations* (June), pp. 42–47

Essen, Ger-Wolfgang, and T.T. Thingo. 1989. *Die Götter des Himalaya*. Munich

Fisher, R.E. 1985. 'The Art of Tibet'. *Arts of Asia* (Nov–Dec), pp. 102–13

— 1993. *Buddhist Art and Architecture*. London

Frédéric, Louis. 1995. *Buddhism*. Paris

Genoud, C. 1982. *Buddhist Wall-Painting of Ladakh*. Geneva

Goepper, R. 1984. *Alchi: Buddhas, Goddesses, Mandalas*. Cologne

— 1993. 'The "Great Stupa" at Alchi'. *Artibus Asiae*, vol 53, no 1/2, pp. 111–43

— 1996. *Alchi: Ladakh's Hidden Buddhist Sanctuary*. London

Gordon, A. 1978 (reprint). *Iconography of Tibetan Lamaism*. Delhi

Govinda, Lama A. 1979. *Tibet in Pictures*. Berkeley

Handa, O.C. 1987. *Buddhist Monasteries in Himachal Pradesh*. Delhi

Handa, O.C. 1994. *Tabo Monastery and Buddhism in the Trans-Himalaya*. Delhi

Hatt, R.T. 1980. 'A Thirteenth Century Tibetan Reliquary'. *Artibus Asiae*, vol 42, no 2/3, pp. 175–220

Heavens' Embroidered Cloths: One Thousand Years of Chinese Textiles. 1995. Hong Kong

Henss, M. 1994. 'A Unique Treasure of Early Tibetan Art: The Eleventh Century Wall Paintings of Drathang Gonpa'. *Orientations* (June), pp. 48–53

— 1996. 'Himalayan Metal Images of Five Centuries: Recent Discoveries in Tibet'. *Orientations* (June), pp. 57–66

— 1996. 'Wisdom and Compassion: The Sacred Art of Tibet' (exhibition review). *Oriental Art*, XLII, no 2 (Summer), pp. 39–44

Huntington, J.C. 1985. 'Book Review and Discussion of the Problem of Style in Tibetan Painting'. *Orientations*, October, pp. 50–58

Huntington, Susan L., and John C. 1990. *Leaves from the Bodhi Tree: The Art of Pala India and its International Legacy*. Dayton

Jackson, David P., and Janice A. 1976. 'A Survey of Tibetan Pigments'. *Kailash*, 4, pp. 273–94

—, and Janice A. 1984. *Tibetan Thangka Painting: Methods and Materials*. London

Jackson, D. 1996. *A History of Tibetan Painting*. Wien

Jing, A. 1994. 'The Portraits of Khubilai Khan and Chabi by

Anige (1245–1306), A Nepali Artist at the Yuan Court'.
Artibus Asiae, vol LIV, 1/2, pp. 40–86

Karmay, Heather. 1975. *Early Sino-Tibetan Art*. Warminster

Karmay, Samten G., ed. 1988. *Secret Visions of the Fifth Dalai Lama*. London

Khosla, R. 1979. *Buddhist Monasteries in the Western Himalaya*. Kathmandu

Kossak, S.M. 1990. 'Lineage Painting and Nascent Monasticism in Medieval Tibet'. *Archives of Asian Art*, vol XLIII, pp. 49–57

Kværne, Per. 1995. *The Bon Religion of Tibet*. Boston

Lauf, D.I. 1979. *Eine Ikonographie des tibetischen Buddhismus*. Graz

Linrothe, R.N. 1994. 'The Murals of Mangyu: A Distillation of Mature Esoteric Buddhist Iconography'. *Orientations* (November), pp. 92–102

Linrothe, R. 1996. 'New Delhi and New England: Old Collections of Tangut Art'. *Orientations* (April), pp. 32–41

Macdonald, A., and A.V. Stahl, eds. 1977. *Essais sur l'art du Tibet*. Paris

Mallman, M.-T. de. 1975. *Introduction à l'iconographie du tântrisme bouddhique*. Paris

Mele, P.F. 1969. *Tibet*. Geneva

Nebesky-Wojkowitz, R. 1975. *Oracles and Demons of Tibet*. Graz

Neumann, H.F. 1994. 'The Wall Paintings of the Lori Gompa'. *Orientations* (November), pp. 79–91

Normanton, S. 1989. *Tibet: The Lost Civilization*. Harmondsworth

Obermiller, E. 1986 (reprint). *History of Buddhism in India and Tibet*

— 1988 (reprint). *Prajnaparamita in Tibetan Buddhism*. Delhi

Oddy, W.A., and W. Zwalf. 1991. *Aspects of Tibetan Metallurgy*. London

Olschak, B. 1973. *Mystic Art of Ancient Tibet*. New York

Pal, P. and H. Tseng. 1969. *Lamaist Art: The Aesthetics of Harmony*. New York

Pal, P. 1983. *Art of Tibet: A Catalogue of the Los Angeles County Museum of Art Collection*. Los Angeles

— 1990. 'Arhats and Mahasiddhas in Himalayan Art'. *Arts of Asia*. (Jan–Feb), pp. 66–78

— 1991. *Art of the Himalayas: Treasures from Nepal and Tibet*. New York

— 1992. 'Himalayan Mandalas in the Zimmerman Collection'. *Orientations* (February), pp. 36–45

—, ed. 1996. *On the Path to Void: Buddhist Art of the Tibetan Realm*. Bombay

Pallis, M. 1940. *Peaks and Lamas*. New York.

Piotrovsky, M., ed. 1993. *Lost Empire of the Silk Road. Buddhist Art from Khara Khoto (X–XIIIth century)*. Milan

Pritzker, T.J. 1989. 'The Wall Paintings of Tabo'. *Orientations* (February), pp. 38–47

— 1996. 'A Preliminary Report on Early Cave Paintings of Western Tibet'. *Orientations* (June), pp. 26–47

Rawson, P. 1991. *Sacred Tibet*. London

Reynolds, V. 1986. *Tibetan Collection: vol. III: Sculpture and Painting*. Newark

— 1990. 'Myriad Buddhas: A Group of Mysterious Textiles from Tibet'. *Orientations* (April), pp. 39–50

— 1997. 'Buddhist Silk Textiles: Evidence for Patronage and Ritual Practice in China and Tibet'. *Orientations* (April), pp. 52–53

Rhie, M., and R. Thurman. 1991 (expanded edition 1996). *Wisdom and Compassion: The Sacred Art of Tibet*. London

Ricca, F., and E. Lo Bue. 1993. *The Great Stupa of Gyantse*. London

Richardson, H. 1962. *Tibet and its History*. London

Roerich, George N. 1995 (reprint). *The Blue Annals*. Delhi

Samuel, Geoffrey. 1995. *Civilized Shamans: Buddhism in Tibetan Societies*. Washington

Schroeder, U. von. 1981. *Indo-Tibetan Bronzes*. Hong Kong

Singer, Jane Casey. 1994. 'Painting in Central Tibet, ca. 950–1400'. *Artibus Asiae*, vol LIV, 1/2, pp. 87–136

— 1995. 'Early Portrait Painting in Tibet', in *Function and Meaning in Buddhist Art*, ed. by K.R. Kooij and H. van der Veere. Groningen, pp. 81–99

— and Philip Denwood, eds. 1997. *Tibetan Art: Towards a Definition of Style*. London

Snellgrove, D., and H. Richardson. 1968. *A Cultural History of Tibet*. New York

Stein, R.A. 1972. *Tibetan Civilization*. Stanford

Taranatha's History of Buddhism in India. Chattopadhyaya, D., ed. (reprint). Delhi

Trungpa, C. 1975. *Visual Dharma*. Berkeley

Tucci, G. 1949. *Tibetan Painted Scrolls*, 3 vols. Rome

— 1967. 'Tibetan Art', in *Encyclopedia of World Art*, vol XIV, pp. 67–81. New York

— 1969. *The Theory and Practice of the Mandala*. New York

— 1973. *Transhimalaya*. Geneva

— 1989 (reprint). *Monasteries of Gyantse*. 3 vols. Delhi

— 1991 (reprint). *Stupa: Art, Architectonics and Symbolism*, trans. U.M. Vesci. Delhi

Turner, J., ed. 1996. 'Tibet', in *The Dictionary of Art*, vol 30. London and New York, pp. 804–51

Uhlig, H. 1995. *On the Path to Enlightenment: The Berti Aschmann Foundation of Tibetan Art in the Rietberg Museum Zurich*. Zurich

Vitali, R. 1990. *Early Temples of Central Tibet*. London

Wu Hung. 1995. *Monumentality in Early Chinese Art and Architecture*. Stanford

Wylie, T. 1959. 'A Standard System of Tibetan Transcription', *Harvard Journal of Asiatic Studies*, vol 22, pp. 261–67

Zwalf, W. 1981. *Heritage of Tibet*. London

Location of Objects and Acknowledgments

Numbers refer to illustration captions

Catherine and Lewis J. Burger, M.D. 102; Cleveland Museum of Art; Andrew R. and Martha Holden Jennings Fund (75.100) 124, Gift of Mary B. Lee, C. Bingham Blossom, Dudley S. Blossom III, Laurel B. Kovacik, and Elizabeth B. Blossom 156, Purchase from the J.H. Wade fund by exchange (70.156) 112; Courtesy John Eskenazi, London 44, 73, 100, 114, 146 Collection of Mr. and Mrs. John Gilmore Ford 13, 14, 21, 39, 66, 70–1, 82, 84, 92, 96, 110, 115, 160, 175; Robert Hatfield Ellsworth Private Collection 26, (Photo Shin Hada) 79, 138; courtesy Ramesh Kapoor, New York 41, 74; Kodaiji, Kyoto 38; The Kronos Collections, New York 32, 46, 88, 95, 136; London, By permission of The British Library (Add.Or.3013) 172; Copyright British Museum 91, 93, 134, Given by Miss Humphreys in memory of Edward Humphreys, Esq. 48; Los Angeles County Museum of Art. Gift of the Ahmanson Foundation (M.75.10) 75, Gift of Dr. Robert Coles (M.82.169.15) 81, From the Nasli and Alice Heeramaneck Collection (M.81.90.16) 90, (M.81.90.13) 122, (M.83.105.16) 166, 168–9, From the Nasli and Alice Heeramaneck Collection, Museum Associates Purchase (M.83.105.17) 36, (M.77.19.9) 40, (M.77.19.9) 49, (M.77.111.2) 76, (M.81.90.2) 85, (M.70.1.6) 159, (M.70.1.4) 161, (M.77.19.14) 174, From the Nasli and Alice Heeramaneck Collection, Purchased with funds provided by the Jane and Justin Dart Foundation (M.81.90.5) 111, (M.81.90.18) 176, Gift of Christian Humann (M.76.143.) 34, (M.77.152) 150, Purchased with funds provided by the Trustees in honor of Dr. Pratapaditya Pal (AC1994.4.1) 97, Gift of Doris and Ed Wiener(M.72.108.3) 12; Michael McCormick Collection 16, 18, 31, 135, 141, 151; Collection of The Newark Museum. Purchase 1920 Albert L. Shelton Collection 56, Purchase 1969 The Members' Fund 149, Purchase 1973 The Members' Fund and Membership Endowment Fund 152, Purchase 1981 W. Clark Symington Bequest Fund 68, Purchase 1993 The Members' Fund, Sophronia Anderson, William C. Symington and

C. Suydam Cutting Bequest Funds and Life Memberships 24; New York, The Asia Society, Mr. and Mrs. John D. Rockefeller 3rd Collection. Photography by Lynton Gardiner 120, 137; New York, The Metropolitan Museum of Art, Purchase, Friends of Asian Art Gifts, 1987 (1987.144) 2, Purchase, Friends of Asian Art Gifts, 1991 (1991.152) 78, Purchase, Miriam and Ira D. Wallach Philanthropic Fund Gift, 1991 (1991.74) 25; Paris, Musée Guimet (© Photo RMN) 11, 121, 171, 173, Gift of Lionel Fournier 99; Patna Museum 109; Peshawar, Peshawar Museum 37; Private Collection 8, 113, 133, 144–5, 167, (Germany) 9, (New York) 30; Richmond, Virginia Museum of Fine Arts 28, The Robert A. and Ruth W. Fisher Fund 94, from the Berthe and John Ford Collection 177, Purchase from the Berthe and John Ford Collection 43, The Arthur and Margaret Glasgow Fund, from the Berthe and John Gilmore Ford Collection 4; Rome, ISMEO-Museo Nazionale d'Arte Orientale 123; Rossi and Rossi, London 17; San Petersburg, The State Hermitage 7, 22, 29, 106, 108, 180; Courtesy A. and J. Speelman, Ltd., London 73, 83, 154, 157; The Zimmerman Family Collection frontispiece, 10, 19, 23, 27, 35, 42, 65, 119, 139, 147–8, 162, 178–9; Taipei, National Palace Museum 132; Art Gallery of Greater Victoria, B.C. 154.

Photographs courtesy of:
American Institute of Indian Studies, Varanasi 20, 109; Jacques Barrere, Paris 158; Bill Bueler 1, 3, 140; Robert E. Fisher 6, 8, 15, 33–4, 36, 38, 43, 45, 47, 49, 51, 62–3, 67, 80, 85–6, 90, 92, 98, 101, 122–3, 125–31, 159, 166, 167–9, 174; John G. Ford 60; Michael Henss 50, 105; Fosco Maraini, Florence 103–4, 107, 116–8, 143; H.H. Richardson 142; Dawn Rooney 61; Rossi and Rossi, London 9, 30, 151; The Swiss Tibetan Refugee Centre 170; Jeff Teasdale 89; Barry Till, Victoria BC 52–5, 58–9, 77, 87, 153, 163–5.

Plan of Yeshe Od temple, 57, after C. Luczanits
Map drawn by Martin Lubikowski

Index